DESERT
Australia

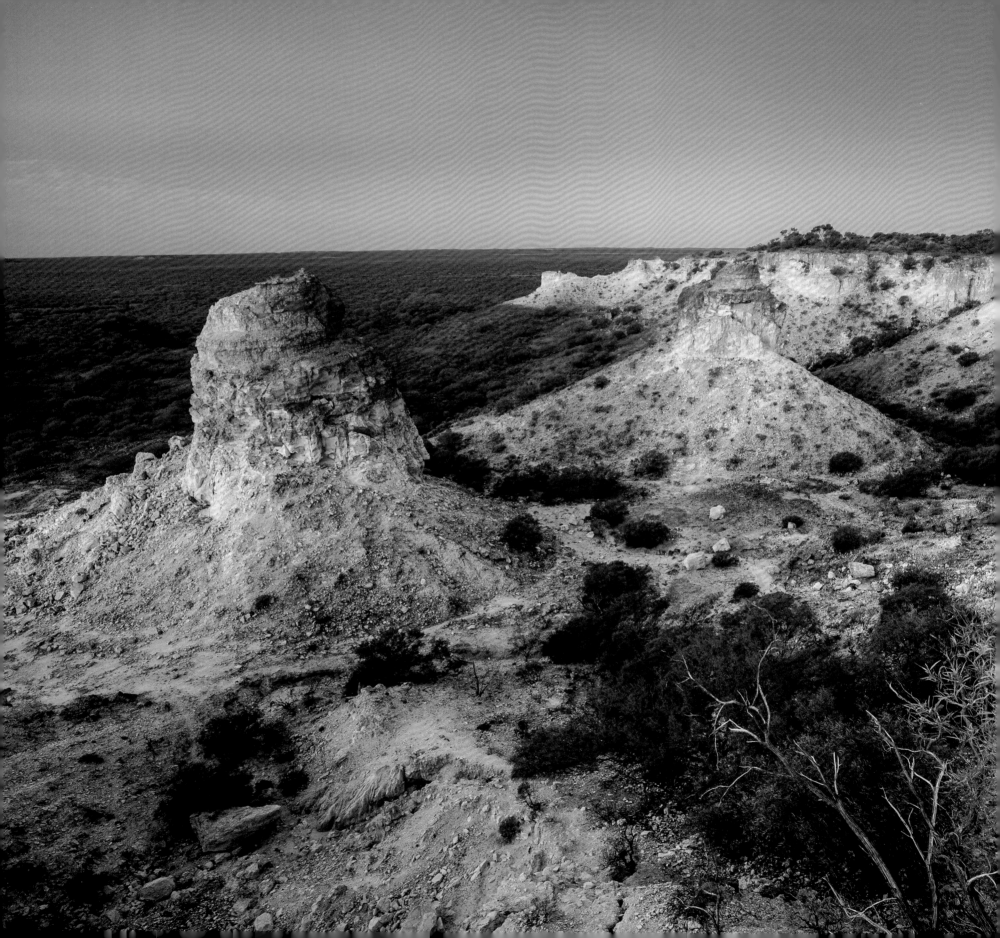

DESERT
Australia

NICK RAINS

EXPLORE
AUSTRALIA

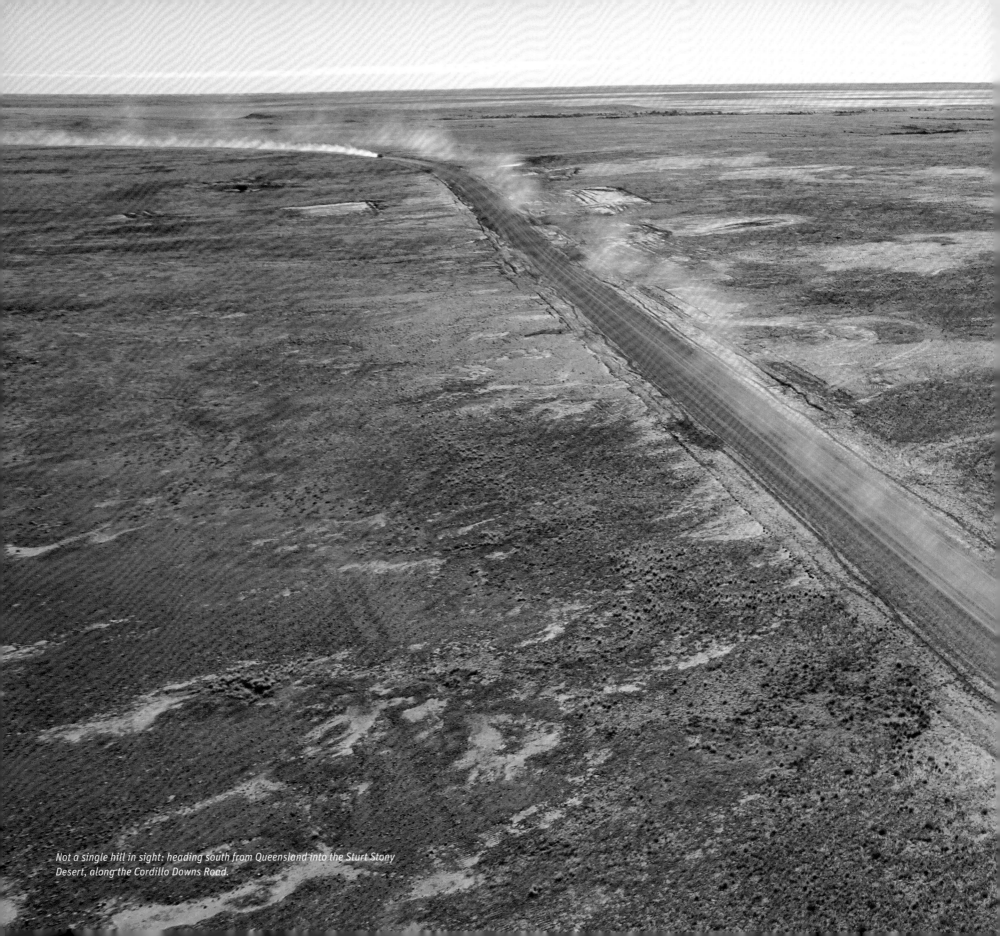

Not a single hill in sight: heading south from Queensland into the Sturt Stony Desert, along the Cordillo Downs Road.

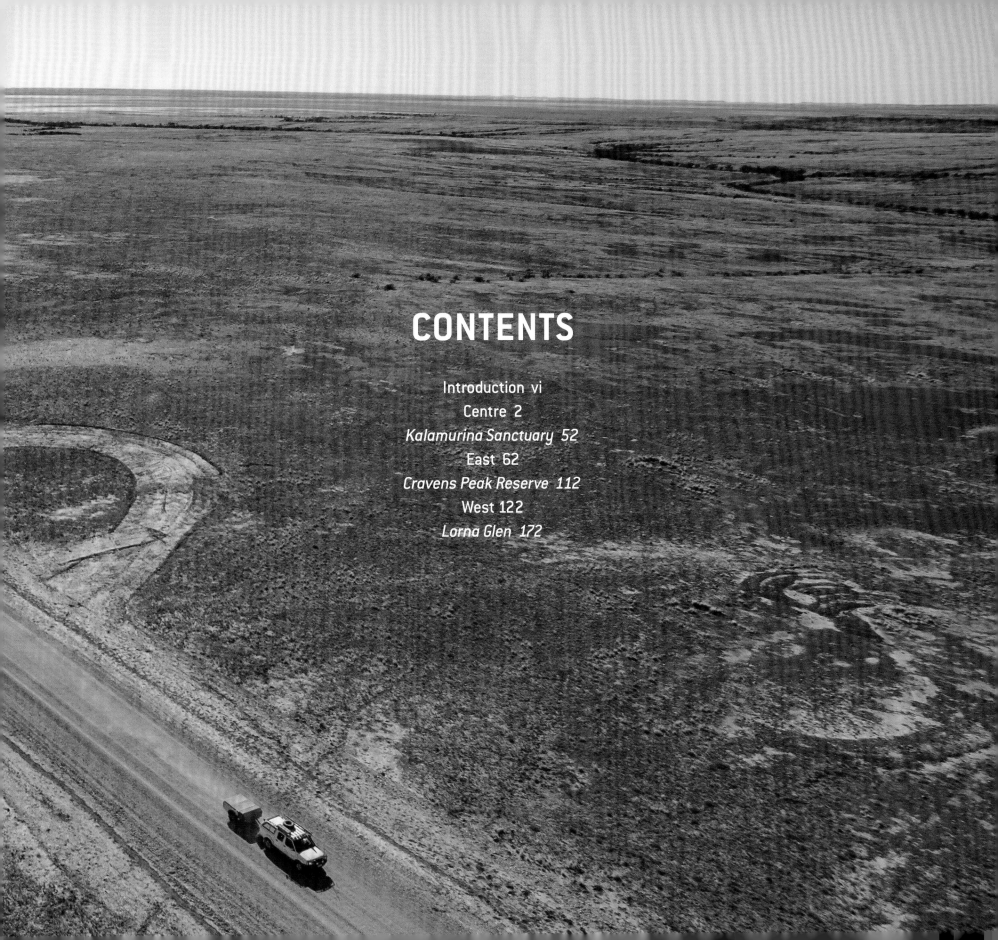

CONTENTS

INTRODUCTION

AUSTRALIA IS WELL known for being a hot, dry continent, and the outback is famous for its harsh conditions, in which only the hardiest of European settlers and pioneers were able to carve out an existence. While clearly not all of Australia is arid – the lush tropics in the north and the more moderate climes of the far south offset the drier central regions – deserts do extend across a large proportion of the continent.

The named deserts of Australia, of which there are 10, cover about 1,300,000 square kilometres in total, primarily on the western plateau and interior lowlands. That's close to 18 per cent of the Australian mainland that clearly meets the definition of a desert: a region that receives less than 250 millimetres of rain per year. However, a further 17 per cent of the Australian continent gets so little rain that it is on the brink of being desert. This book covers these arid regions as well as the named deserts.

In order of size, the named deserts are:

Great Victoria Desert, WA, SA: 350,000 square kilometres

Great Sandy Desert, WA: 270,000 square kilometres

Tanami Desert, WA, NT: 185,000 square kilometres

Simpson Desert, NT, QLD, WA: 175,000 square kilometres

Gibson Desert, WA: 156,000 square kilometres

Little Sandy Desert, WA: 110,000 square kilometres

Strzelecki Desert, SA, QLD, NSW: 80,000 square kilometres

Sturt Stony Desert, SA, QLD, NSW: 30,000 square kilometres

Tirari Desert, SA: 15,000 square kilometres

Pedirka Desert, SA: 1200 square kilometres

Evidently, the bulk of these deserts are in Western Australia and South Australia, but the arid regions also extend well into New South Wales and the Northern Territory.

Climate patterns

If you look at a climate map of Australia, you'll see that the arid regions stretch across the middle of the continent, roughly centred on the Tropic of Capricorn, which runs from Shark Bay in Western Australia across to near Yeppoon in Queensland. To the north are the tropics, typified by a monsoonal climate, and to the south the more moderate climates, characterised by cold wet winters and dry summers.

Zoom out a bit and it becomes clear that this dry belt occupies a zone from about 20 degrees south of the equator to about 32 degrees south, and that another dry belt exists an equivalent distance north of the equator. These arid bands are the result of hot, moist air rising from the equatorial regions,

spreading north and south and then drying out as it falls along the Tropic of Cancer and the Tropic of Capricorn. This dry descending air creates permanent high-pressure zones, which, consequently, receive little rainfall and are mostly hot.

The Australian deserts are at a similar latitude to the Kalahari Desert of South Africa in the Southern Hemisphere; in the Northern Hemisphere the arid belt includes several major deserts, such as the Sahara, Arabian, Gobi and Great Basin deserts. Between these two belts lie the tropics; to the north and south lie the world's two main temperate and polar zones.

Deserts are obviously characterised by low rainfall. From a natural history perspective the Australian deserts are relatively benign because they all receive some rain (even if only sporadically). In contrast, parts of the Atacama Desert in South America have had no rain at all since records began!

In fact by international standards, Australian deserts receive relatively high rates of rainfall. No weather station situated in an arid region records less than 100 millimetres annually. Not only that but Australian deserts are not necessarily completely devoid of vegetation. Most have large areas where vegetation is quite dense, albeit low growing. There are no 'seas of sand' like those you find in the Sahara or Namib deserts of Africa.

It's the rainfall and the temperatures that shape the biology of the flora and fauna – creatures and plants need to be able to deal with extremes of temperature as well as extremes of water supply. Summer in the desert can be scorching. The highest official recorded temperature in Australia is 50.7°C, measured in 1960 at Oodnadatta, South Australia, on the eastern fringes of the Great Victoria Desert. But in winter clear skies and dry air mean that some deserts experience night-time temperatures well below zero – down to –8°C in the Red Centre in 1976.

Water supply is variable too. It might not rain for months, even years, and then suddenly there will be a flood. Some of the ephemeral lakes dry up completely into hard-baked claypans that you can drive a heavy vehicle across with no trouble at all. Then there is a sudden storm or flash flood, the claypans fill with water, creatures that have been hibernating (aestivating) in the deep mud come back to life, and suddenly the place is teeming with shrimp, desert freshwater fish and frogs. Deserts are very far from being lifeless places.

A challenging realm

The Australian outback is well known around the world as a place where huge cattle and sheep stations were created in spite

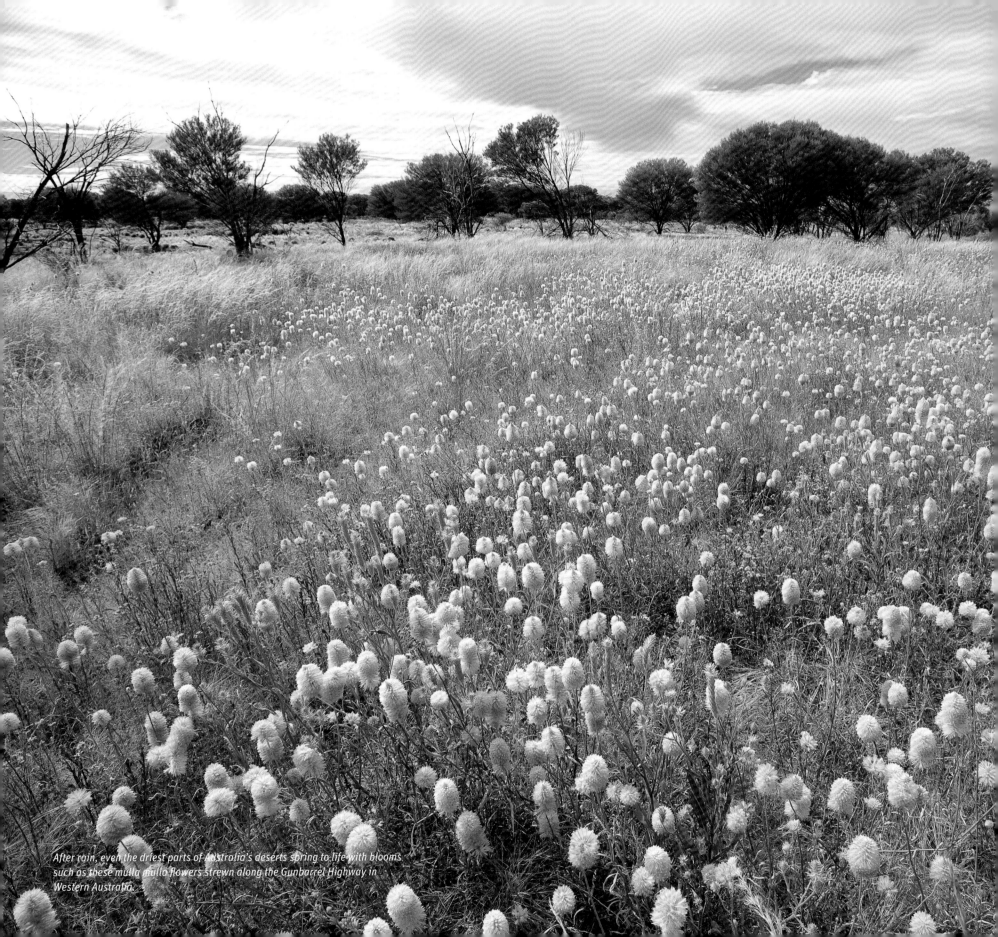

After rain, even the driest parts of Australia's deserts spring to life with blooms such as these mulla mulla flowers strewn along the Gunbarrel Highway in Western Australia.

of incredible hardships and, in many cases, catastrophes. Some of the massive empires built up in the late 19th century formed the basis of Australia's 20th-century economy, and sheep and cattle still constitute a substantial part of Australia's exports to this day.

Creating these stations, or ranches, as the Americans would say, took great fortitude. To 19th-century European eyes, the land was there for the taking, but because it was so sparse, massive areas were needed to support viable populations of livestock. In the 1890s, the Durack family operated huge stations in the Kimberley region of Western Australia, after taking 3000 head right across central Australia on the world's longest ever cattle drive. Even today, Anna Creek Station, near Lake Eyre, is the world's largest operating cattle station: at over 23,000 square kilometres, it's bigger than Israel and more than seven times the size of the largest ranch in the United States.

Having spent many months over many years travelling in these arid regions, I find it hard to imagine what it must have been like to live in the desert even 40 or 50 years ago, let alone in Victorian times. The heat is unrelenting, the remoteness can easily be life threatening and the vast, treeless horizons can wear you down.

Nevertheless, I love travelling through the deserts and outback of Australia. They're not the easiest places to photograph, but they reward a patient approach, a keen eye and a certain amount of tenacity.

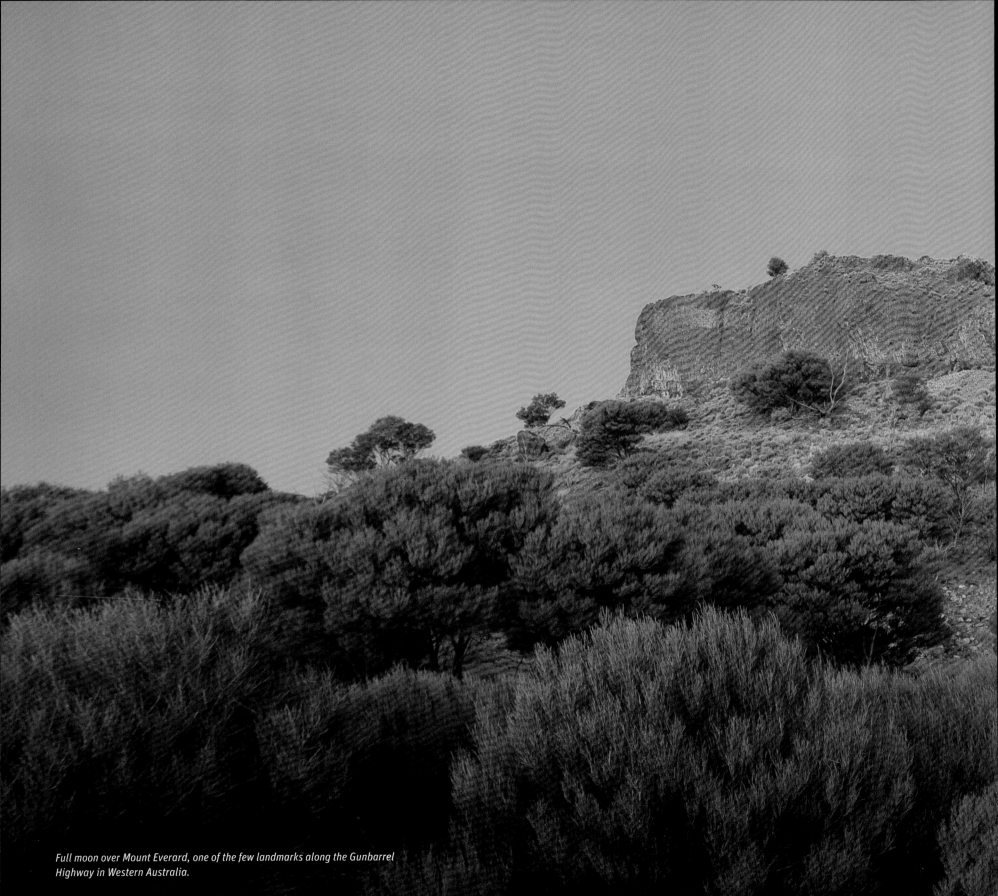

Full moon over Mount Everard, one of the few landmarks along the Gunbarrel Highway in Western Australia.

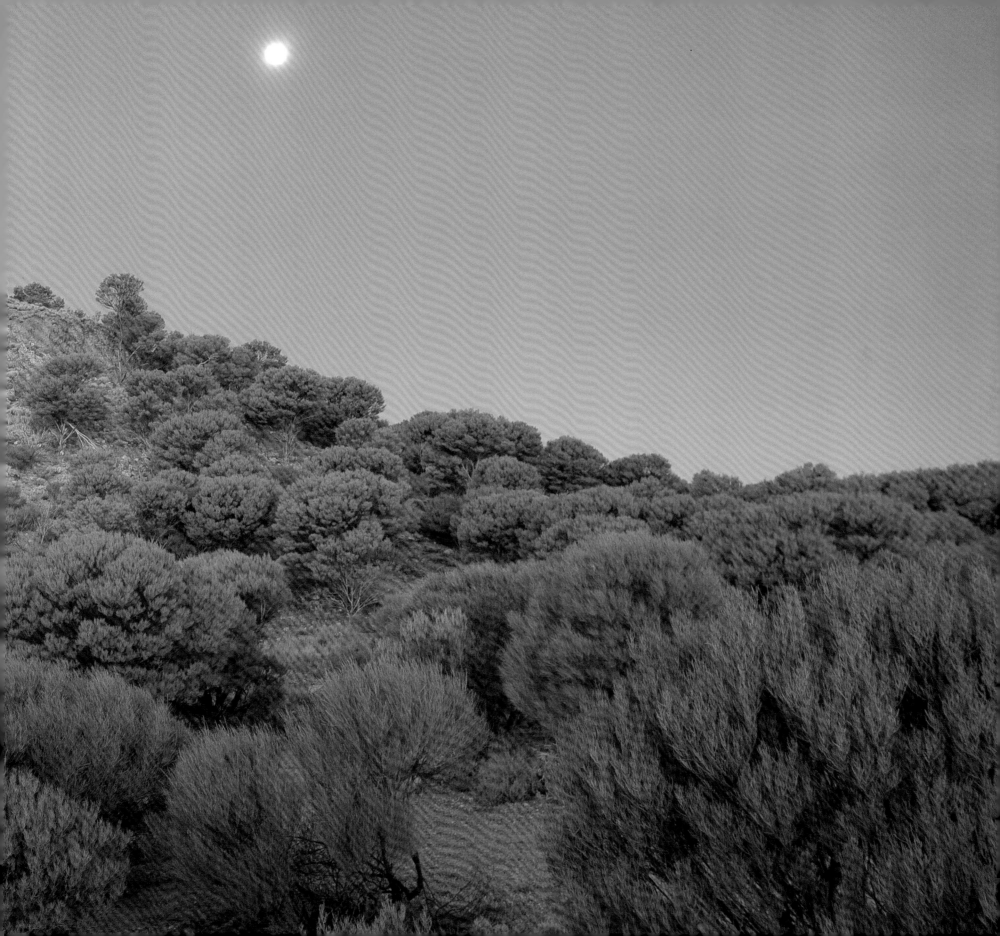

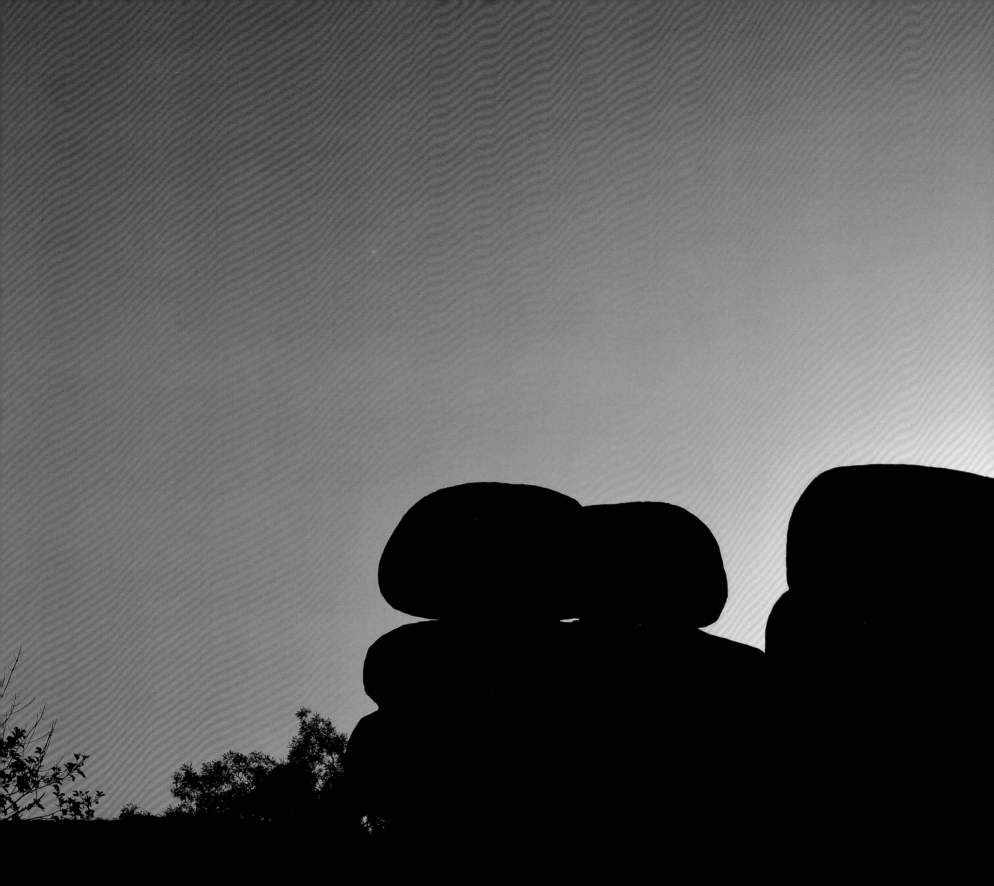

The sun rises behind Karlu Karlu/Devils Marbles in the Northern Territory.

CENTRE

THE CENTRAL DESERTS of Australia occupy a huge region from roughly Tennant Creek in the north all the way south to around Port Augusta. This is the region that comes to mind when you think of the outback or, as the travel brochures call it, the Red Centre.

This name is not without merit: the region really is incredibly red. Around Alice Springs, the first thing that many visitors notice is just how crazily red the ground is. I have heard people say 'It's just like in the photos!', and I take that as a compliment because I do try to keep my images realistic – you don't need to add any saturation to capture the intense reds and blues of this part of Australia.

Why is the centre so red? Well, Australia is essentially rusting away as the millennia pass by. There is a huge concentration of iron in some parts of the country – under the Pilbara in Western Australia, for instance, there are places where the ground is well over 50 per cent pure iron ore. In the central regions, the levels of iron aren't high enough to attract the big mining companies, but they still create that distinctive rust-red colour.

Geologists think of Australia as 'old, flat and red'. Uluru (Ayers Rock), for example, in the Red Centre, was formed from sedimentary rock laid down over 500 million years ago, before uplifting and folding created that familiar shape. The whole continent has remained relatively stable over the aeons, and even the highest outcrops or ranges have been steadily worn down by erosion. Today the average elevation across the continent is a mere 325 metres above sea level, compared to 870 metres for the rest of the planet.

As for the colour, it's all down to something known as the regolith, a term used by geologists to describe a layer of loose superficial material covering solid rock. If you look at a geological map of Australia, you'll see that the regolith covers approximately 80 per cent of the surface. The actual source of the red colour is a mineral in the regolith called hematite (from the Greek *haimatites*, meaning 'blood-like'). It's the mineral form of iron (III) oxide; and of course when iron is exposed to oxygen, it rusts. Hematite is also a great pigment – try getting outback dust stains out of

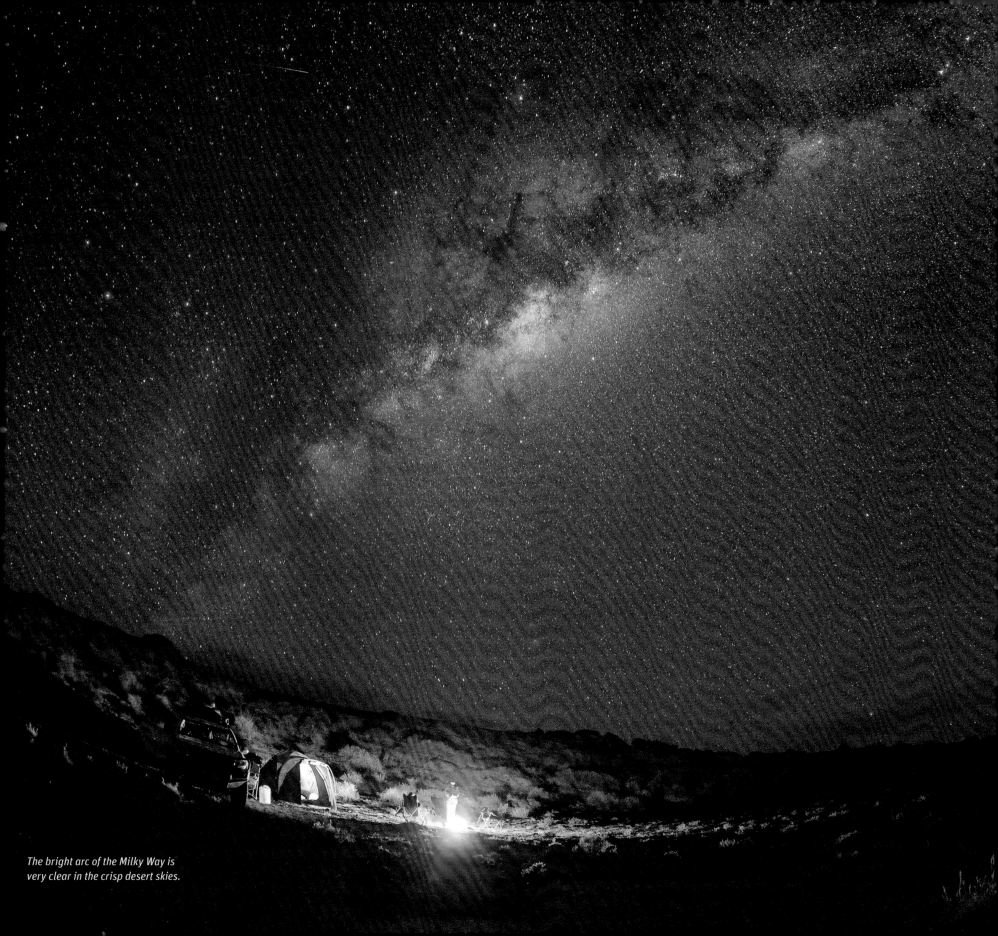

*The bright arc of the Milky Way is
very clear in the crisp desert skies.*

your clothes – and hematite-laced clay has been long and widely used in Indigenous art.

Another consequence of this rich red hue is the well-known phenomenon of Uluru appearing to glow like a red-hot ember in the evening light. I'll let you into a secret here. As most people know, as the sun goes down the rock takes on the intensity of the warm evening light and looks very red against a clear blue sky. But, if you ever visit, don't head back to the hotel as soon as the sun sets, because the show is not over yet.

About 20 minutes after the sun drops below the horizon, the sky behind Uluru will be a deep indigo blue, but the sky where the sun has just set (behind you to the west) will take on a bright yellow-magenta hue. This is enough to illuminate the red rock of Uluru, and for about another five minutes it will look even more intensely red. Cameras have no trouble picking this up: take a look at the image of Uluru on page 13 and you'll see what I mean.

Kati Thanda–Lake Eyre attracts a wide range of migratory birds when it floods.

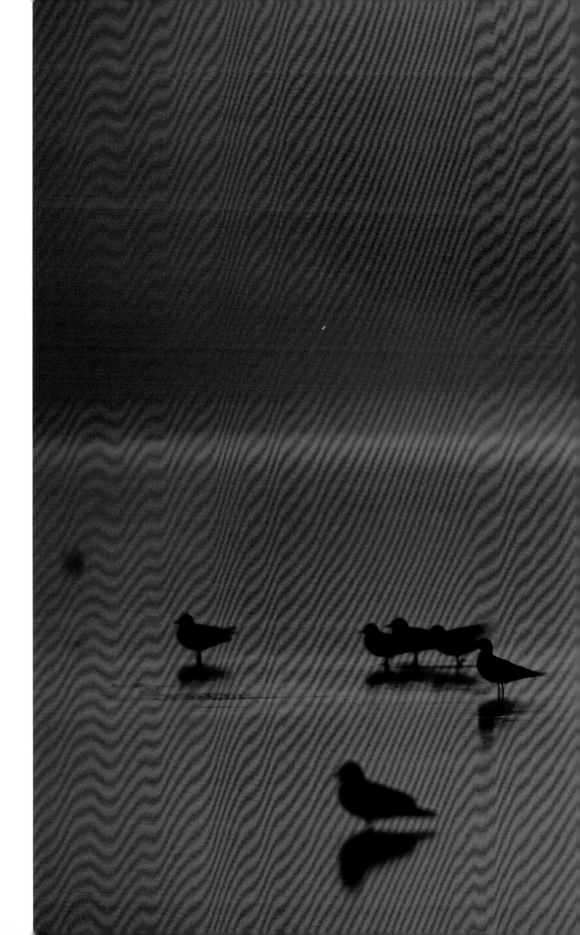

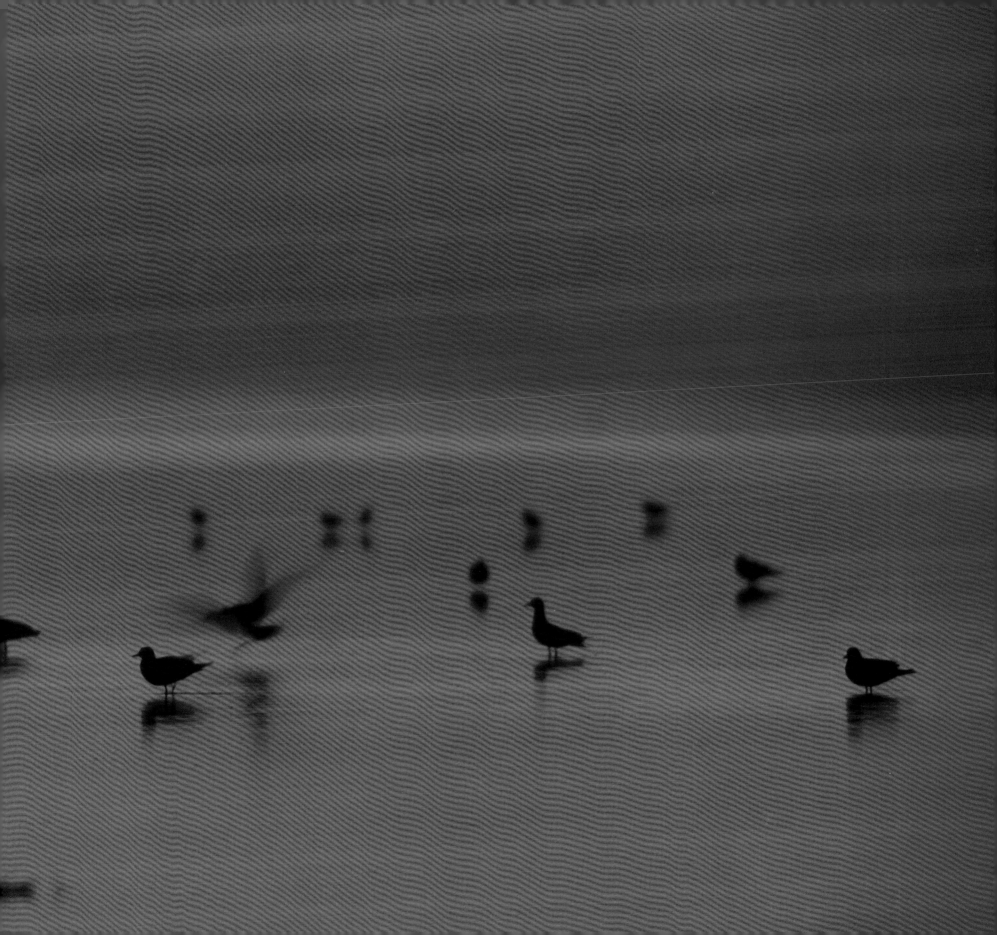

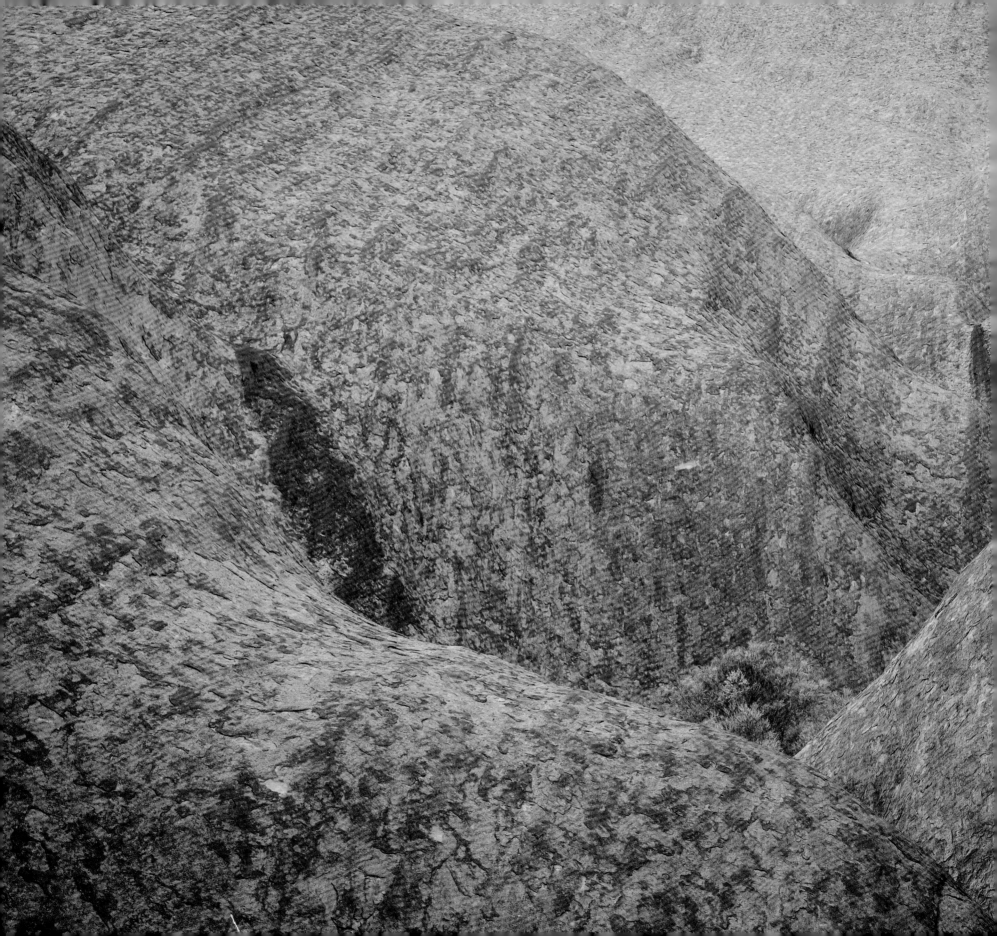

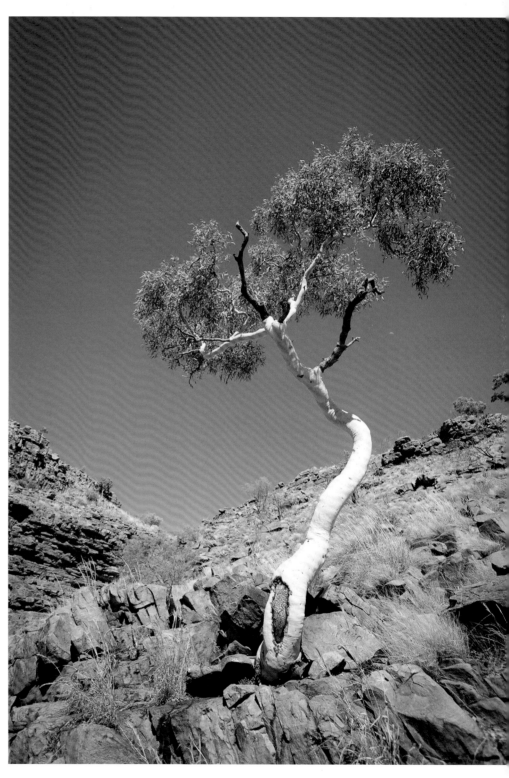

ABOVE Australia's eucalypt trees can grow in the most marginal of places.

LEFT Water erosion has carved deep channels into the flanks of Uluru.

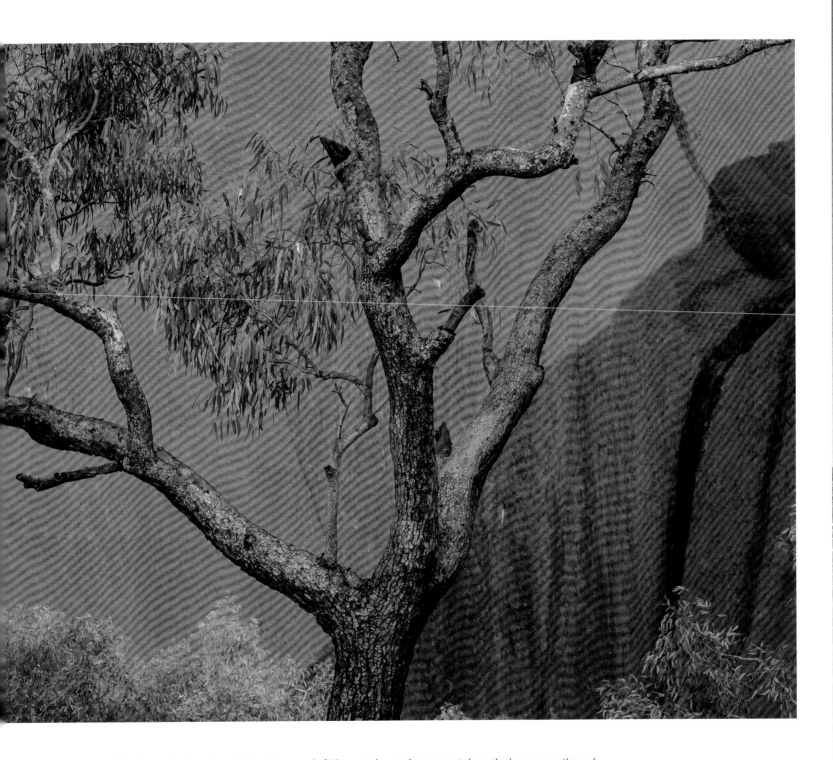
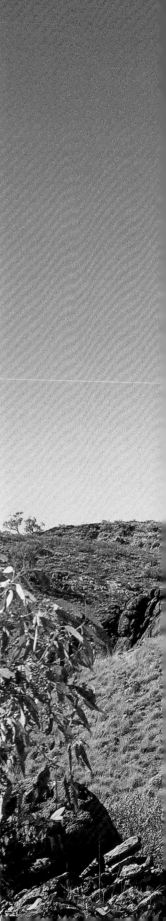

ABOVE *A desert bloodwood stands out against the intense red of Uluṟu, as the evening sun casts long shadows across the rock.*

RIGHT *Located an hour's drive east of Alice Springs, Corroboree Rock is a place of great significance for the local Arrernte people.*

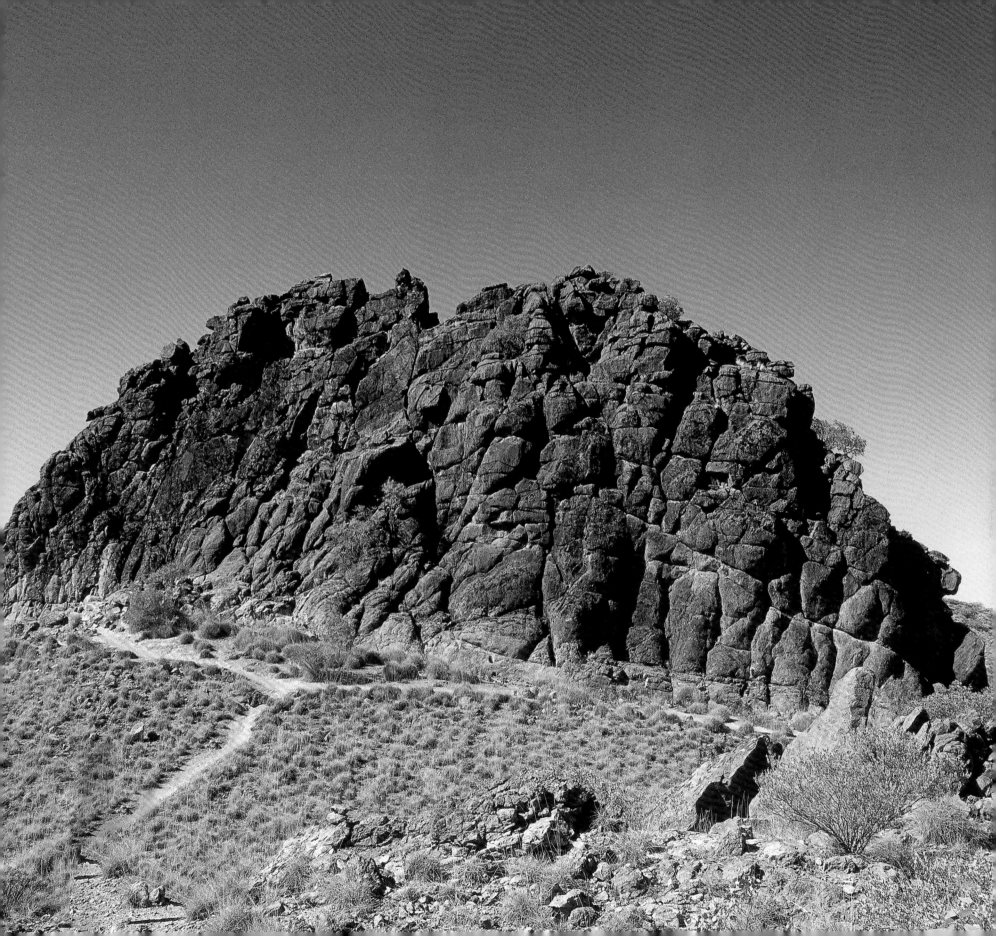

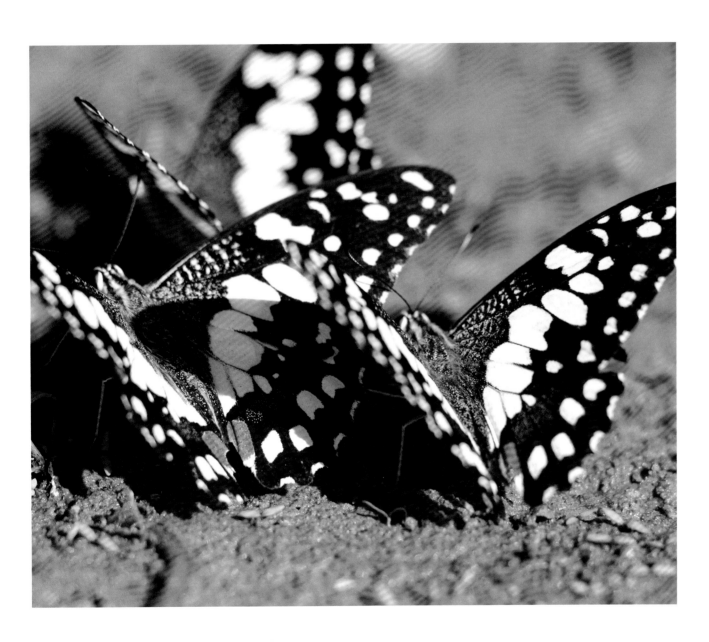

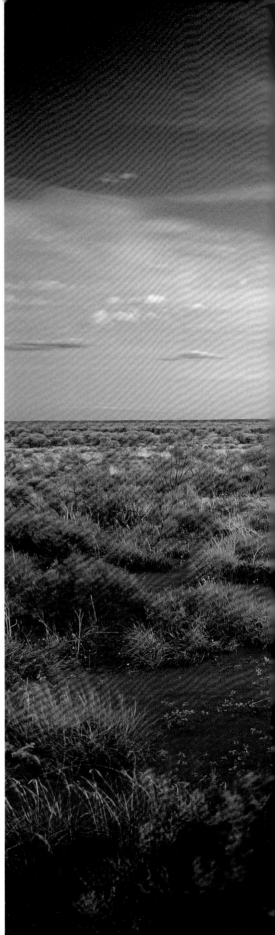

ABOVE Chequered swallowtail butterflies suck up moisture from damp sand at the water's edge, on Muloorina Station near Lake Eyre.

RIGHT The most recognisable view in Australia? Uluru at dusk.

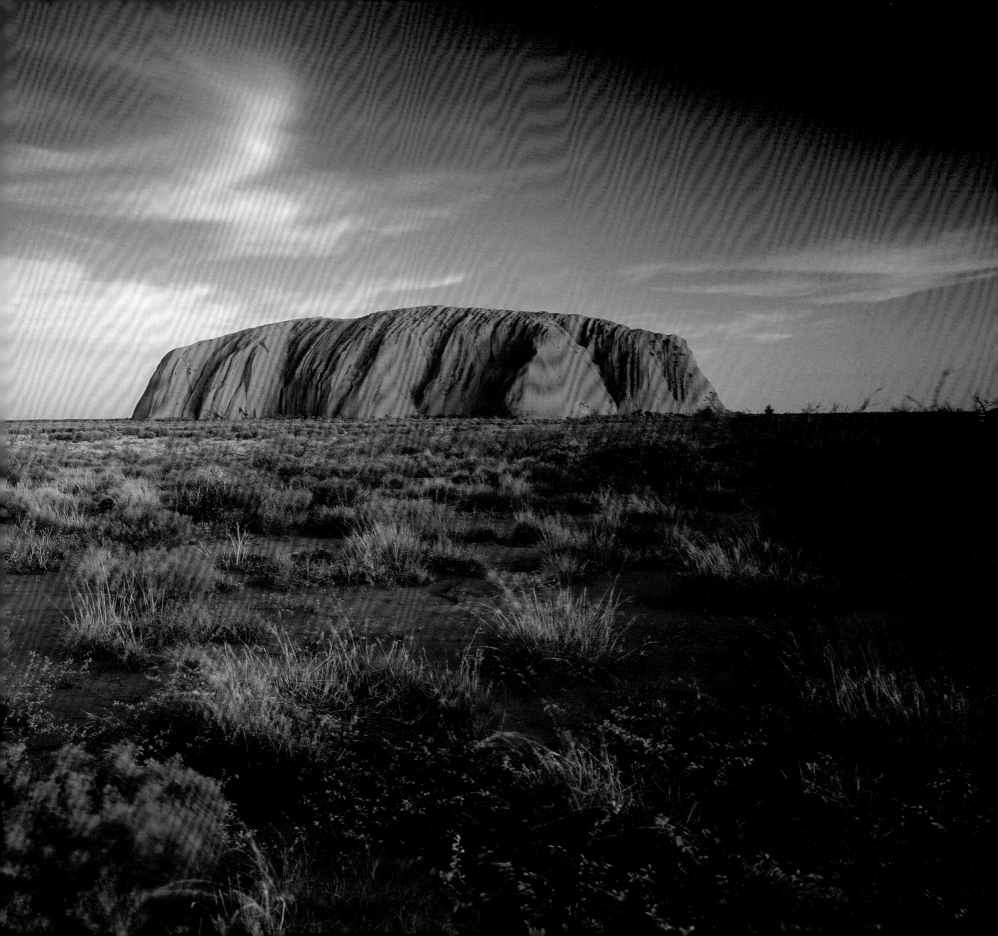

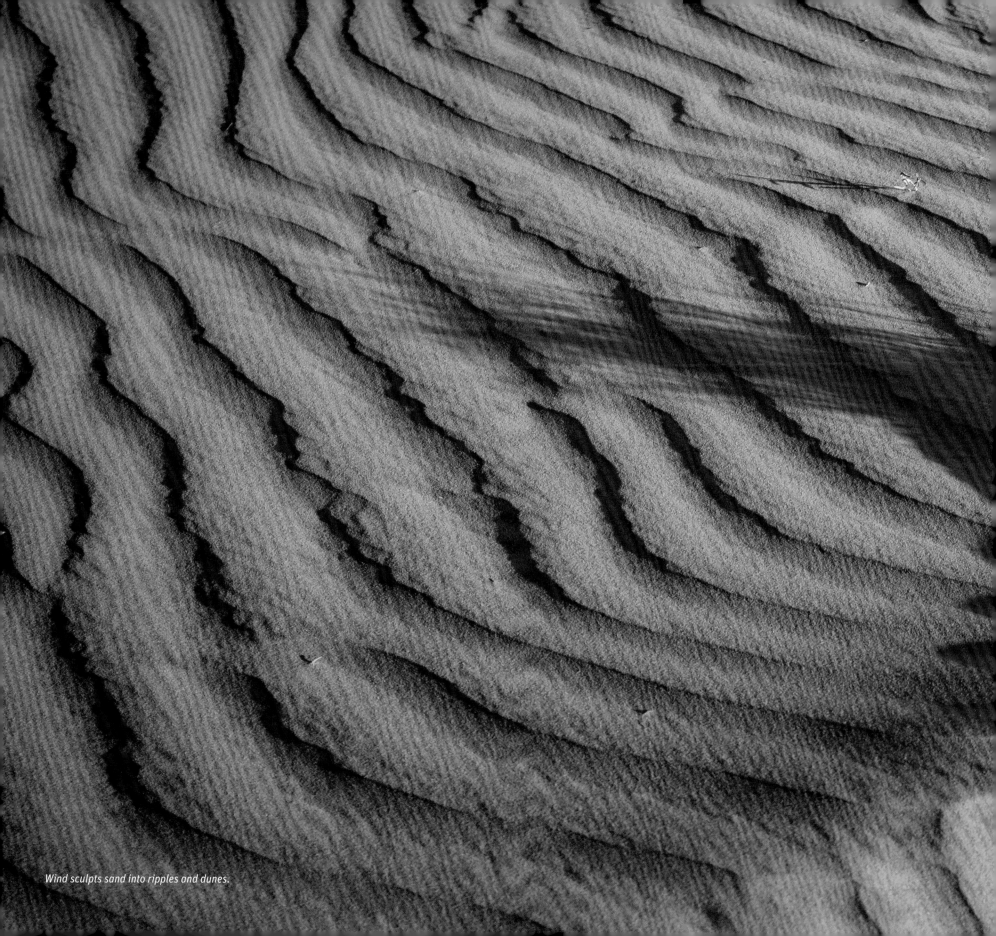

Wind sculpts sand into ripples and dunes.

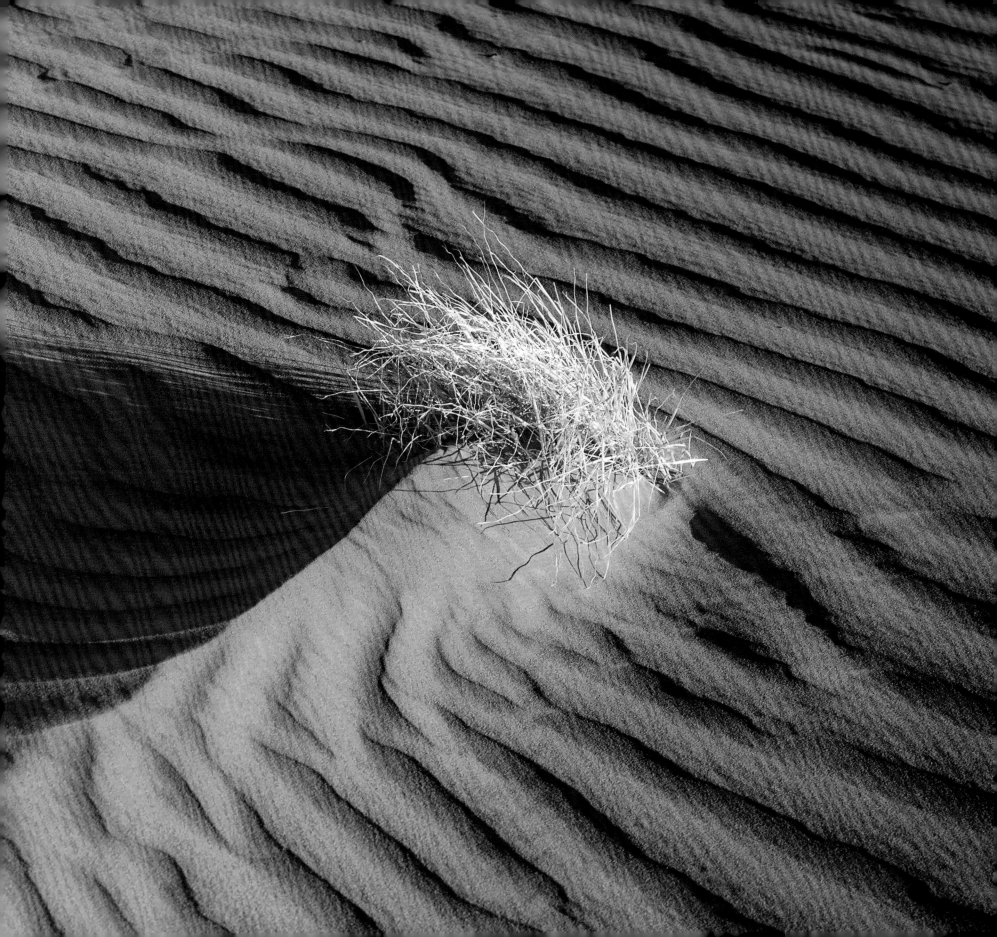

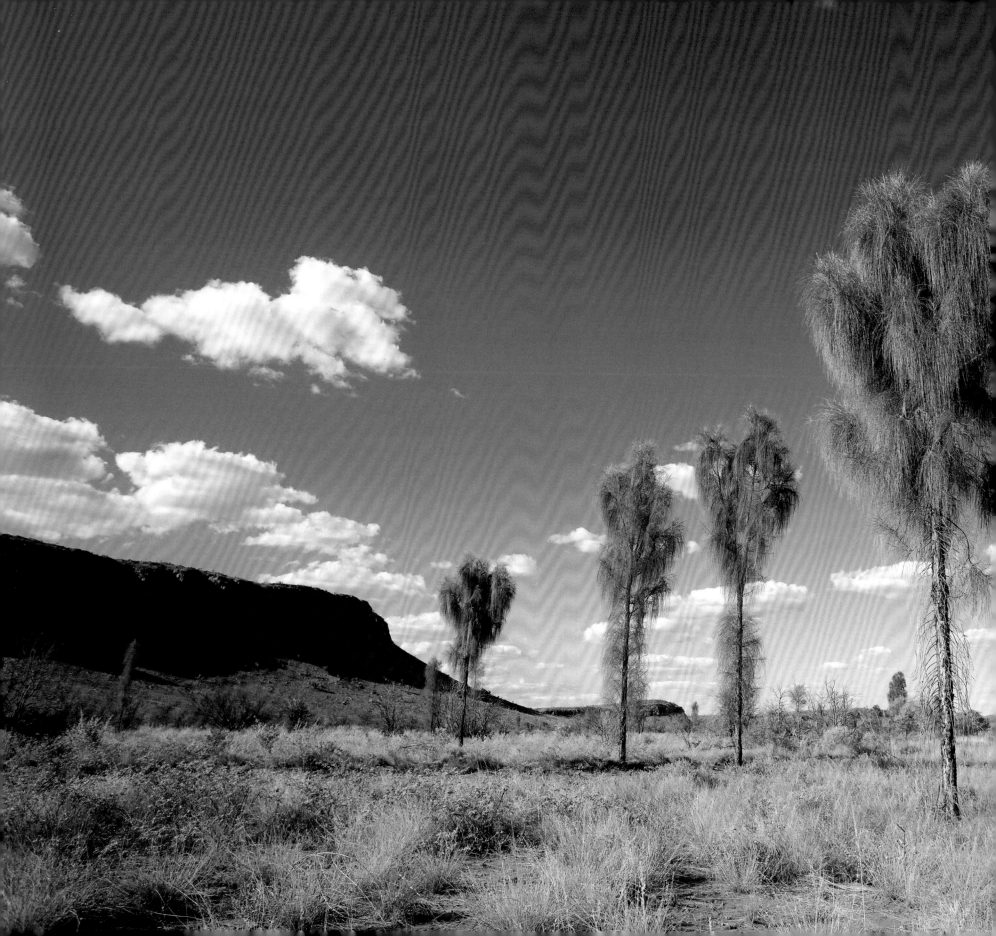

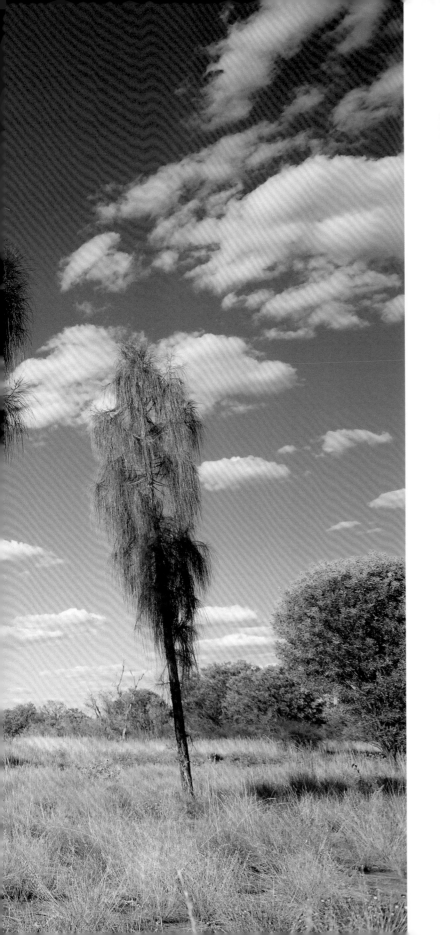

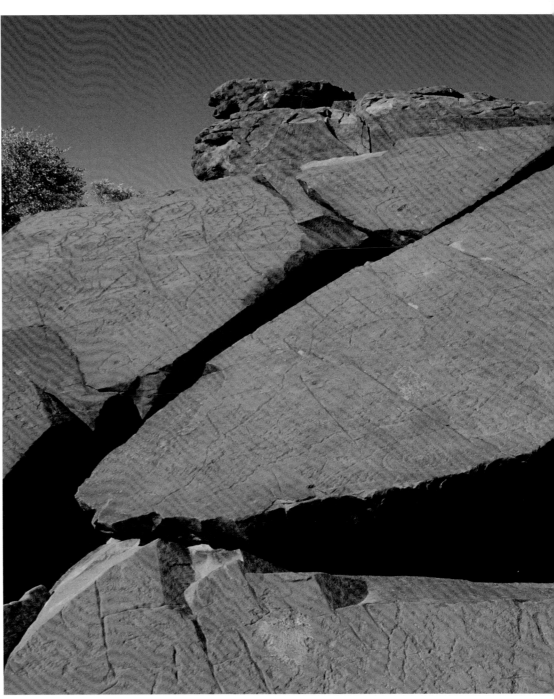

ABOVE The petroglyphs at Ewaninga near Alice Springs are thought to be up to 30,000 years old.

LEFT Desert oaks start off their lives looking like odd Christmas trees before they assume the broad, spreading shape of their later years.

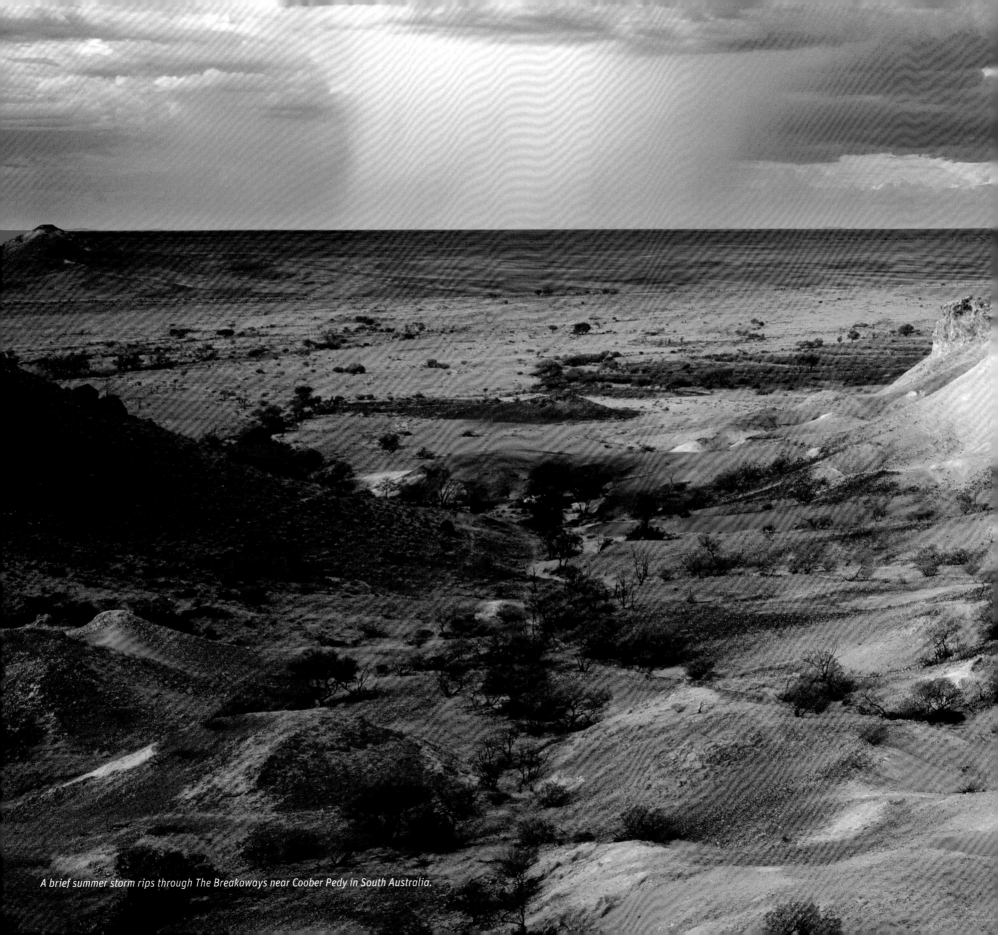

A brief summer storm rips through The Breakaways near Coober Pedy in South Australia.

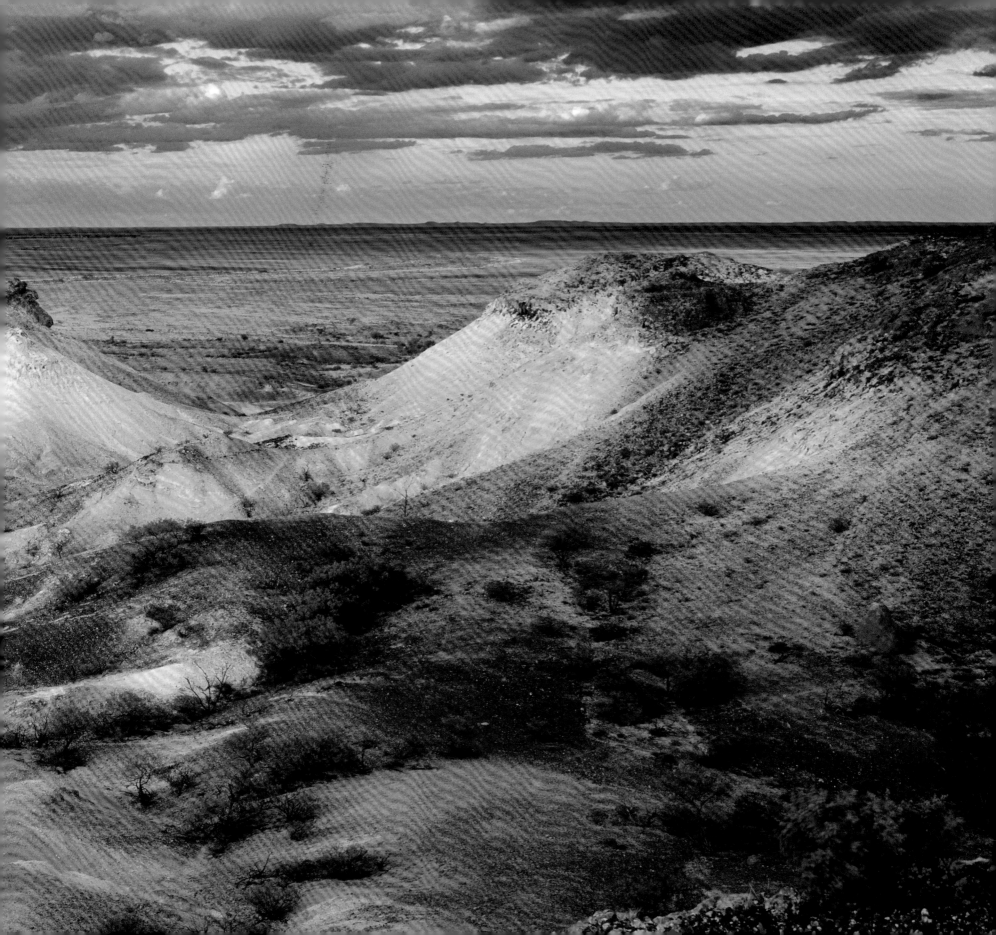

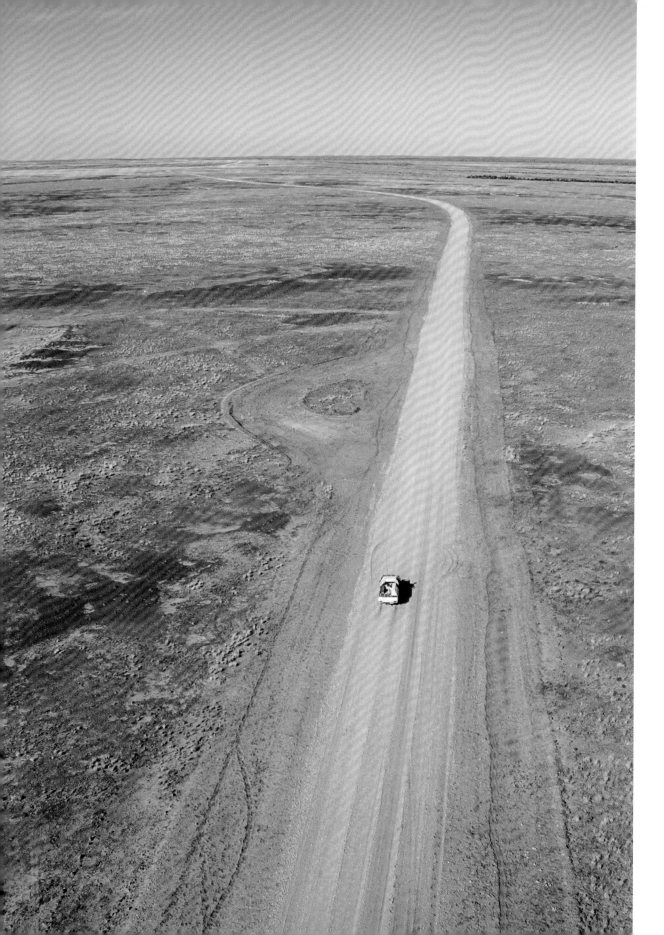

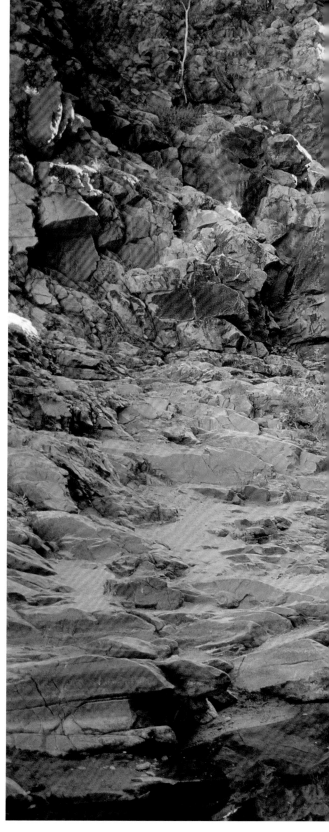

LEFT *The Birdsville Track crosses some of the most inhospitable parts of Australia.*

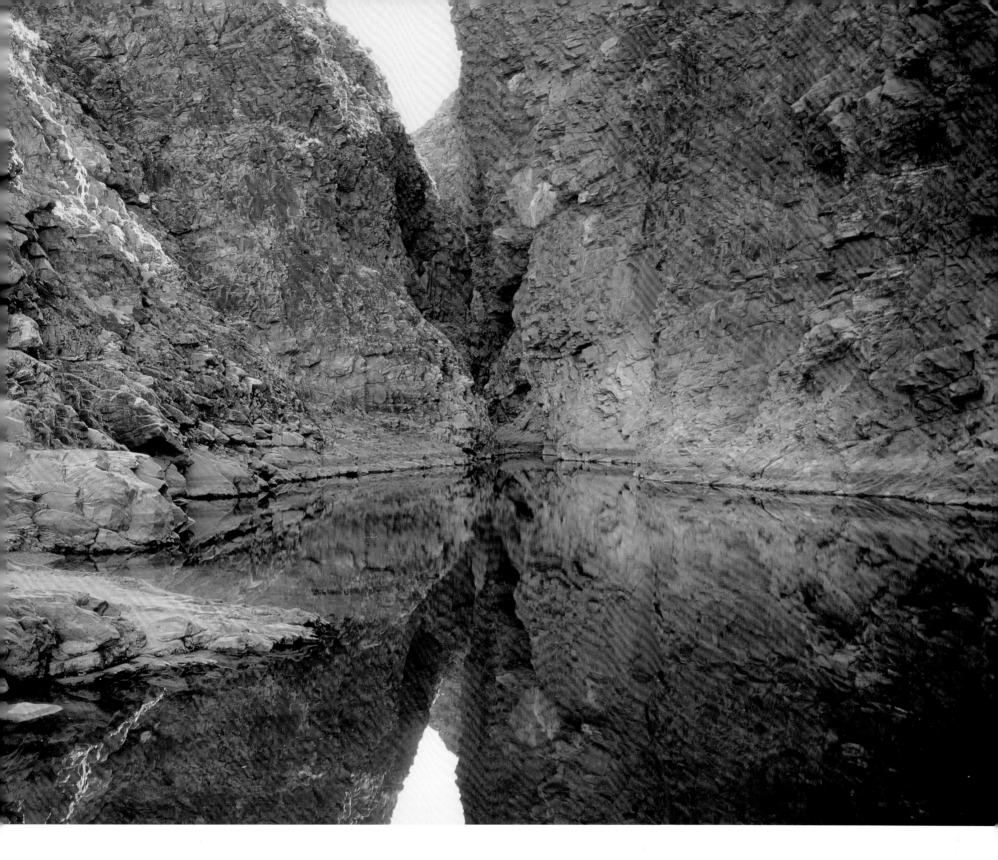

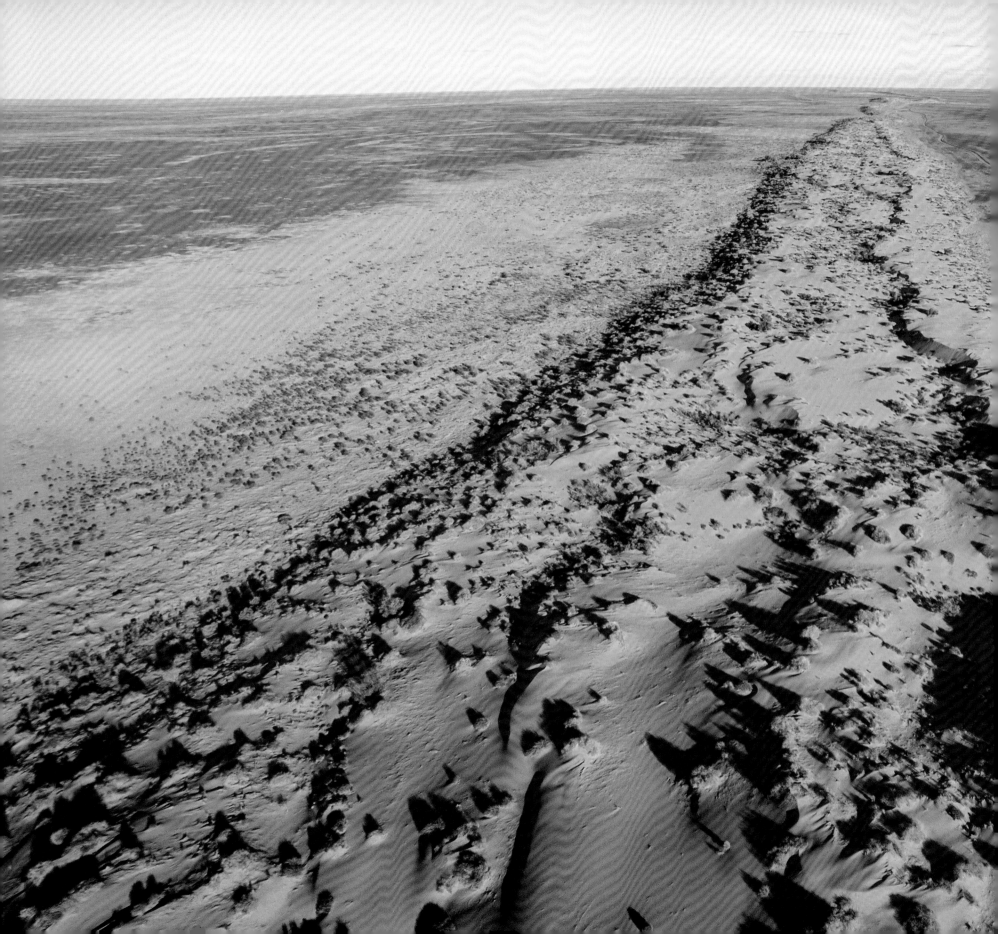

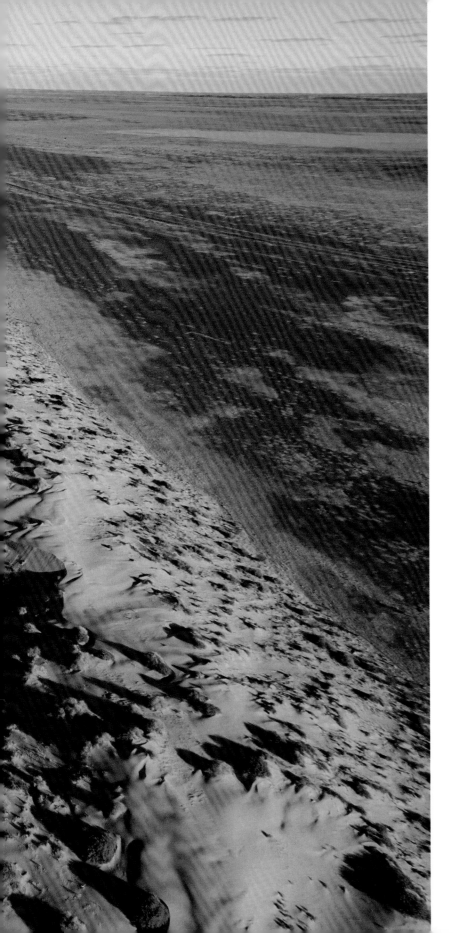

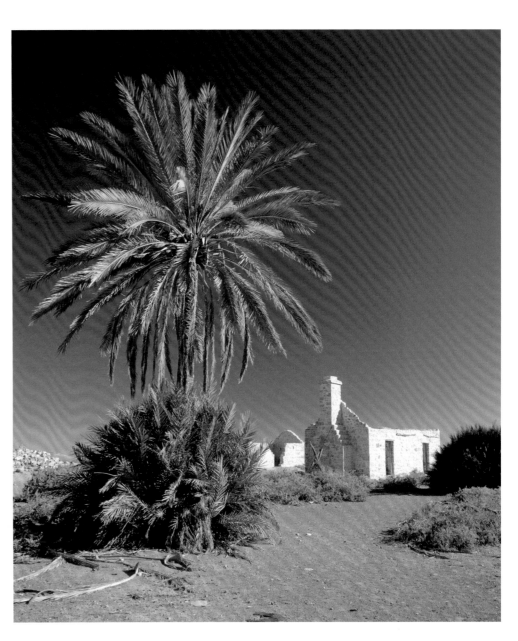

ABOVE Early European settlers planted date palms at Dalhousie Springs, on the western fringe of the Simpson Desert.

LEFT In this typical central Australian scene, a long dune system bisects flat gibber plains.

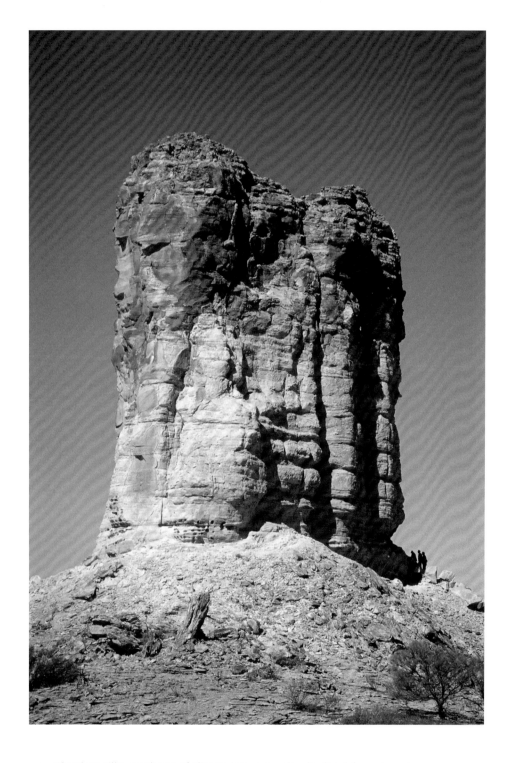

ABOVE Chambers Pillar, south-east of Alice Springs, was a clear landmark for early explorers.

RIGHT The dingo reached Australia about 5000 years ago and has become a highly successful predator in central Australia.

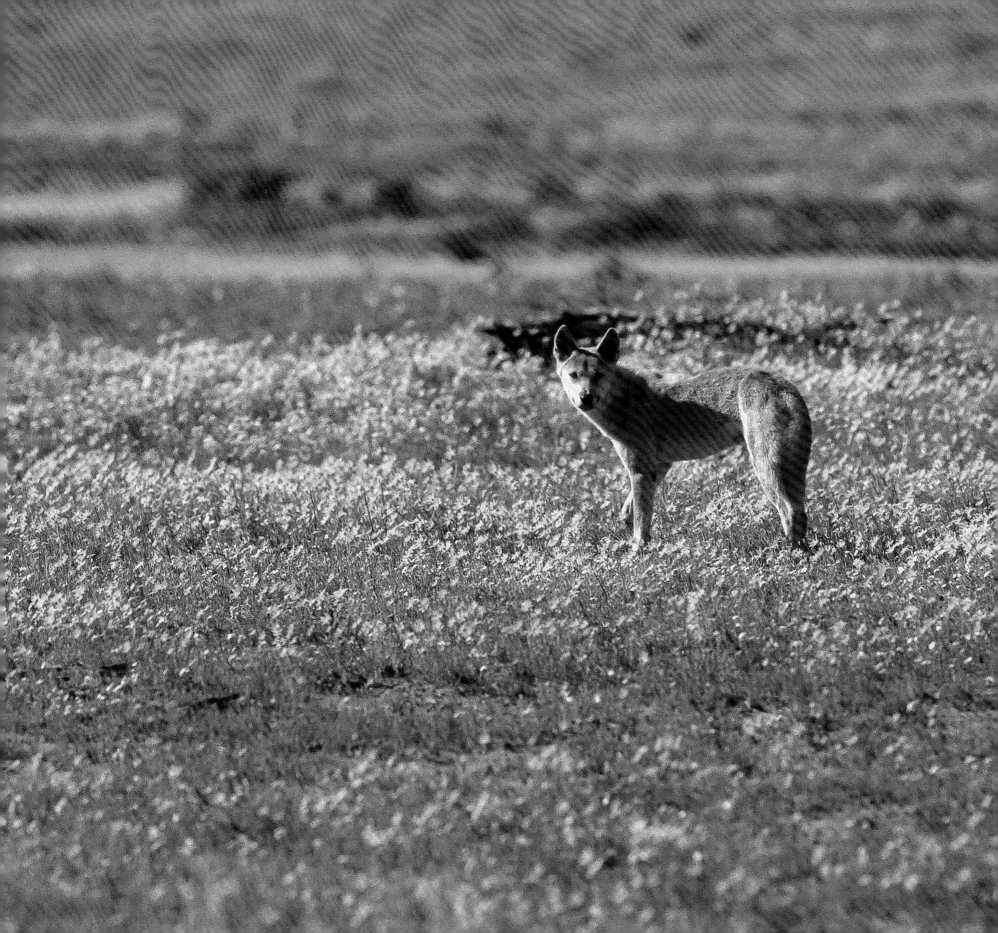

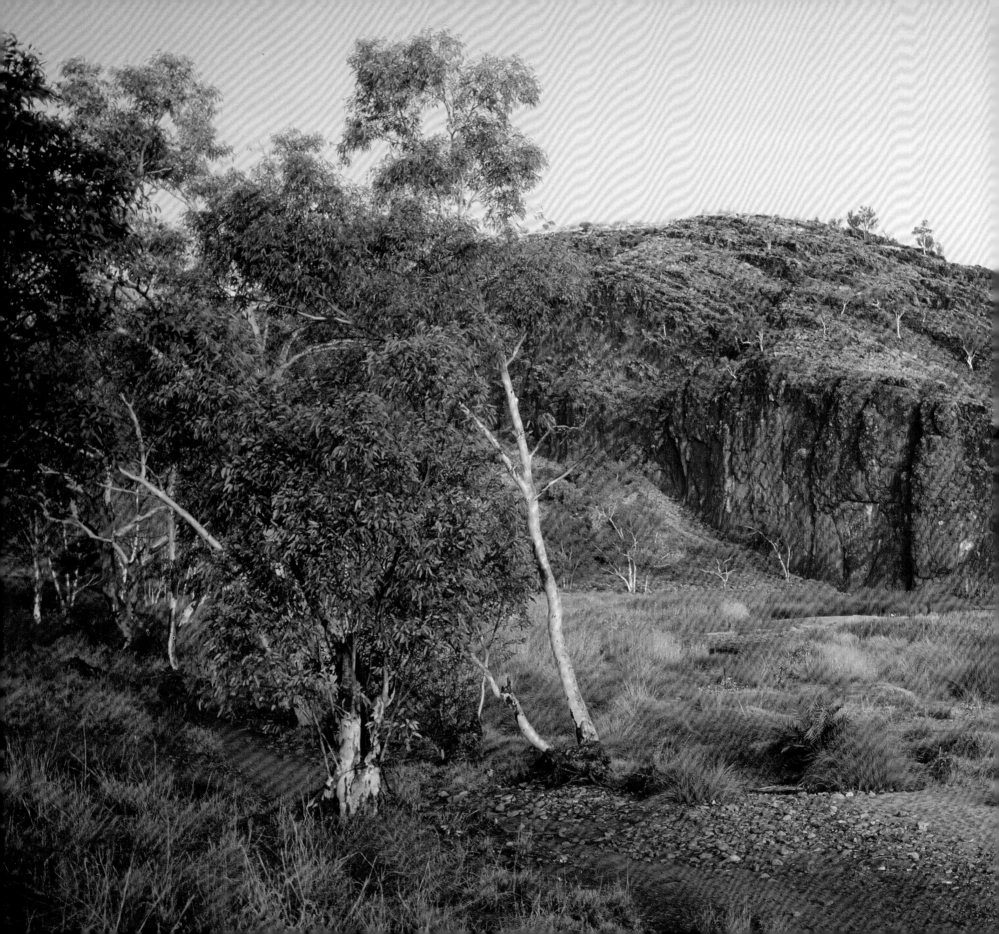

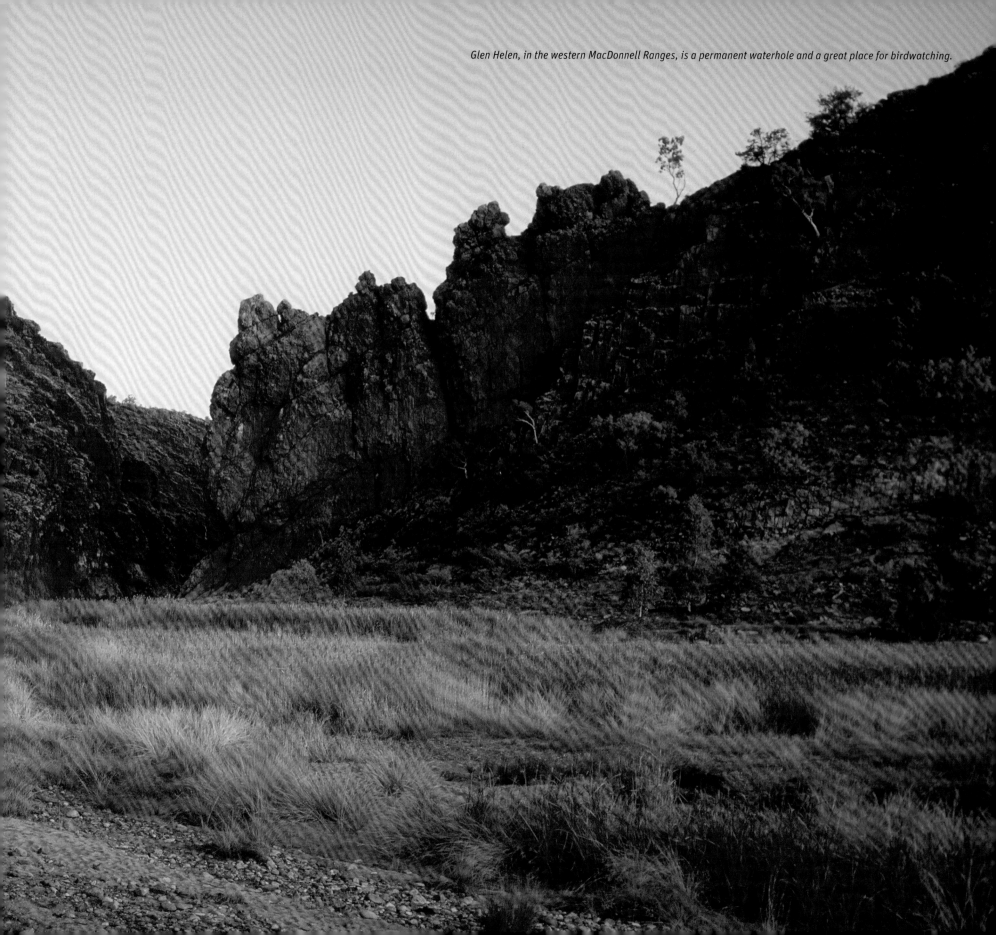

Glen Helen, in the western MacDonnell Ranges, is a permanent waterhole and a great place for birdwatching.

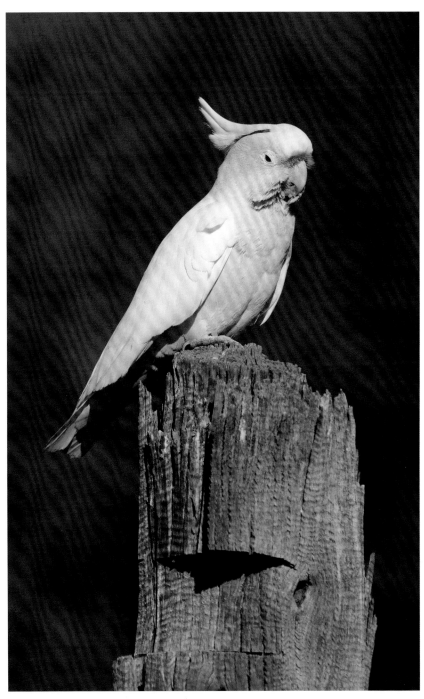

ABOVE Sadly, the distinctive Major Mitchell's cockatoo is becoming a rare sight these days.

LEFT A dusty outback traveller soaks in hot water from an artesian bore.

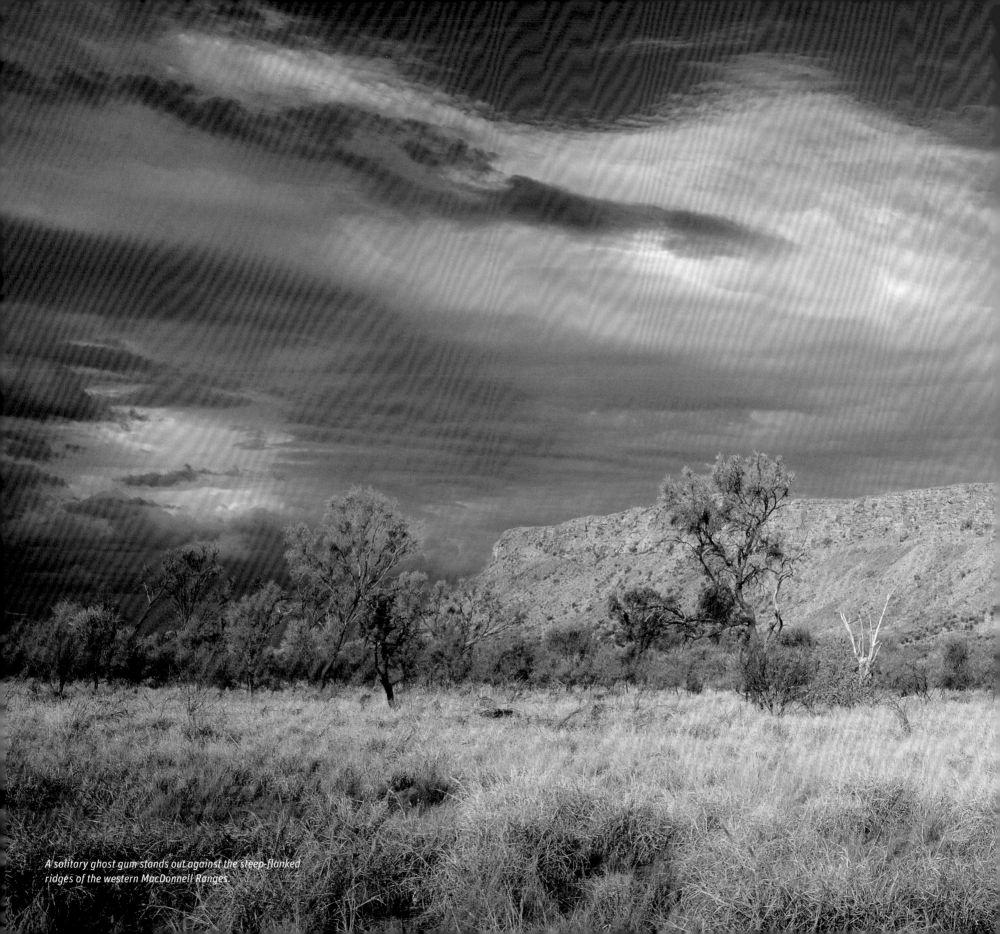

A solitary ghost gum stands out against the steep-flanked ridges of the western MacDonnell Ranges.

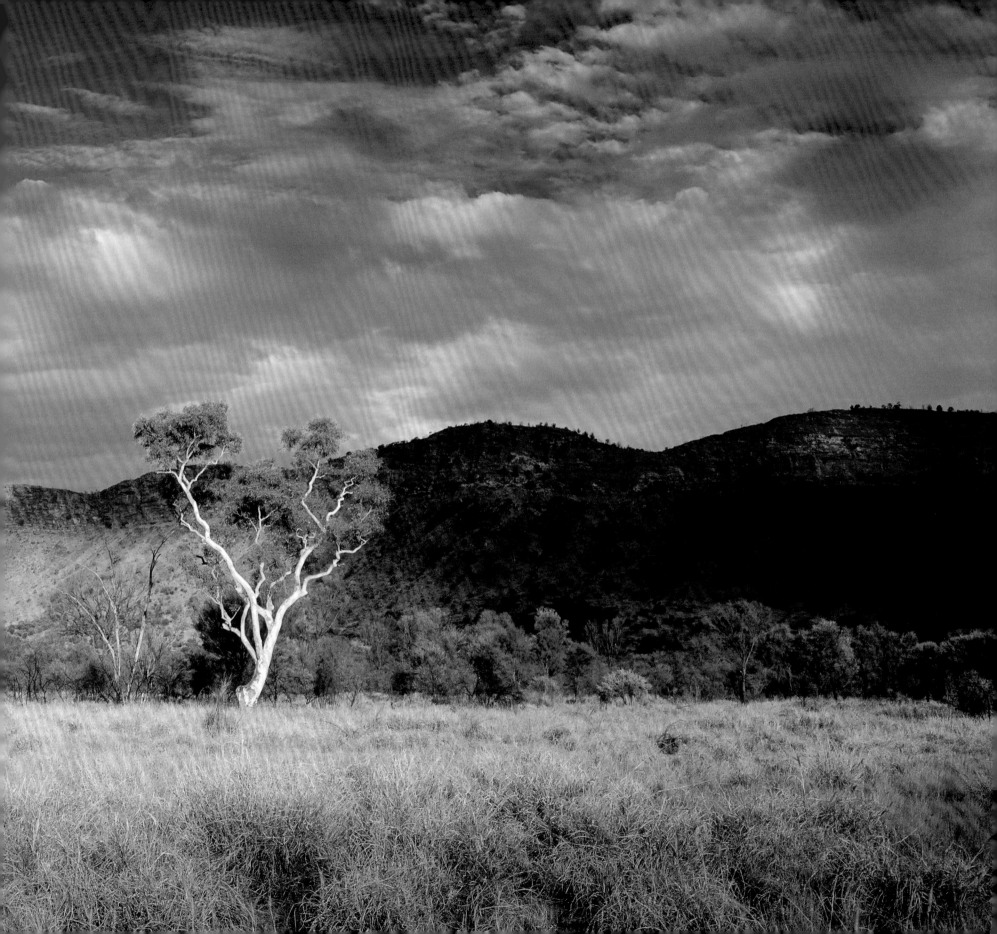

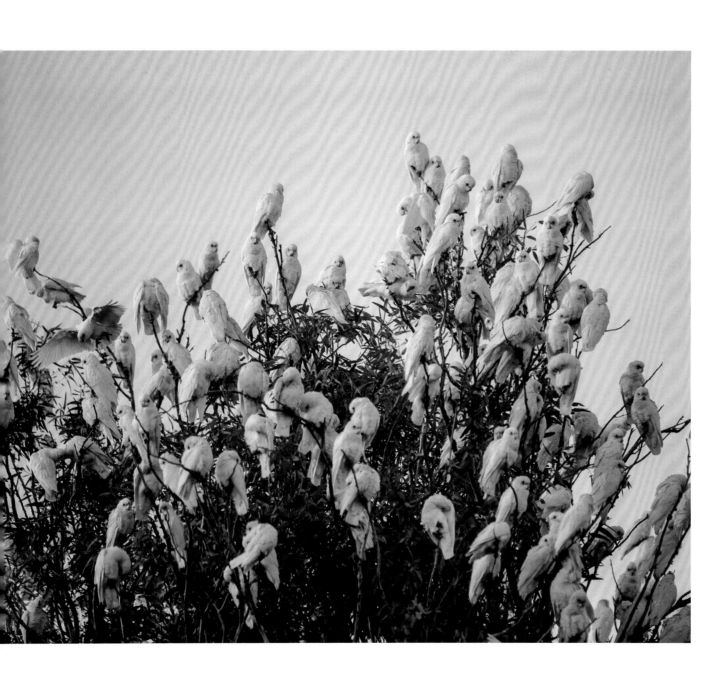

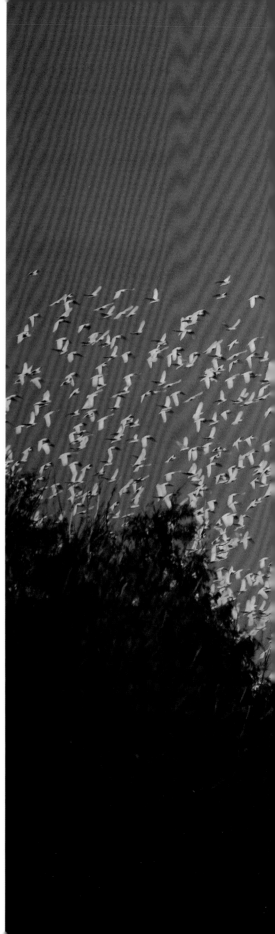

ABOVE *Huge flocks of corellas roost overnight in the trees along waterways.*

RIGHT *In the morning, the corellas take to the air en masse in the dawn light.*

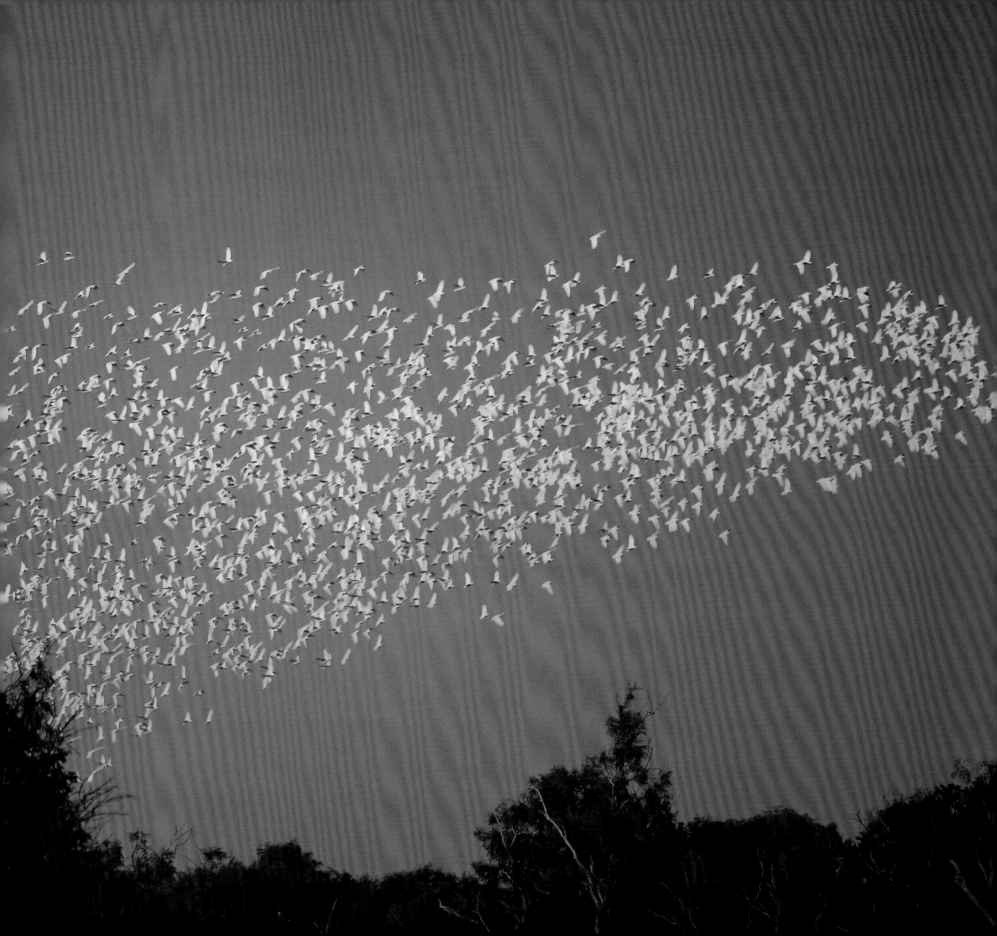

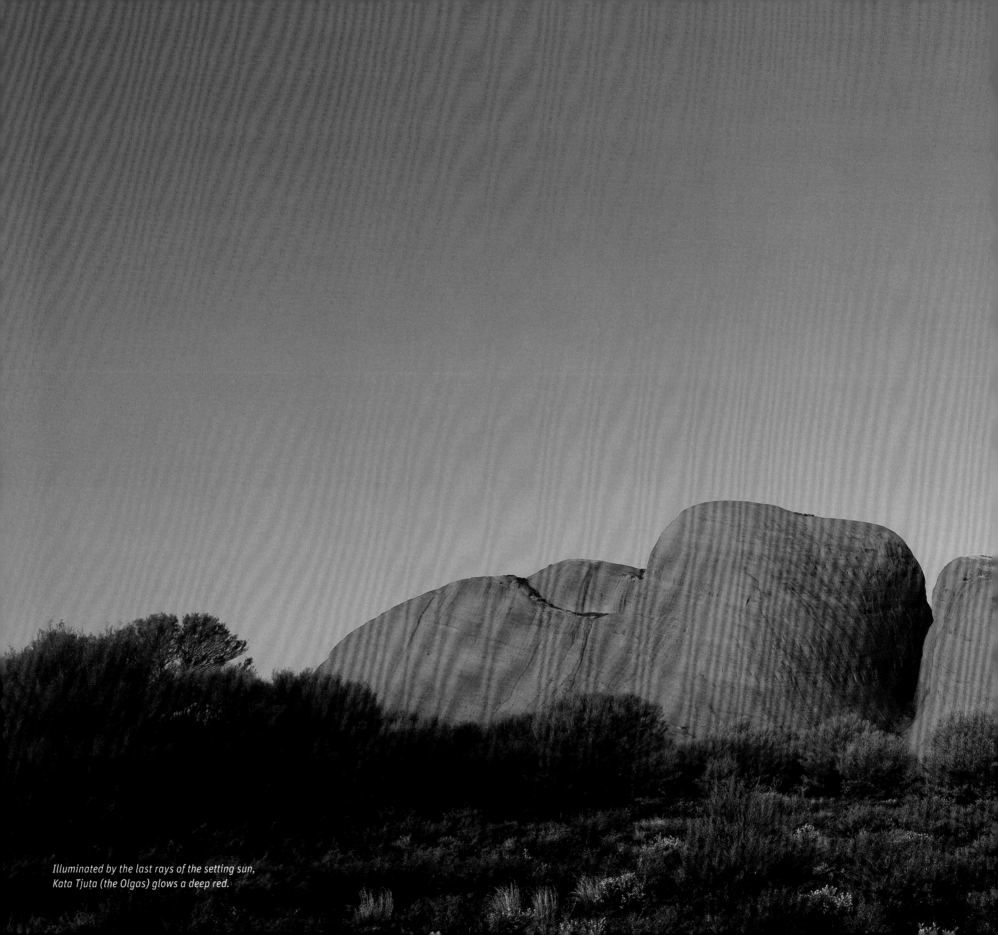

Illuminated by the last rays of the setting sun,
Kata Tjuta (the Olgas) glows a deep red.

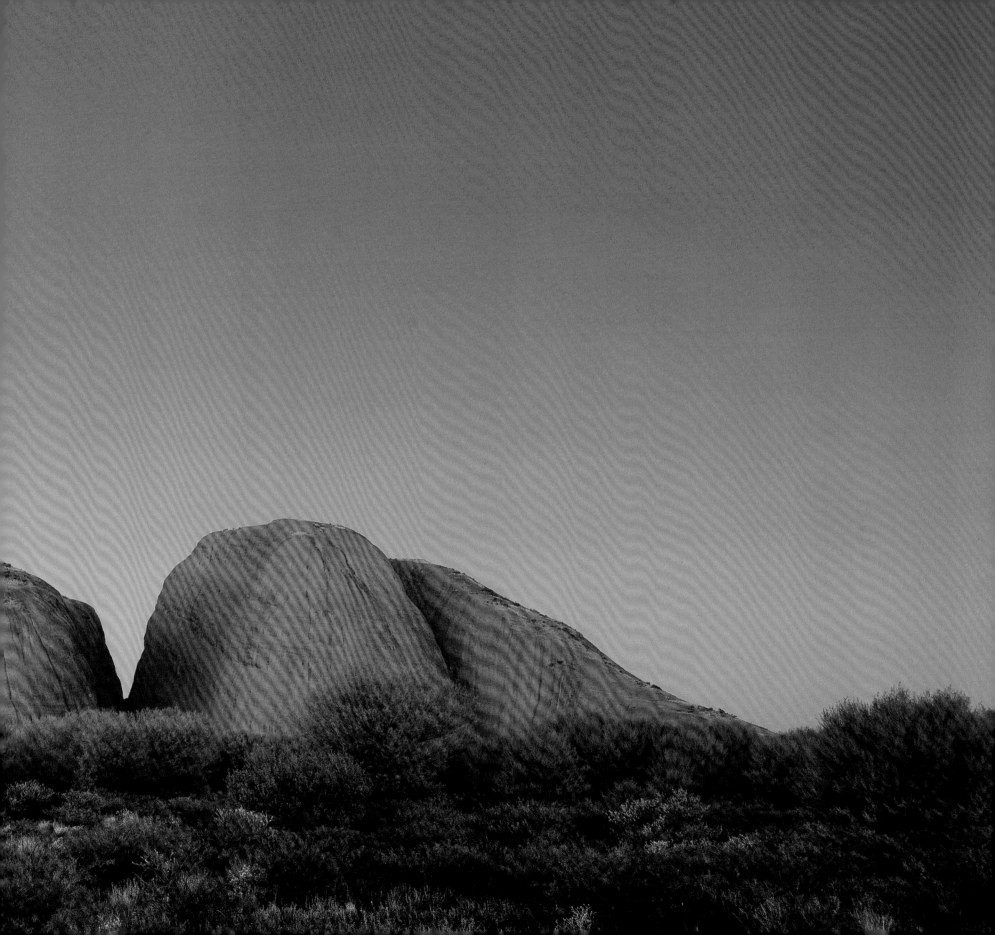

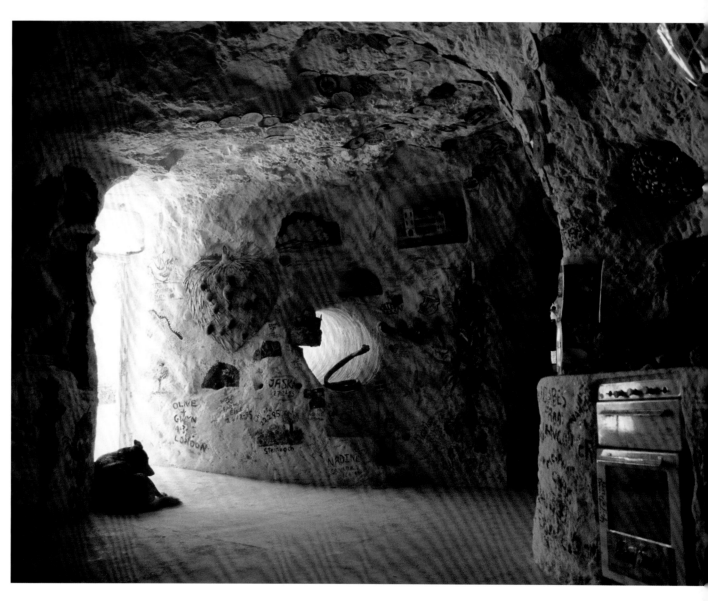

ABOVE *To escape the heat in Coober Pedy, South Australia, some opal miners live underground, where the temperature is a constant 23–25°C.*

LEFT *Small-scale opal-mine diggings around Coober Pedy create a lunar landscape.*

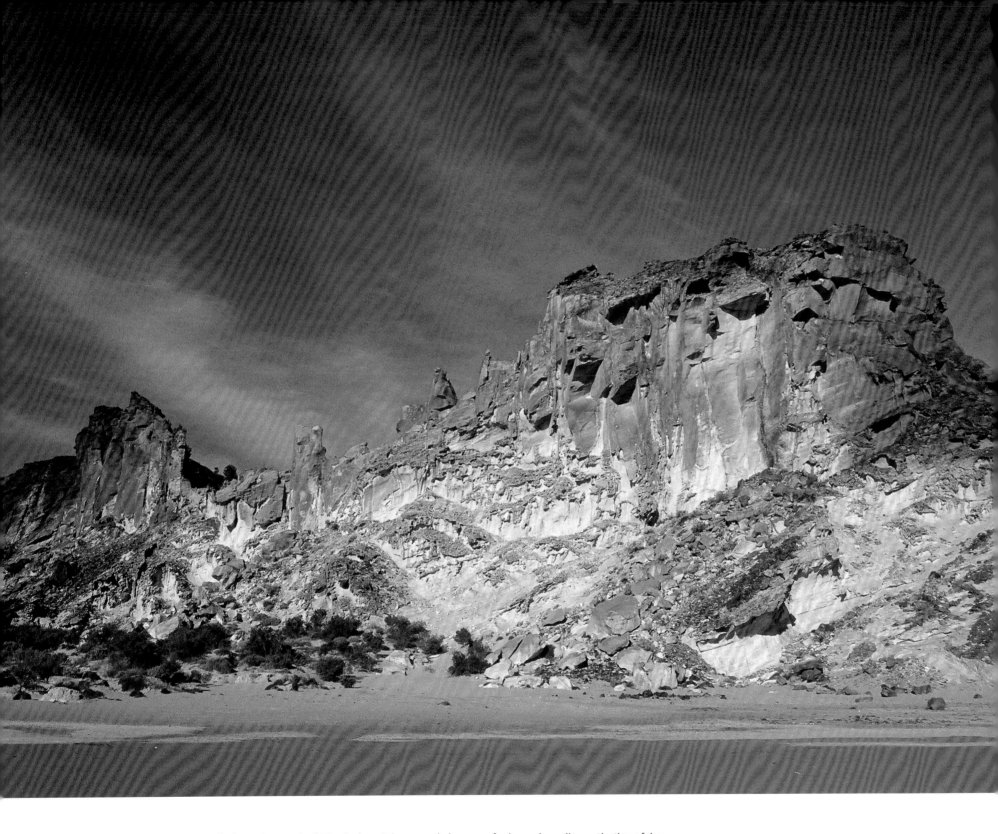

Rainbow Valley living up to its name: the formation, south of Alice Springs, takes on a whole range of colours, depending on the time of day.

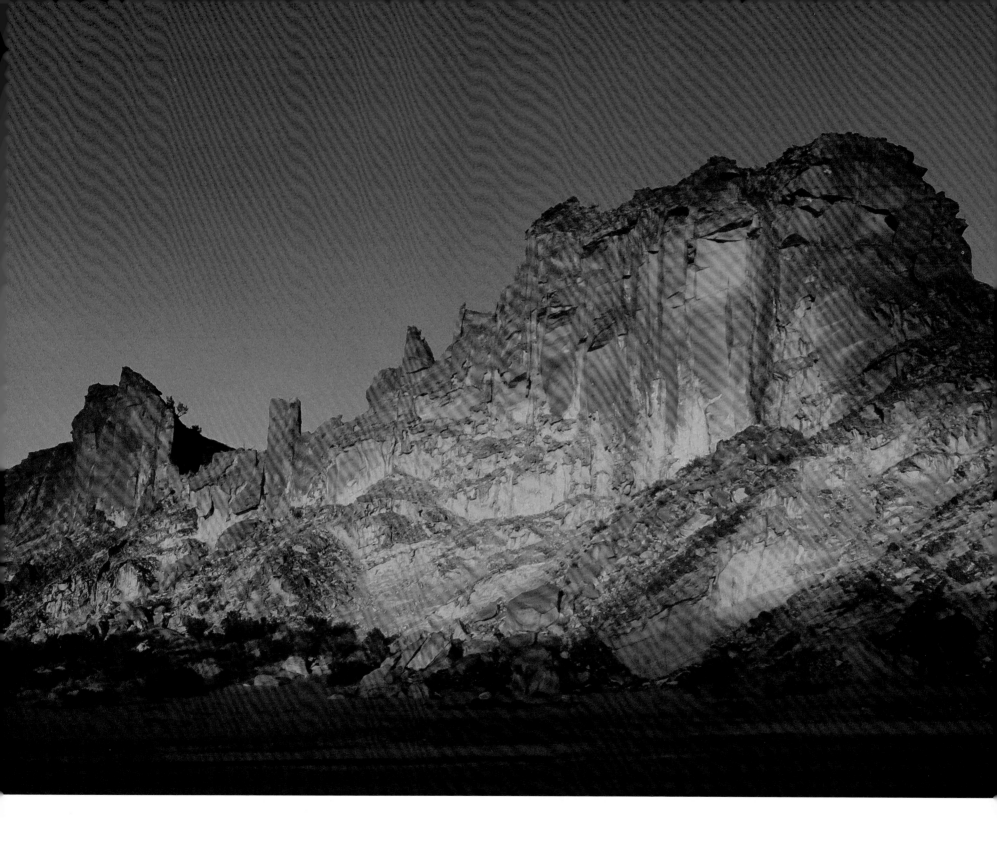

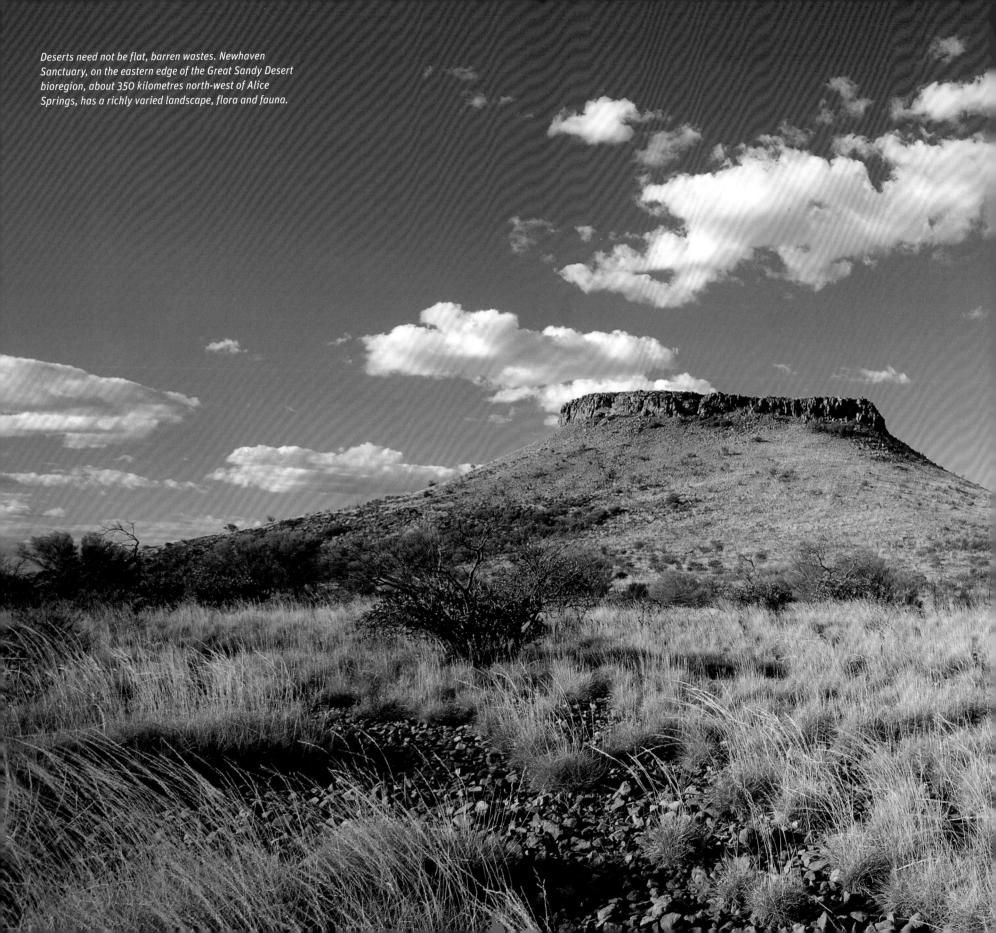

Deserts need not be flat, barren wastes. Newhaven Sanctuary, on the eastern edge of the Great Sandy Desert bioregion, about 350 kilometres north-west of Alice Springs, has a richly varied landscape, flora and fauna.

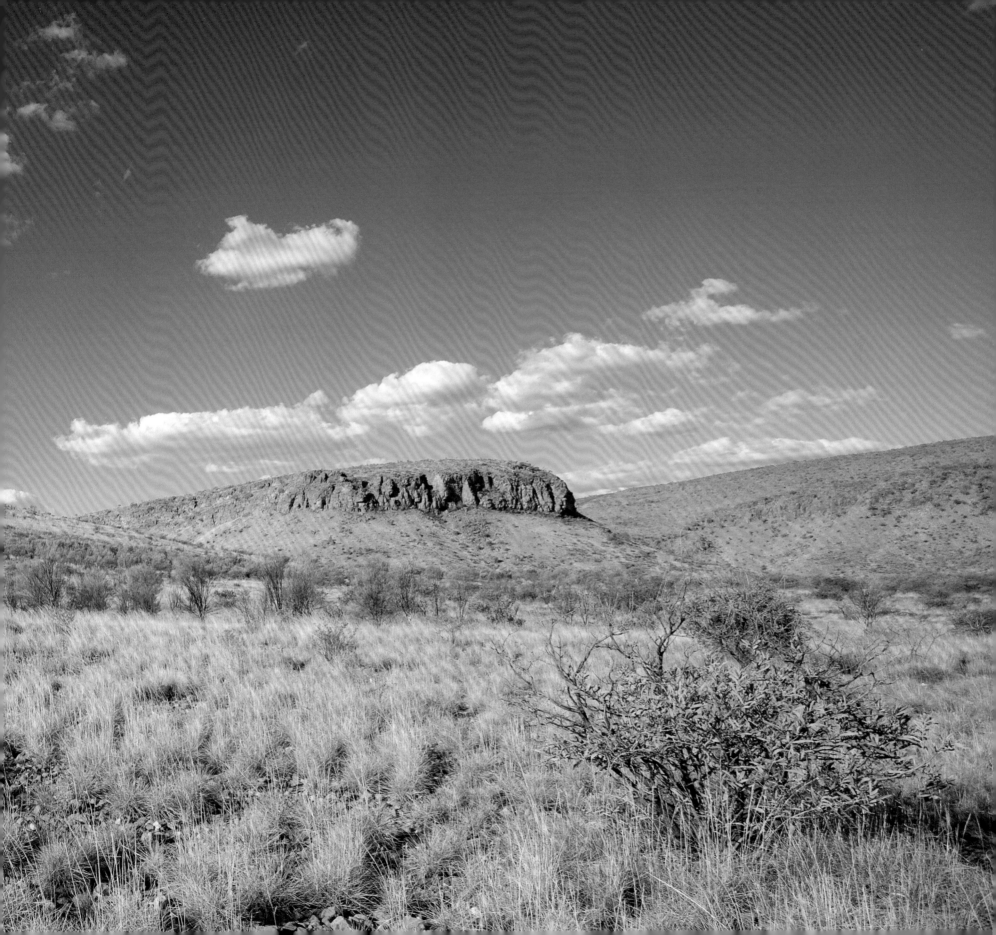

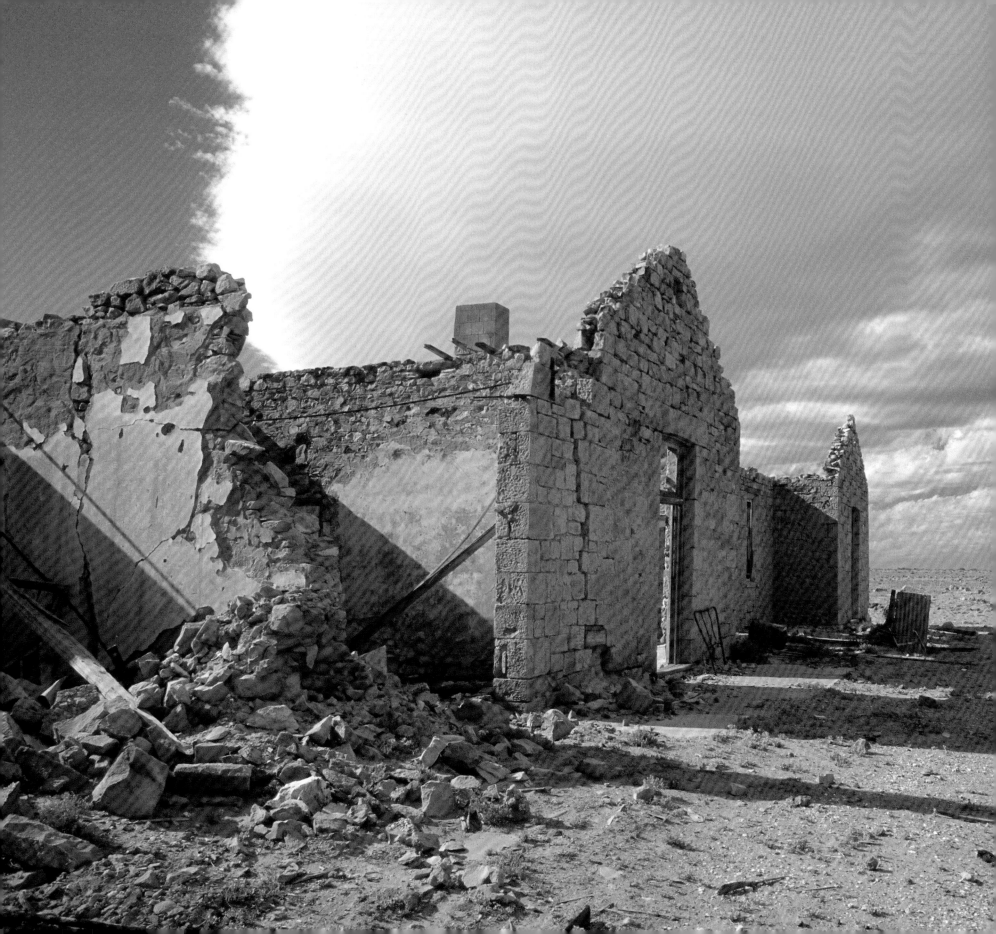

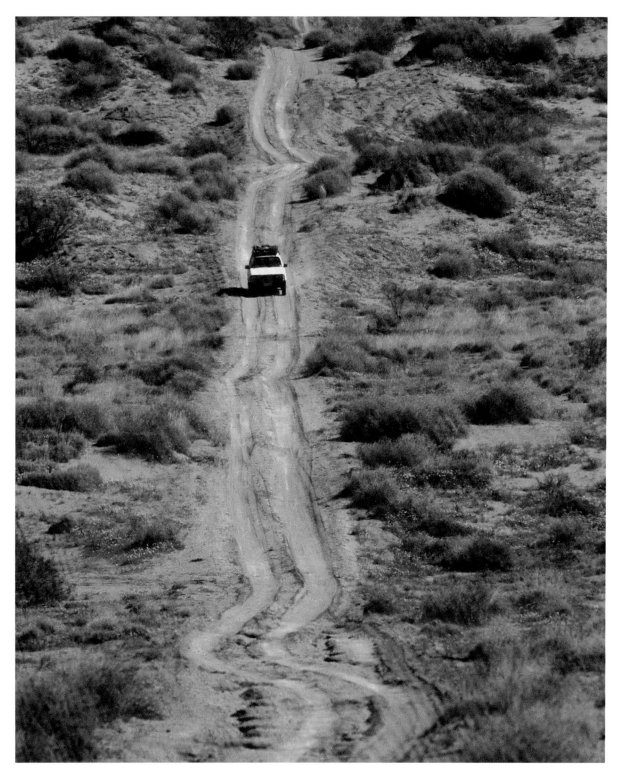

ABOVE *Running for 500 kilometres across the Simpson Desert, the French Line track crosses about 1200 sand dunes.*

LEFT *It's hard to imagine that Farina in South Australia had a population of 600 in the late 19th century.*

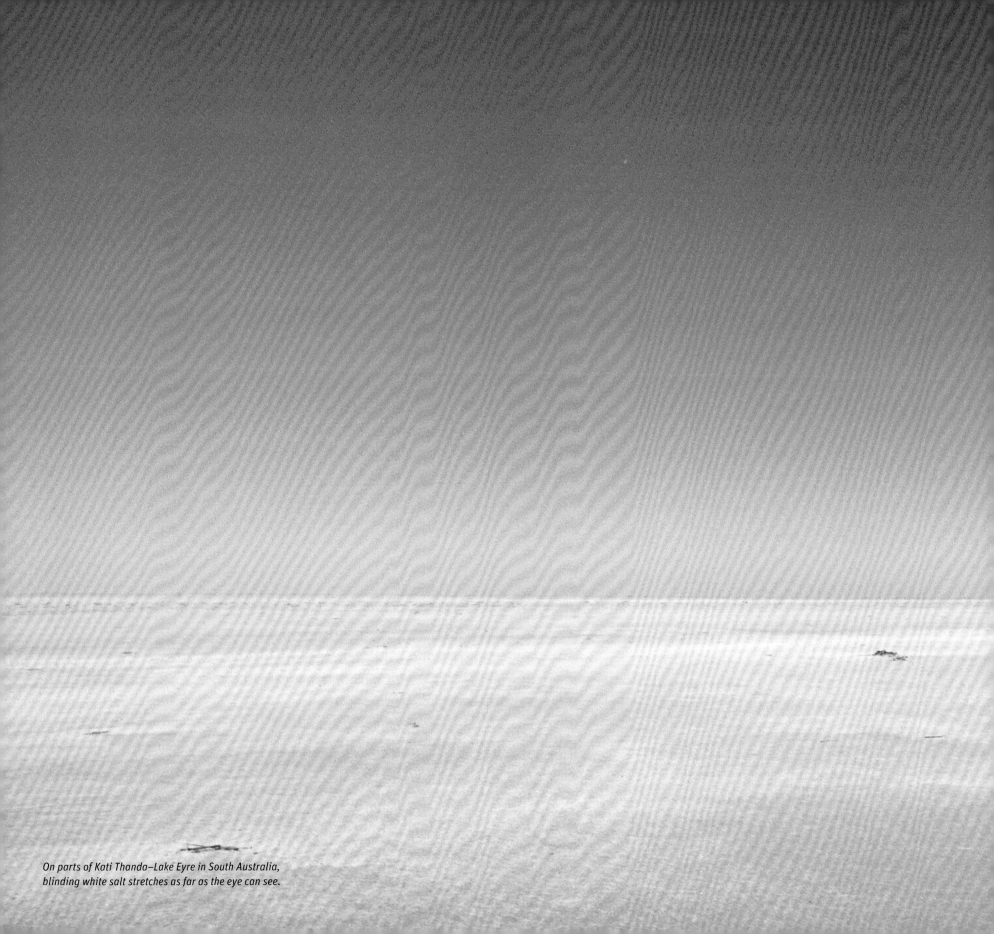

On parts of Kati Thanda–Lake Eyre in South Australia, blinding white salt stretches as far as the eye can see.

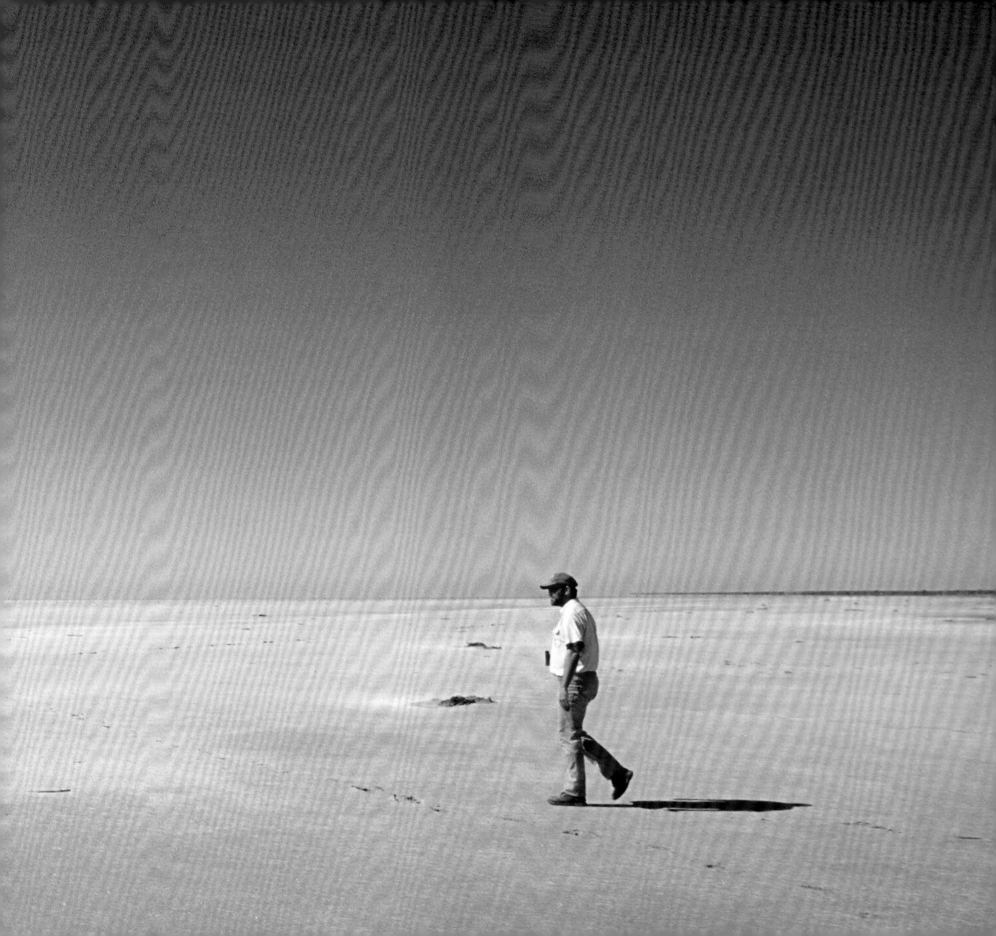

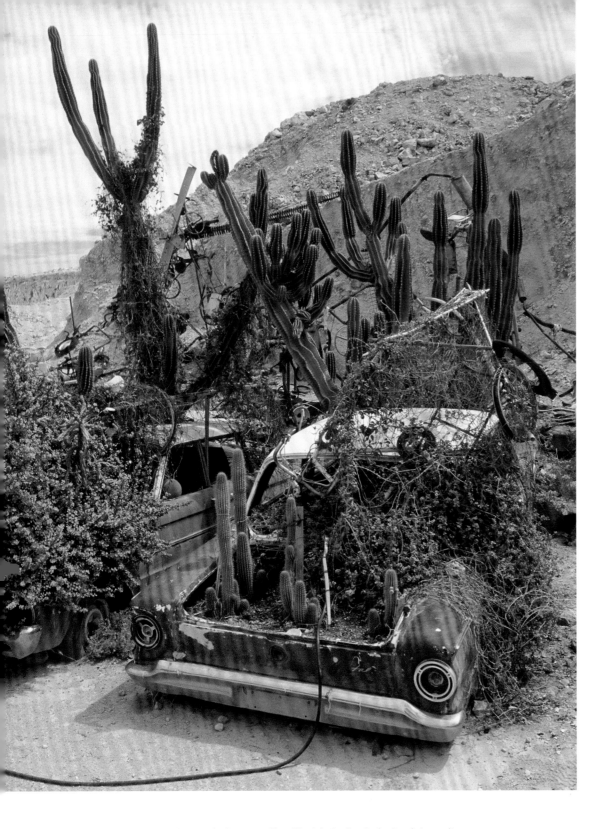

ABOVE *An innovative gardener has made the most of local junk in Coober Pedy, South Australia.*

RIGHT *Karlu Karlu/Devils Marbles in the Northern Territory is easily accessed, being right next to the Stuart Highway, south of Tennant Creek.*

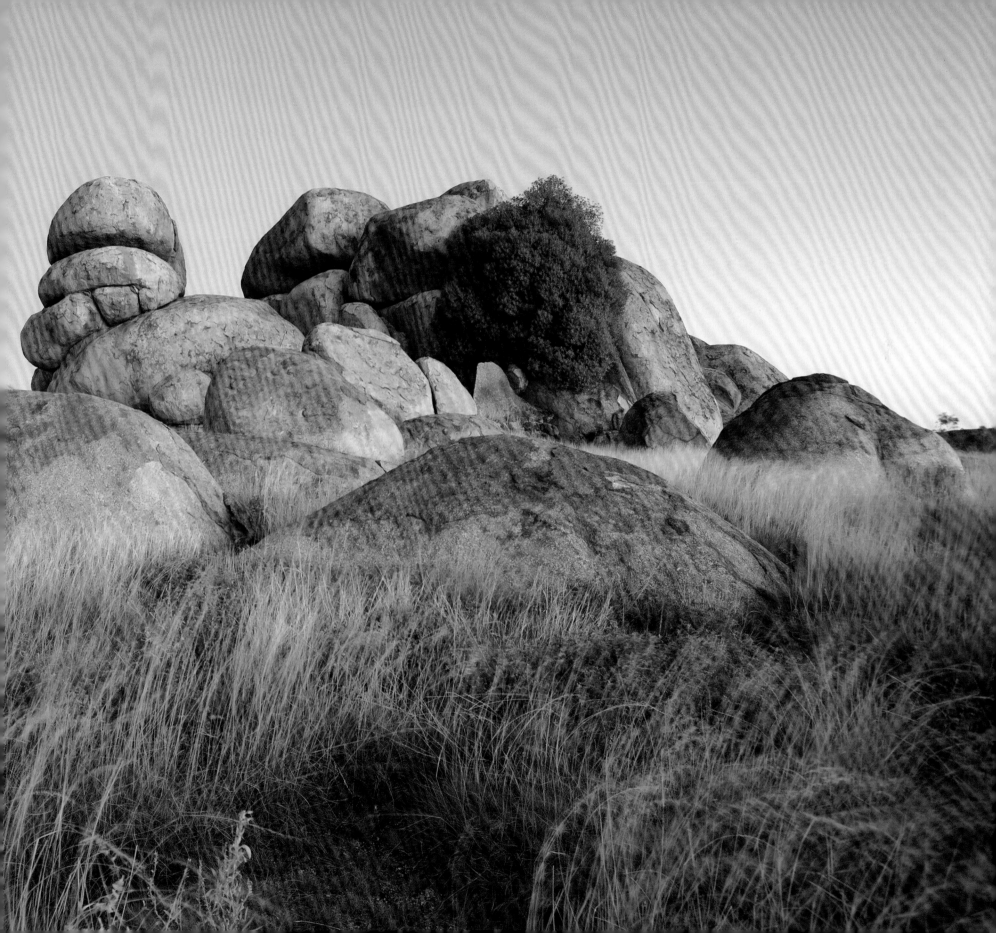

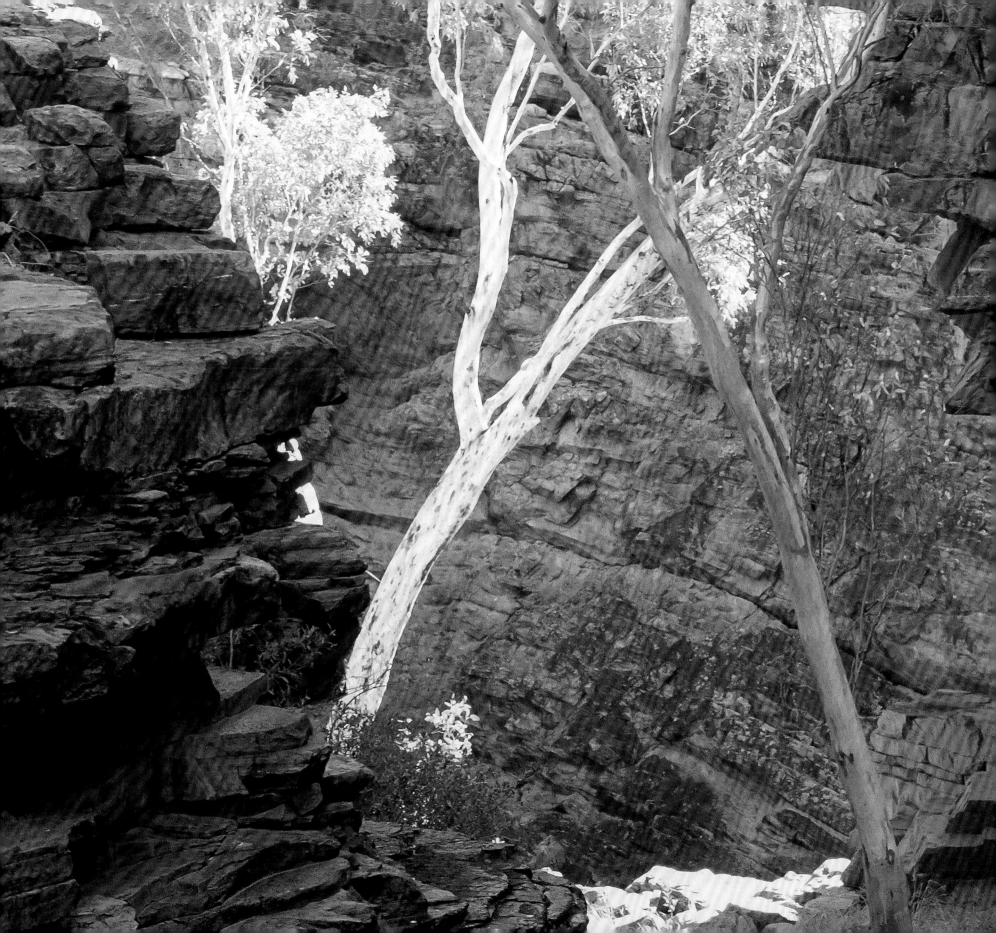

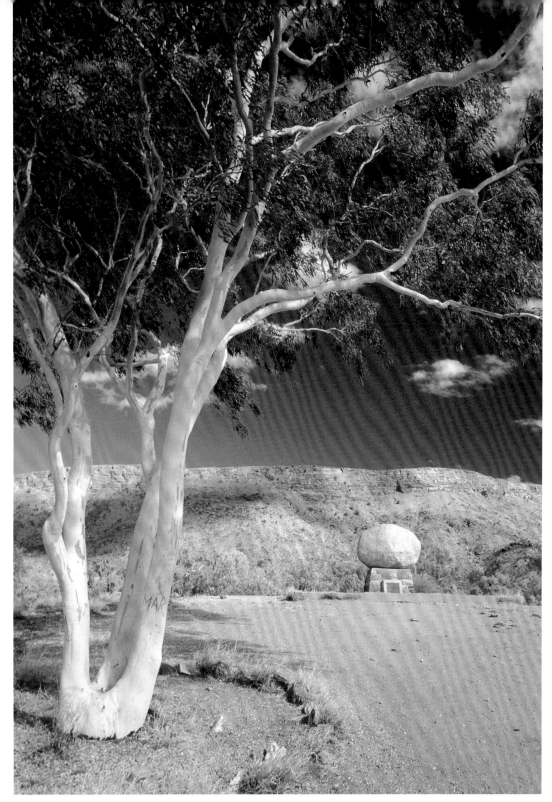

ABOVE The John Flynn Memorial near Alice Springs commemorates the founder of the Royal Flying Doctor Service.

LEFT Sun lights up a corner of delightful Trephina Gorge, east of Alice Springs.

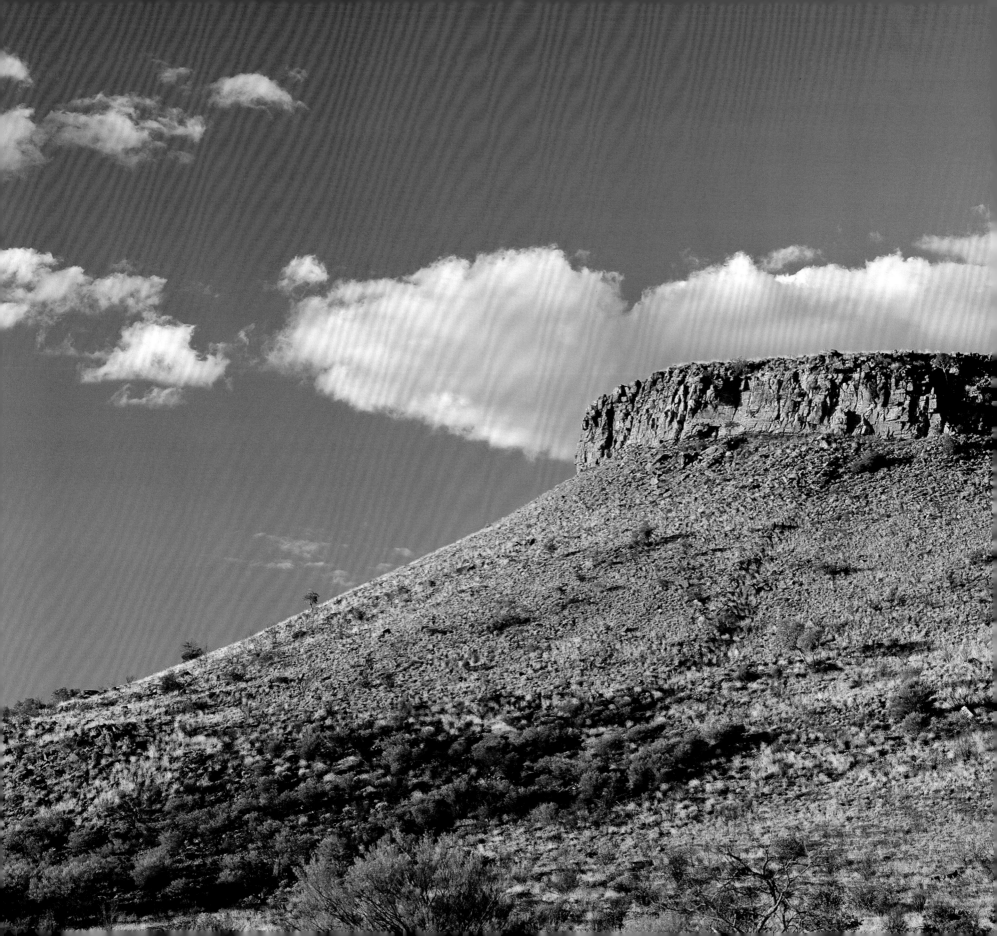

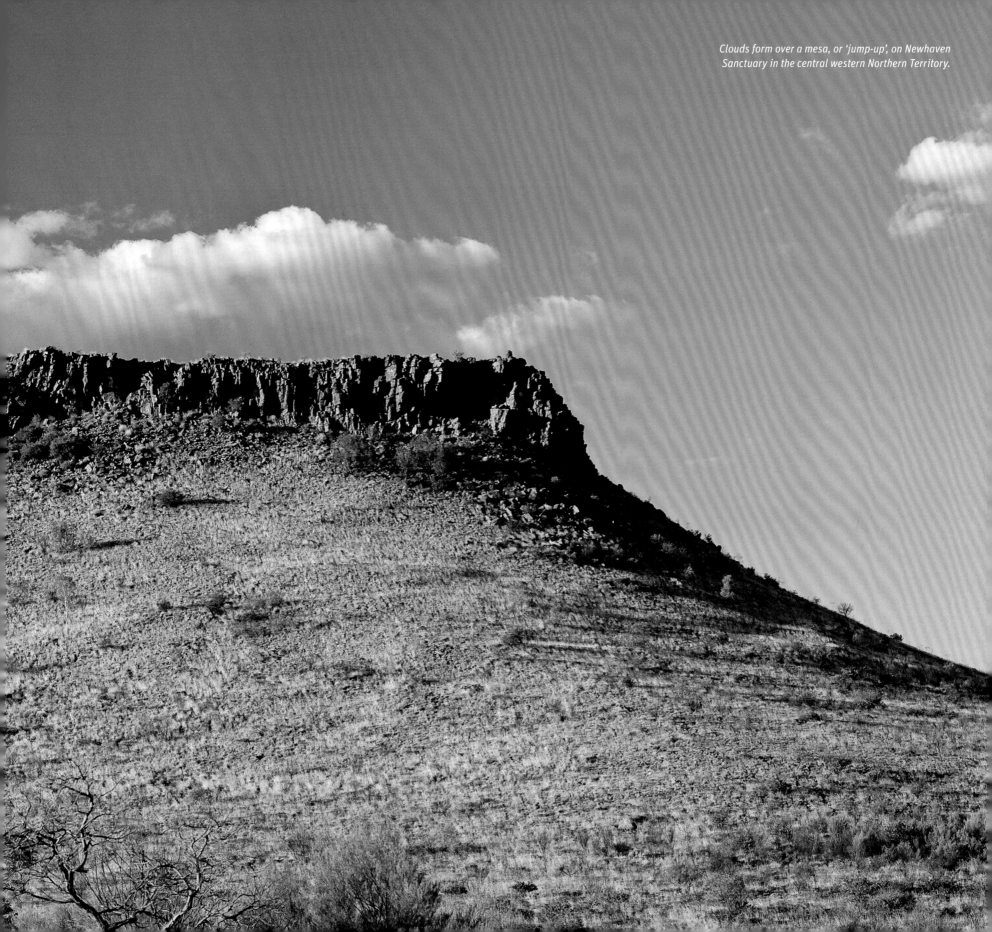

Clouds form over a mesa, or 'jump-up', on Newhaven Sanctuary in the central western Northern Territory.

Kalamurina Sanctuary

Deep in the heart of Central Australia lies Kalamurina Sanctuary, a sheep station founded in the 1880s that is now operated by the Australian Wildlife Conservancy (AWC) as a wildlife and nature reserve.

The sanctuary's location is of great significance because the 6700-square-kilometre property is bordered to the north by the Simpson Desert Regional Reserve and to the south by Kati Thanda–Lake Eyre National Park, creating a continuous protected area larger than Tasmania and enclosing some of the most pristine parts of the Australian continent.

It's an extremely remote place, the only access being by air or via the notorious Birdsville Track, which runs from Birdsville in Queensland down to Marree to the south, both of which are tiny outback settlements. The nearest town of any size is Hawker, roughly 600 kilometres further south, although the Mungerannie Hotel on the Birdsville Track does get regular traffic and deliveries.

Geographically, Kalamurina lies on the very edge of the Simpson Desert dune systems, right on Warburton Creek, which, after rare heavy rains, sometimes flows into Lake Eyre. Look at a map and you'll see that the sanctuary sits across the intersection of three different deserts – the Tirari, the Simpson and the Sturt Stony Desert – so the range of geology and ecology is extremely varied.

Much of the reserve consists of a vast swathe of elongated dune systems running north–south, including both red and white dunes, saltpans, creek lines and billabongs. This is most apparent from the air: from 200 metres up you can see dunes running 20 kilometres or more and rising to almost 20 metres high.

Since the property was destocked and fenced, wildlife populations have gradually returned to natural levels. Kalamurina is home to many specialist desert species, including mulgaras, hopping mice, long-haired rats and a huge variety of birds, particularly after rain. Protected areas like these, whether government-operated national parks or NGO-run sanctuaries, are a critical part of Australia's conservation efforts.

... a vast swathe of red and white dunes, saltpans, creek lines and billabongs

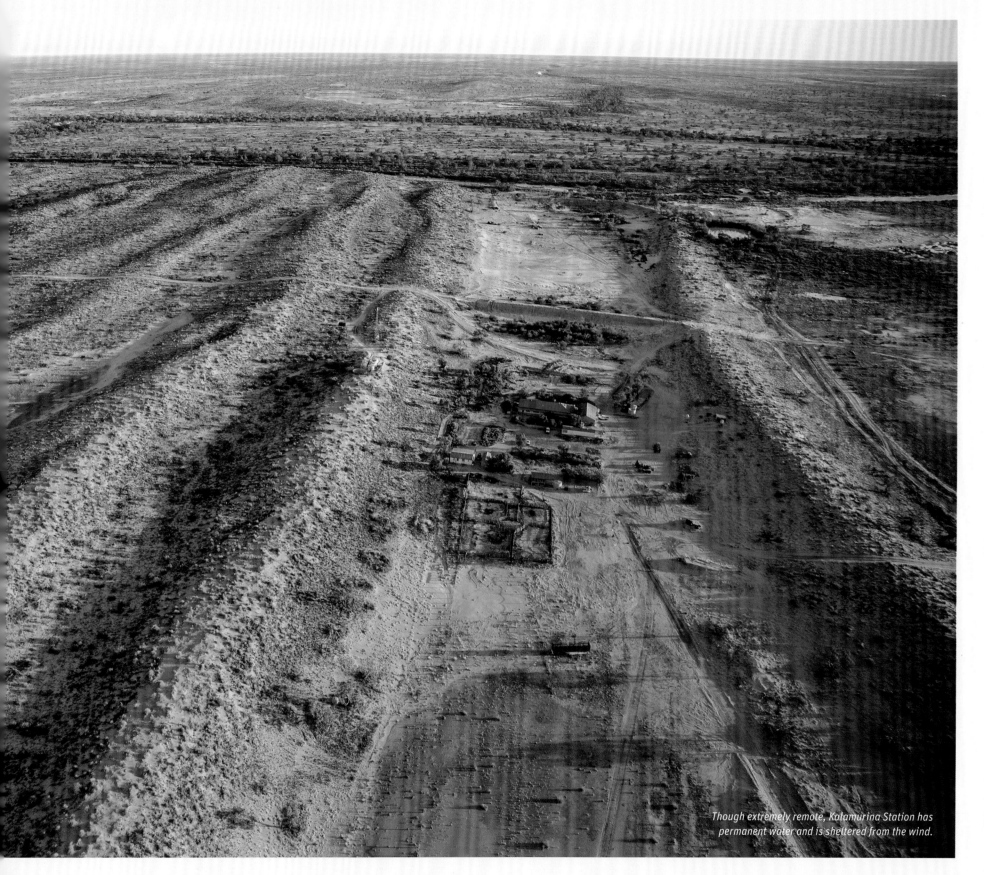

Though extremely remote, Kalamurina Station has permanent water and is sheltered from the wind.

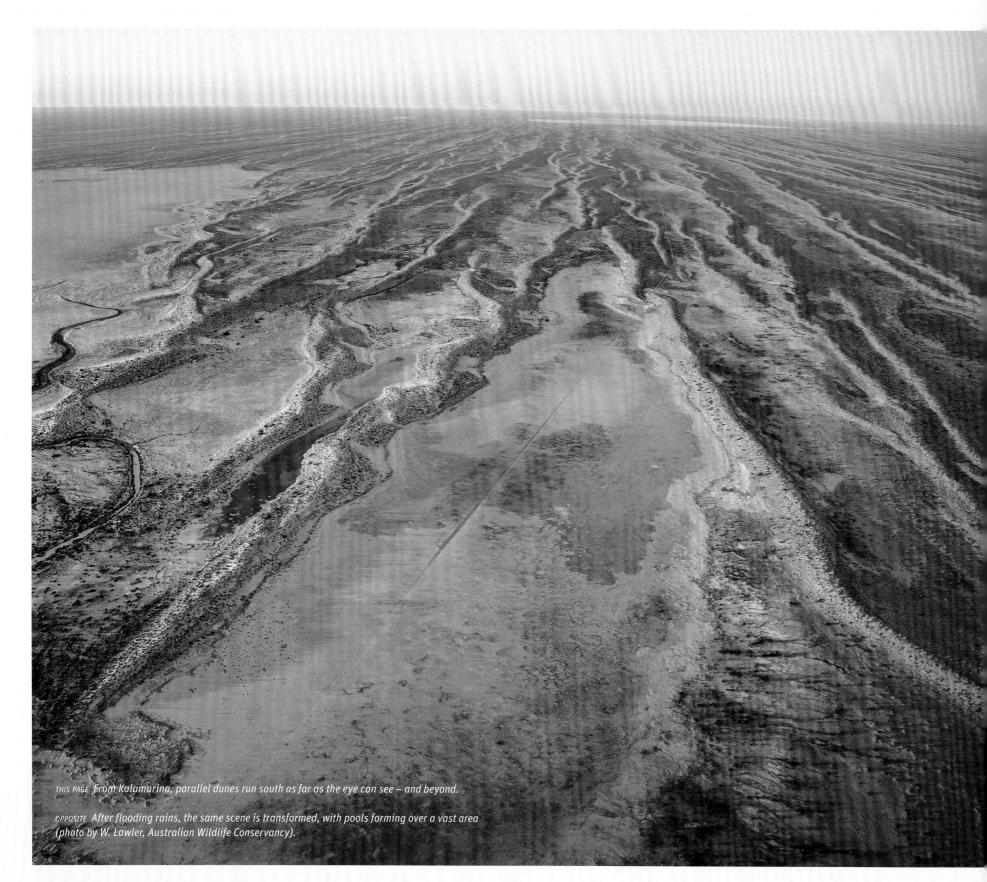

THIS PAGE *From Kalamurina, parallel dunes run south as far as the eye can see – and beyond.*

OPPOSITE *After flooding rains, the same scene is transformed, with pools forming over a vast area (photo by W. Lawler, Australian Wildlife Conservancy).*

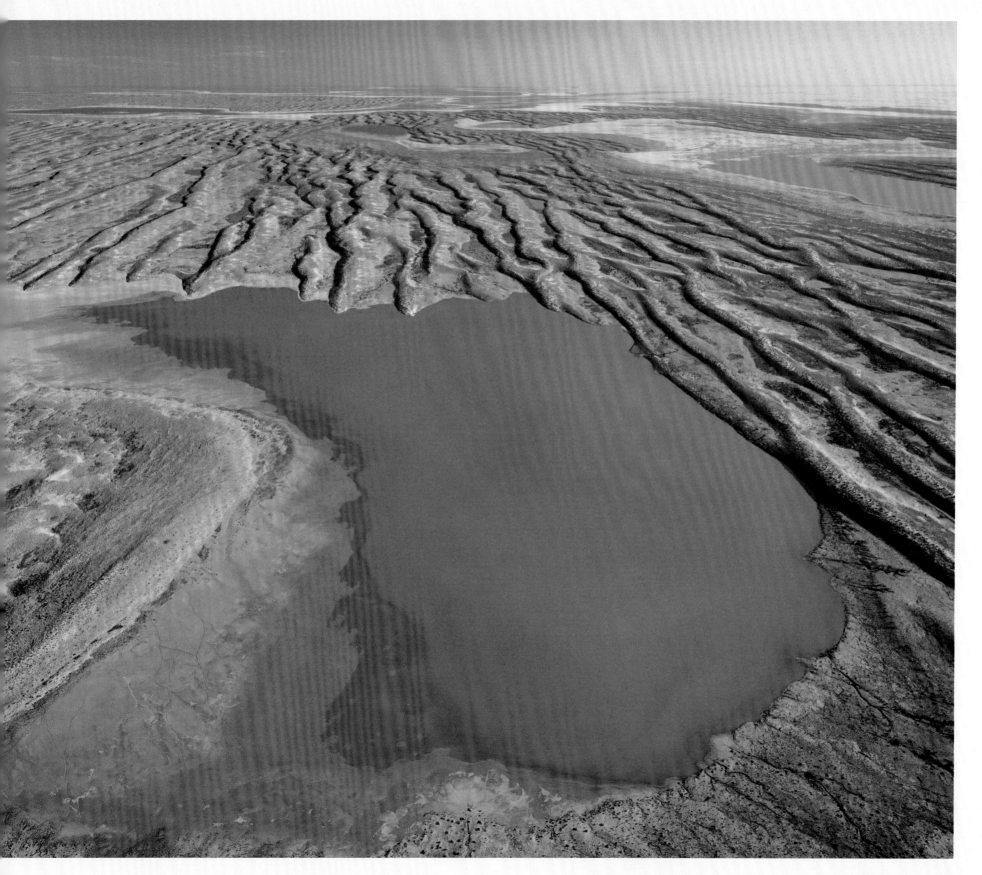

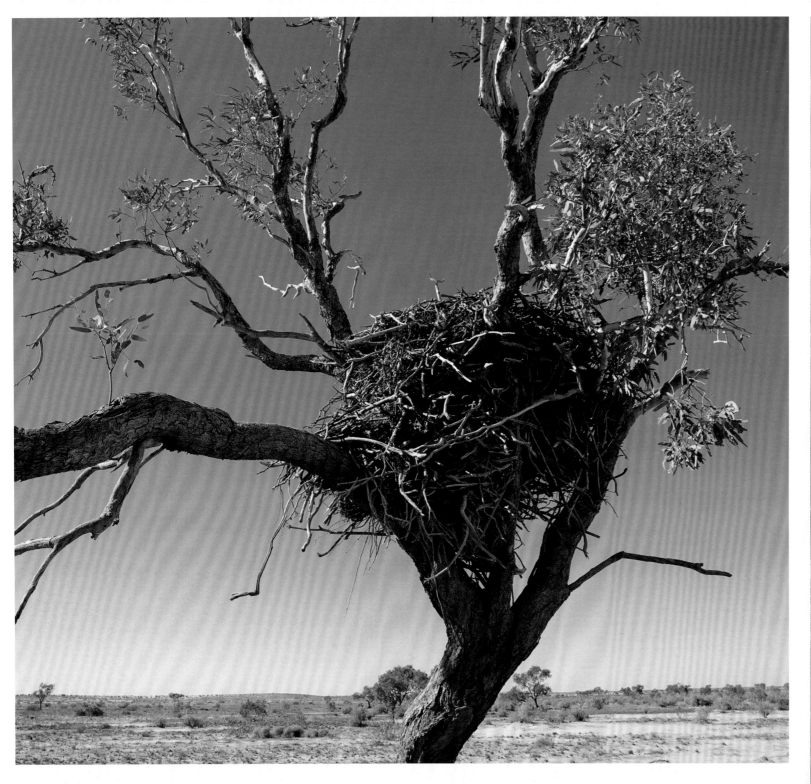

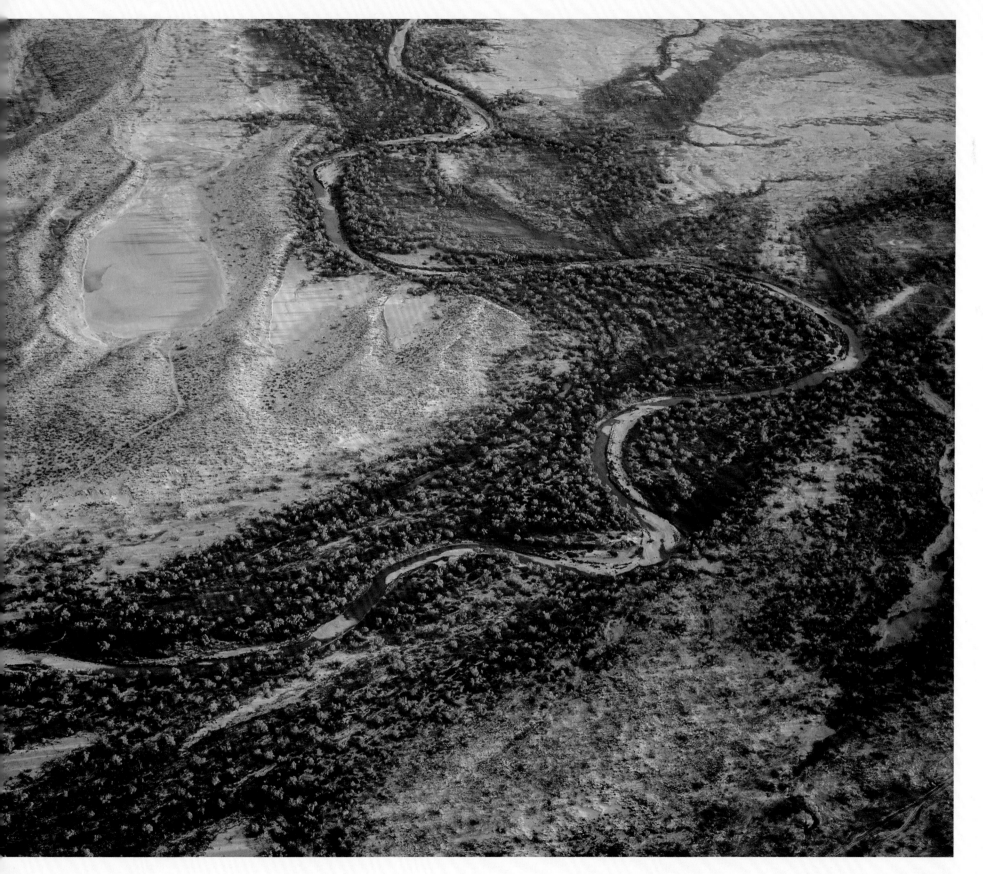

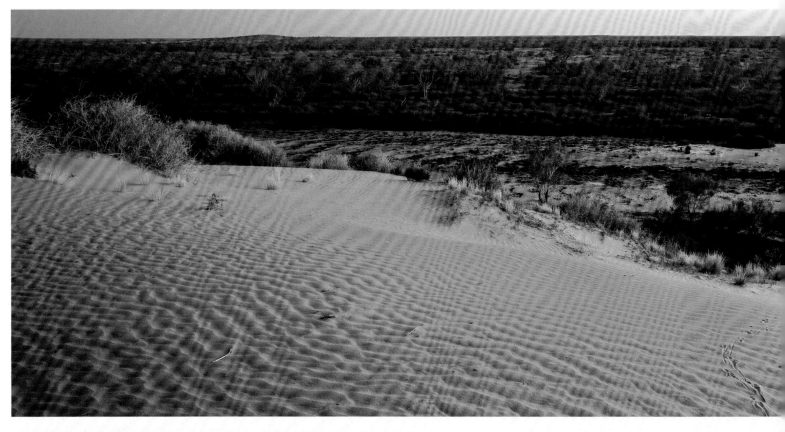

ABOVE RIGHT The so-called Sunset Dune overlooks Warburton Creek.

RIGHT Samphire grows in the dry riverbed of Warburton Creek and is common where seasonal water flows.

CENTRE RIGHT The original stockyards still exist but are no longer used.

FAR RIGHT The cool waters of Warburton Creek are a welcome contrast to the surrounding arid countryside.

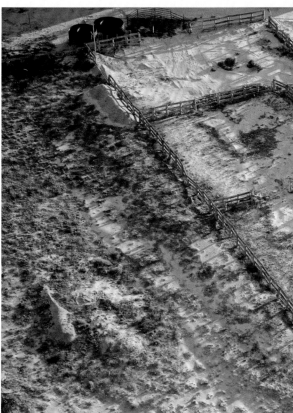

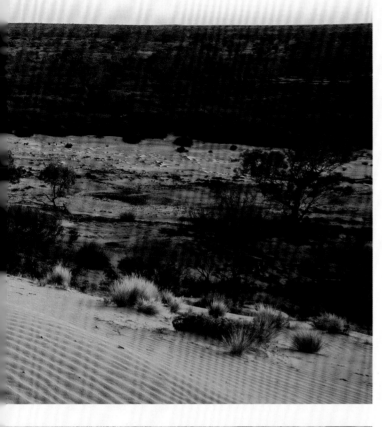

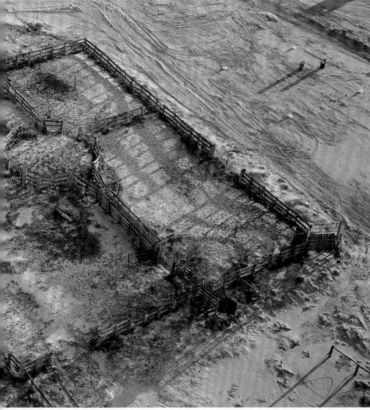

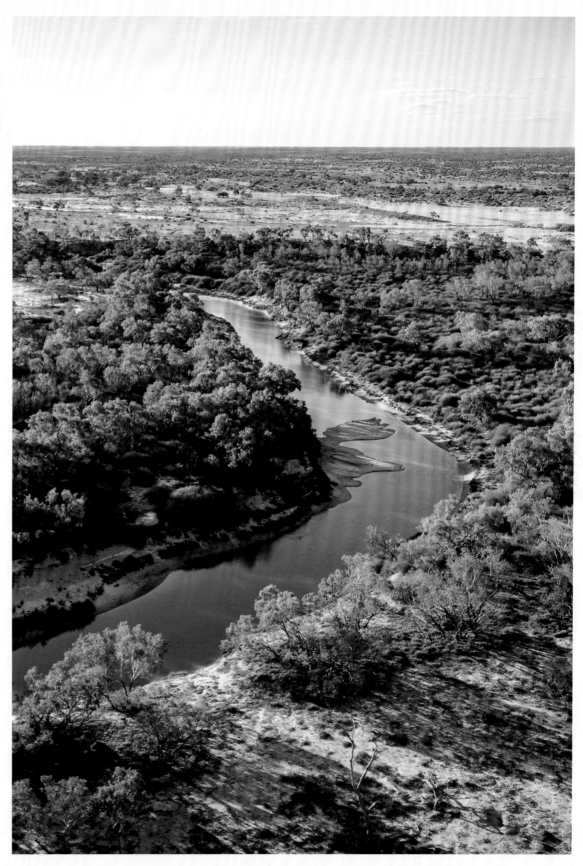

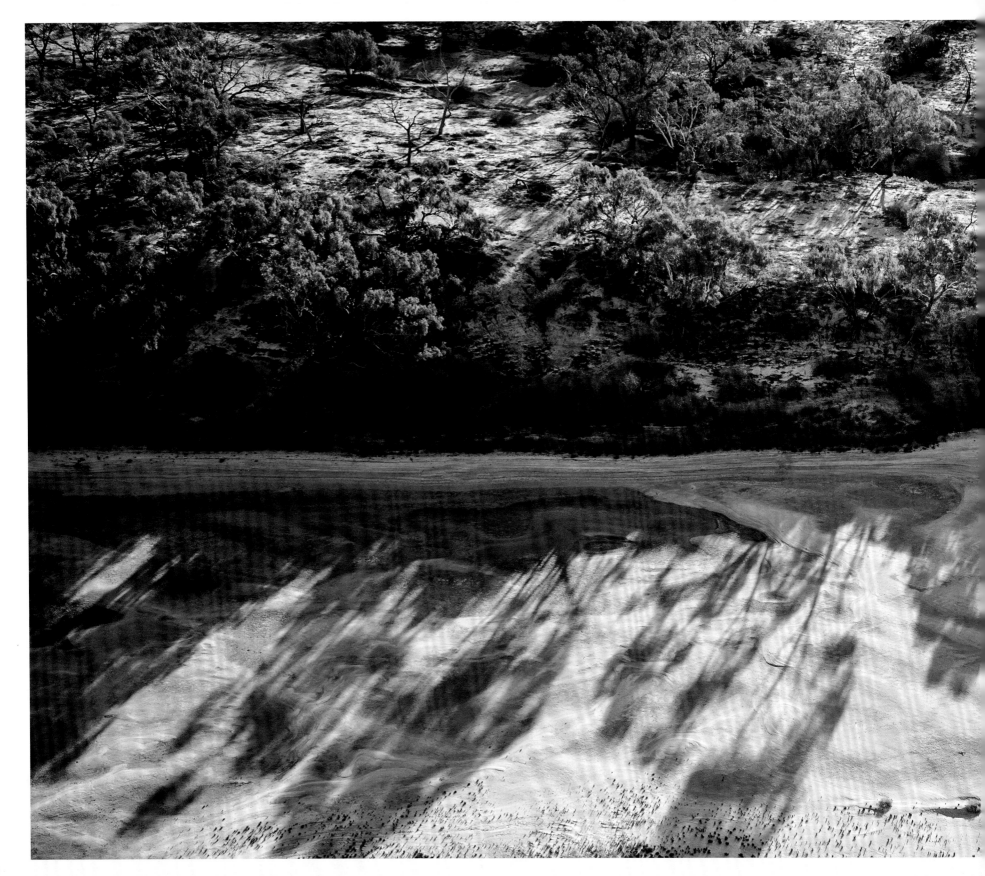

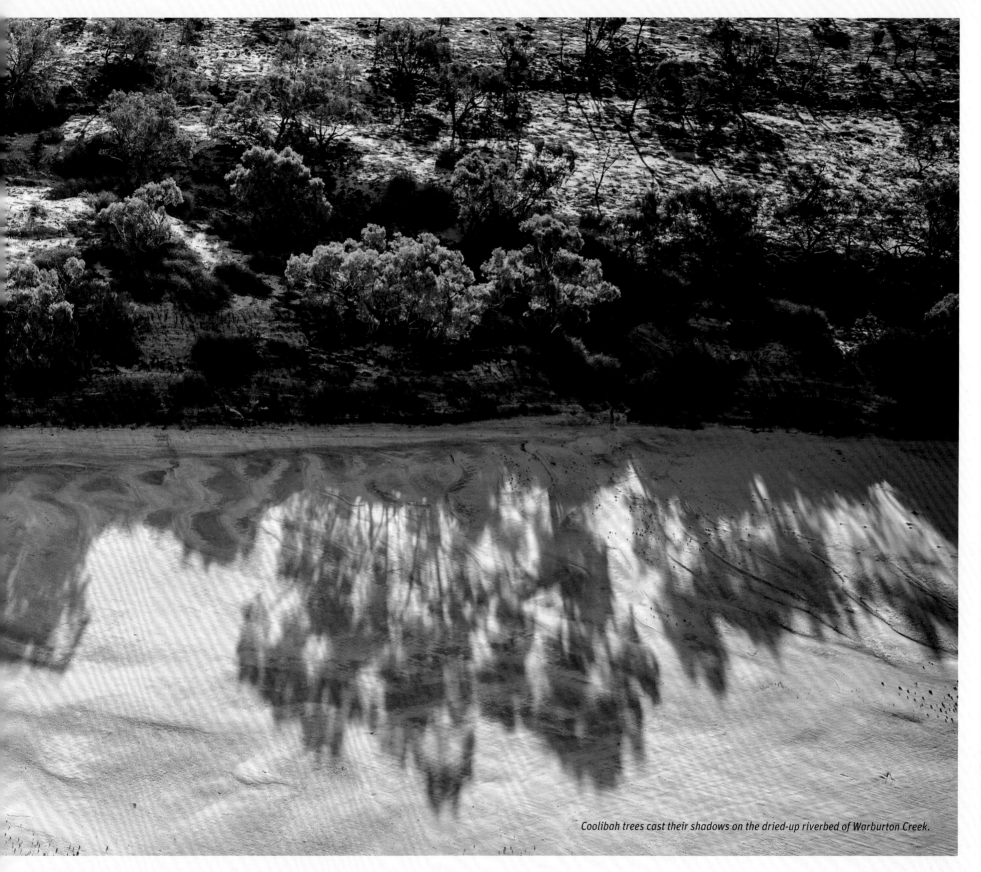

Coolibah trees cast their shadows on the dried-up riverbed of Warburton Creek.

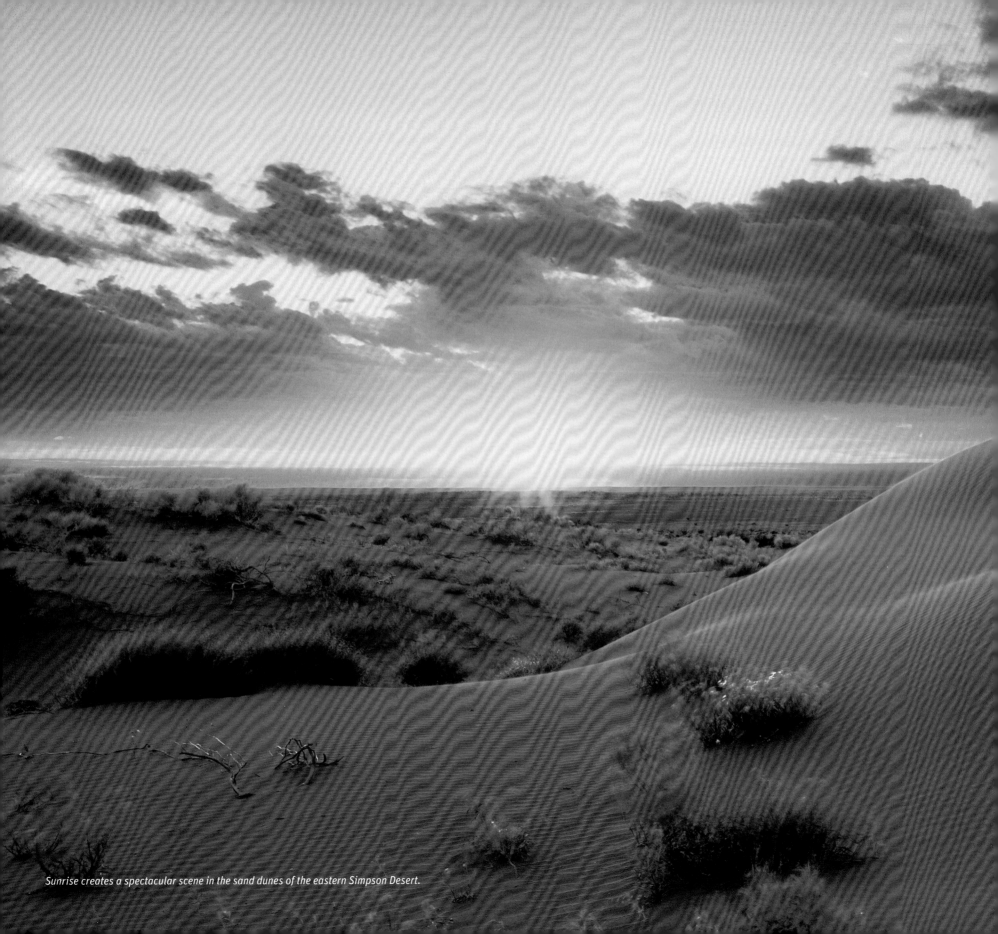

Sunrise creates a spectacular scene in the sand dunes of the eastern Simpson Desert.

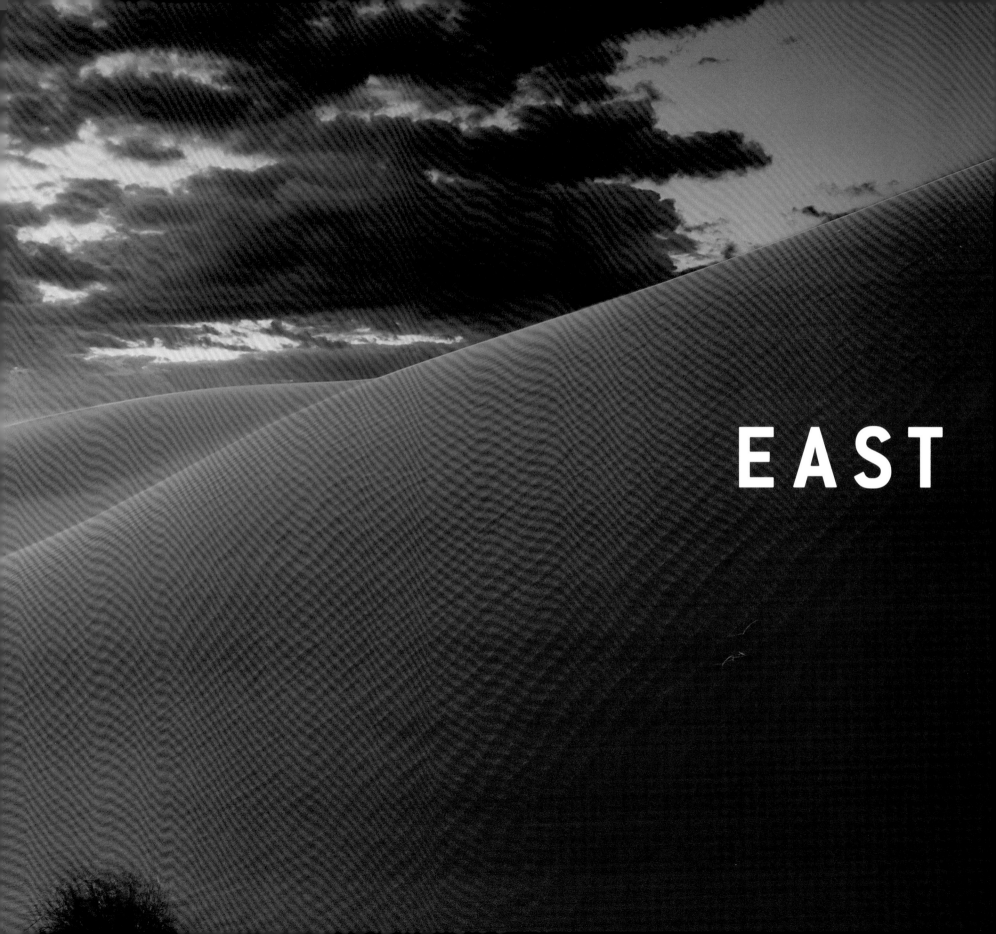

EAST

THE DESERTS OF AUSTRALIA have no respect for political divisions; they, of course, follow geology. I consider the eastern desert regions to be those areas straddling the Queensland–Northern Territory border, the Queensland–South Australia border and the New South Wales–South Australia border. This vast region encompasses the eastern reaches of the Simpson Desert west of Boulia and Birdsville; the Sturt Stony Desert south and west of Innamincka and the Channel Country of New South Wales; and the Strzelecki Desert along the New South Wales–South Australia border, including the arid area that stretches south to the Flinders Ranges.

I enjoy finding out about the origins of the names of Australian places. Some desert names are a bit plain and lacking in imagination: Great Sandy, Little Sandy … hmm, it's a desert, so it's going to be sandy! But most of the rest are named after prominent citizens who were associated with pioneering expeditions to these regions, either as participants, colleagues of participants, or sponsors.

The Simpson Desert was first explored by Charles Sturt, but it was named by explorer Cecil Madigan after Alfred Allen Simpson, an Australian industrialist, philanthropist, geographer and one-time president of the South Australian branch of the Royal Geographical Society of Australasia. Mr Simpson was also the owner of the Simpson washing-machine company. The Simpson Desert is known for its vast numbers of parallel sand dunes running for hundreds of kilometres in a mostly north–south orientation. If you follow the popular four-wheel-drive tracks from Birdsville to Mount Dare, you'll cross over 1400 such dunes along the way.

The first European to visit the Sturt Stony Desert was Charles Sturt, in 1844, and he named it after himself (he actually called it 'Sturt's Stony Desert'). It is in fact extremely stony, with the inter-dunal flats being covered with 'gibbers' – hard red rocks that must have made trekking on horseback a nightmare. These stones sit mostly on top of the underlying soil: it's just a single layer with fewer gibbers buried below. This has confused geologists, and there are various theories as to why these 'gibber plains' occur. According to conventional thinking, they were created

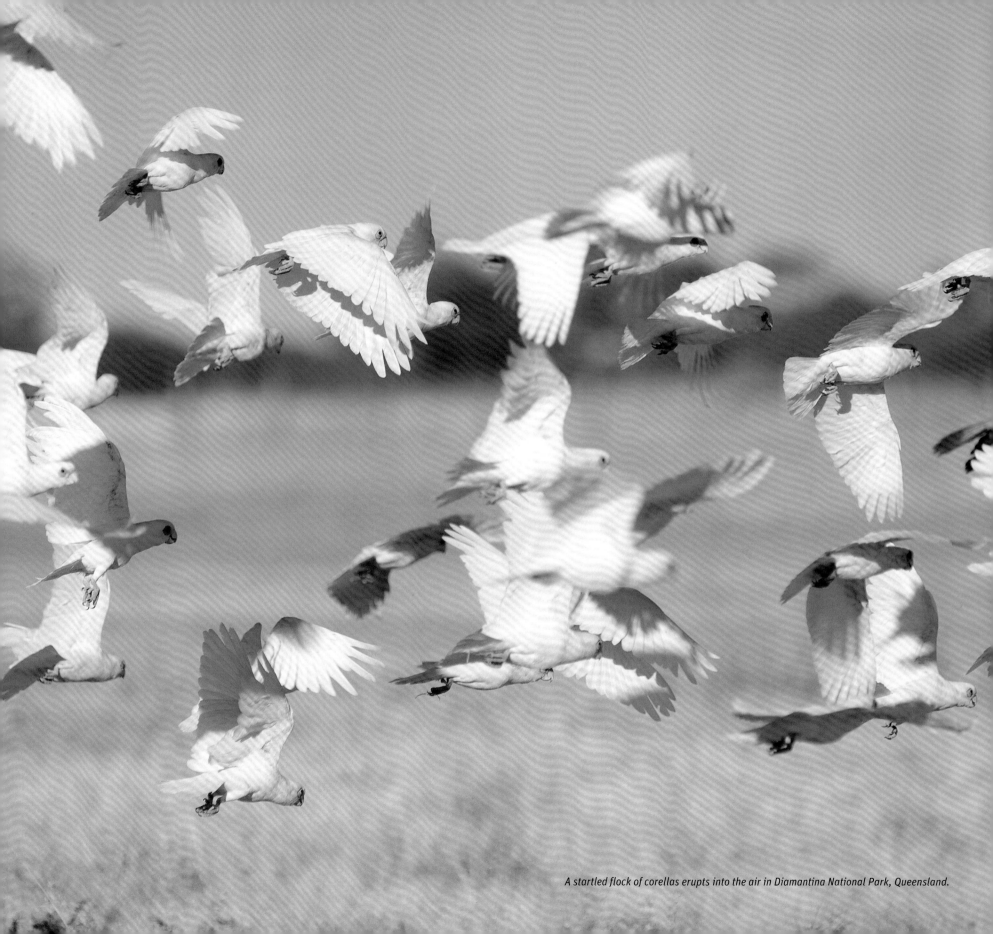

A startled flock of corellas erupts into the air in Diamantina National Park, Queensland.

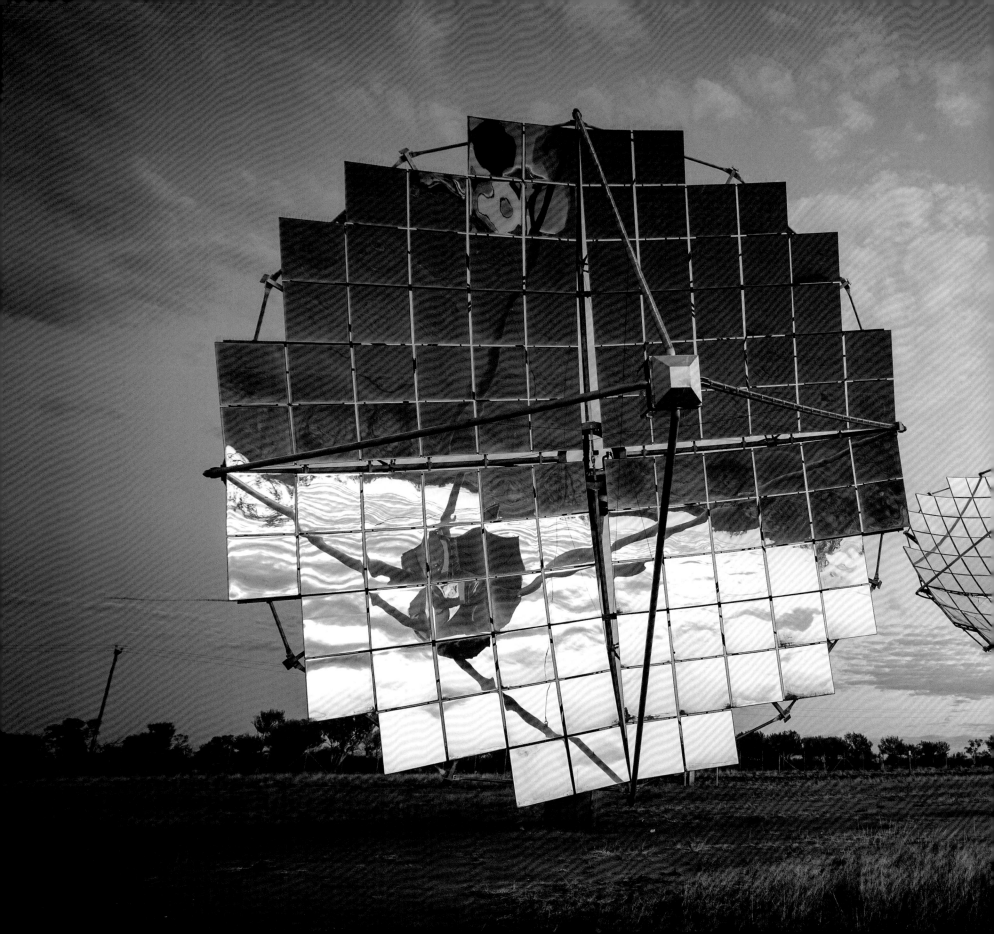

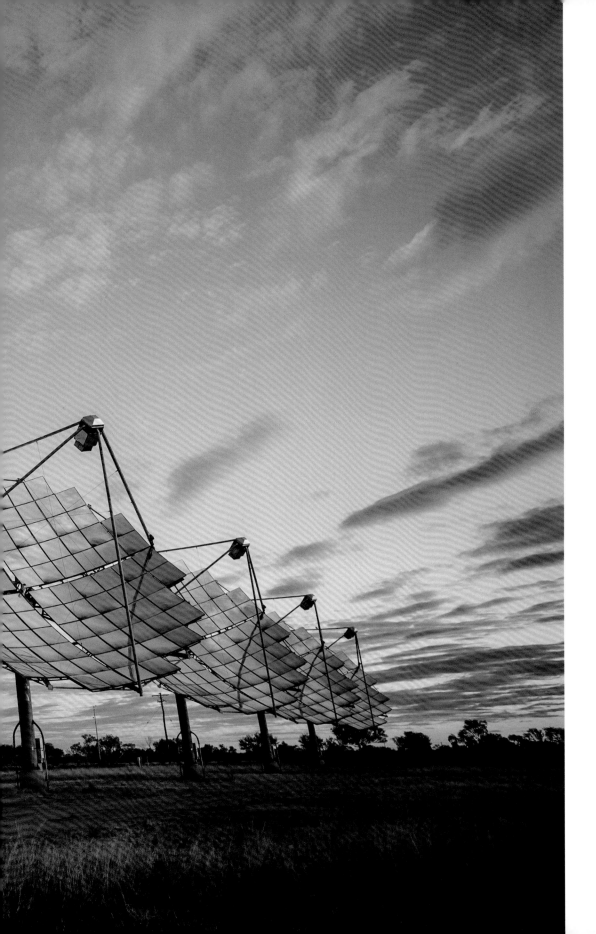

by a combination of fragmentation, erosion and the continuous winds carrying away the lighter particles to accumulate in dunes. However, since the stones all appear to be much the same age, a newer theory has arisen, which suggests that they began as lava flows that gradually broke up and then the fragments 'floated' on the underlying soil as a result of frost and/or salt heave, a swelling of the soil that can lift stones to the surface.

The Strzelecki Desert was named after the Polish explorer Pawel Edmund Strzelecki by good old Charles Sturt, on his third and last major expedition, in 1844. Strzelecki had explored much of Australia's south-east, particularly in the High Country of Victoria and New South Wales – he was the first to climb to Australia's highest point, naming it Mount Kosciuszko after Polish national hero Tadeusz Kosciuszko. The Strzelecki Desert, like the Simpson, is characterised by long parallel dune systems and encompasses some very large dry lakes, such as 100-kilometre-long Lake Frome.

Residents of Windorah, Queensland, are benefiting from an experimental solar power array on the outskirts of town.

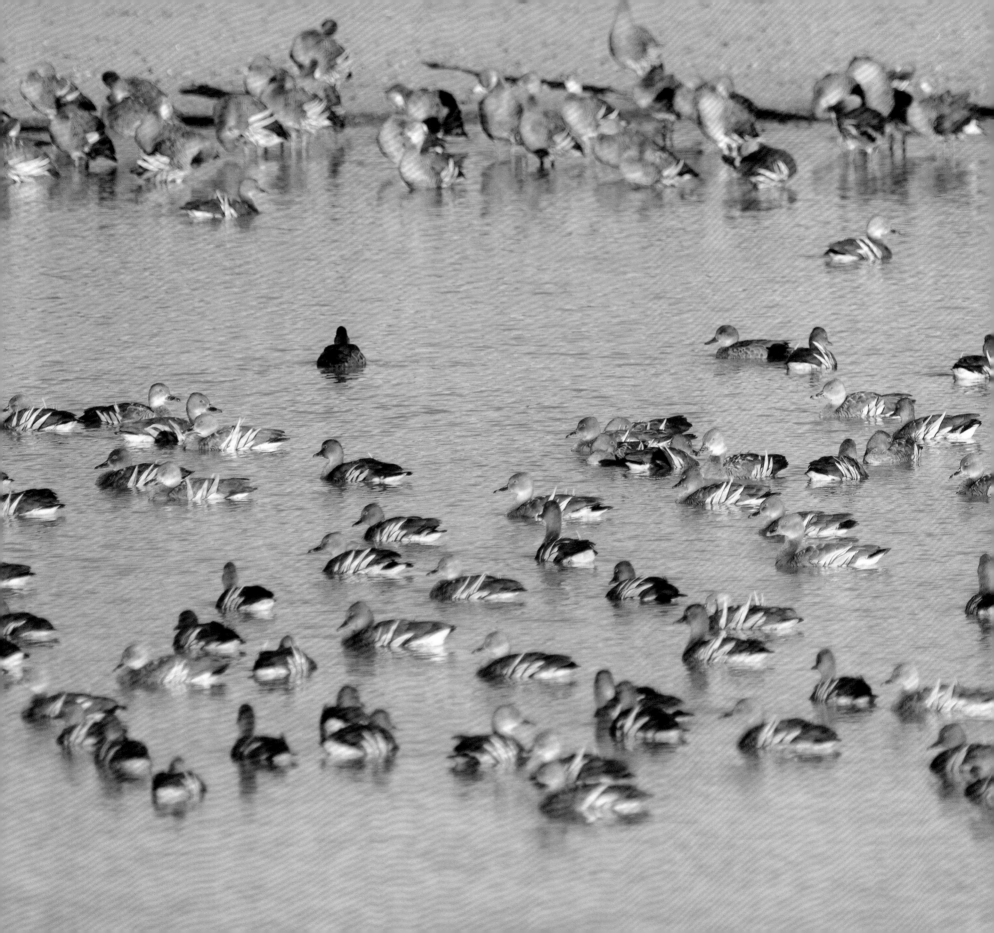

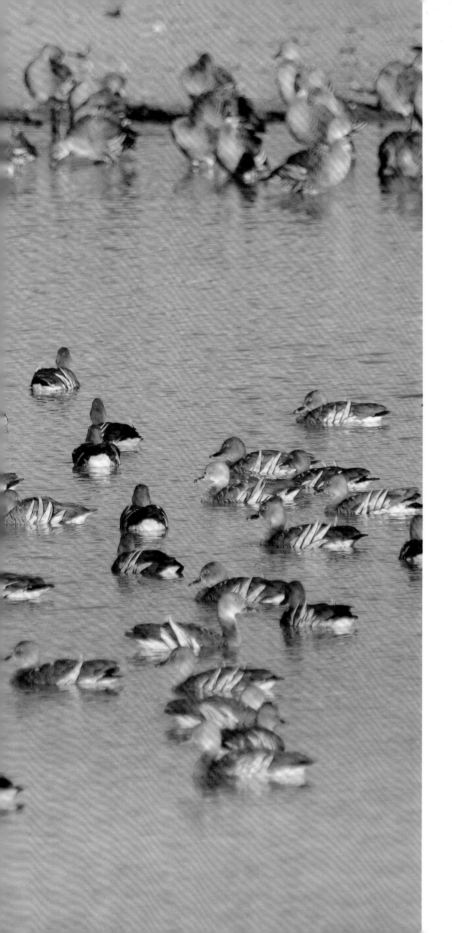

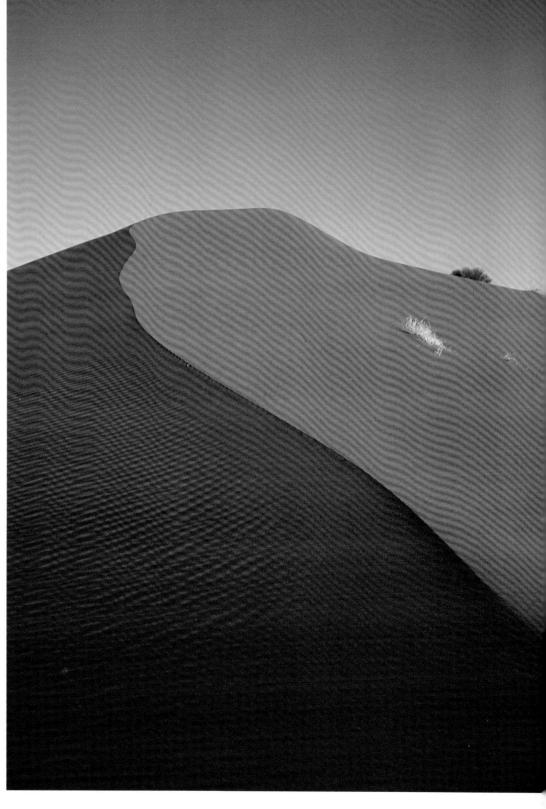

ABOVE *Some of the east's most intensely red dunes are found at Windorah, Queensland.*

LEFT *Whistling plumed ducks take advantage of overflow water from a station tank in Diamantina National Park, Queensland.*

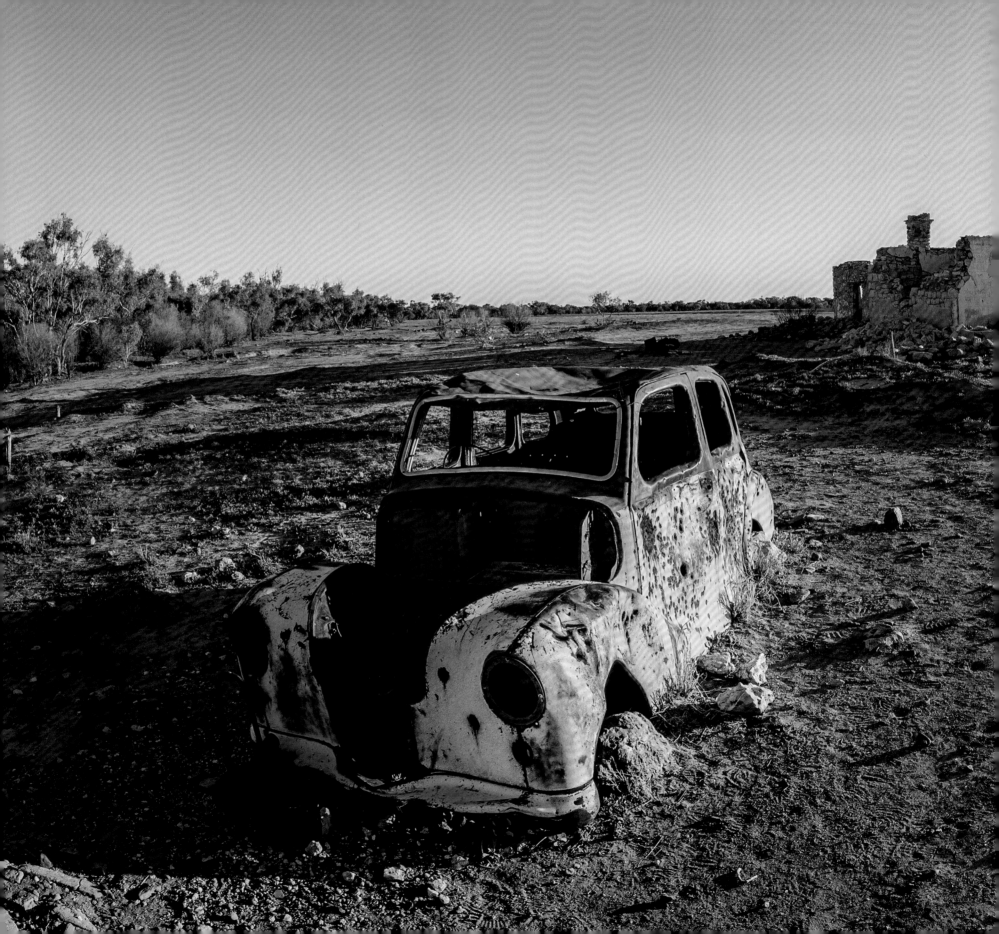

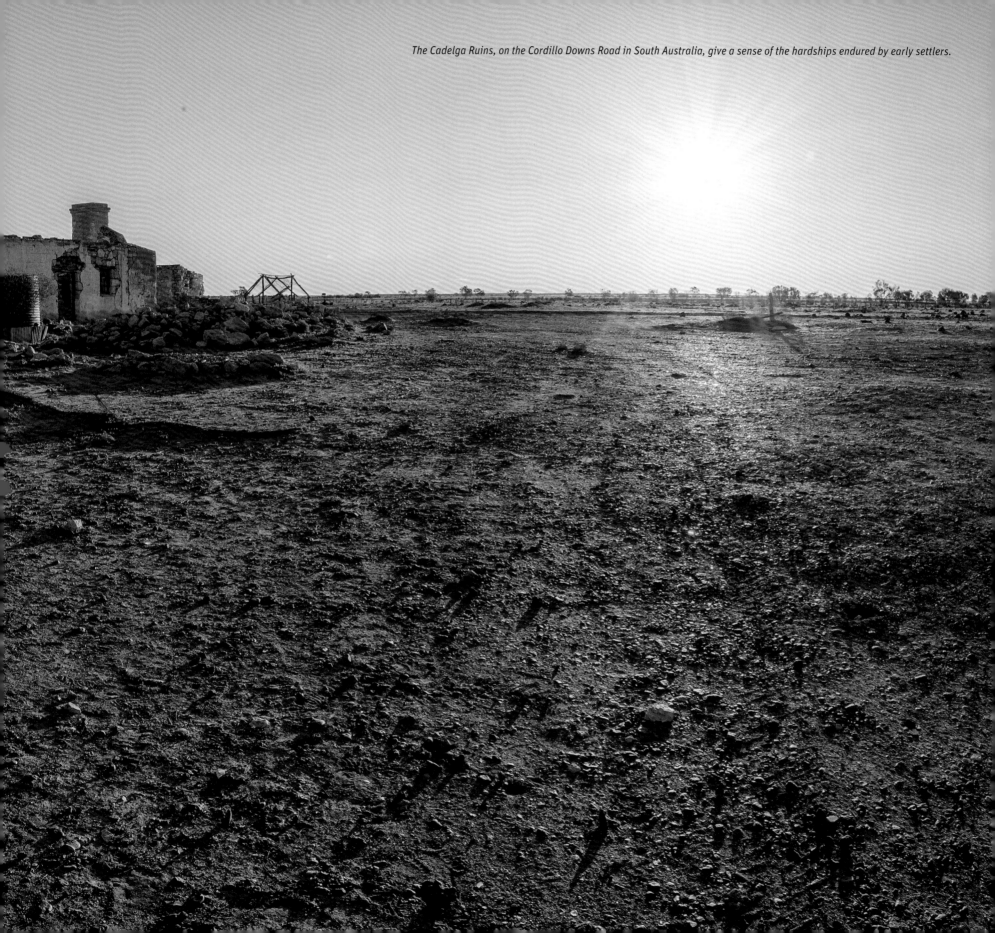

The Cadelga Ruins, on the Cordillo Downs Road in South Australia, give a sense of the hardships endured by early settlers.

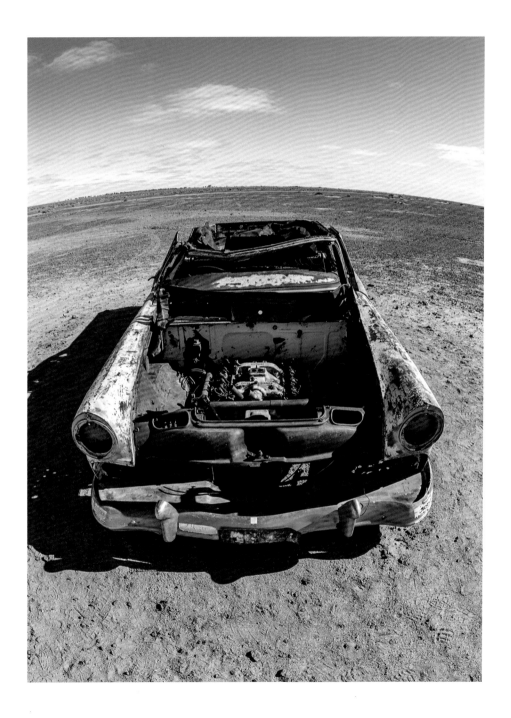

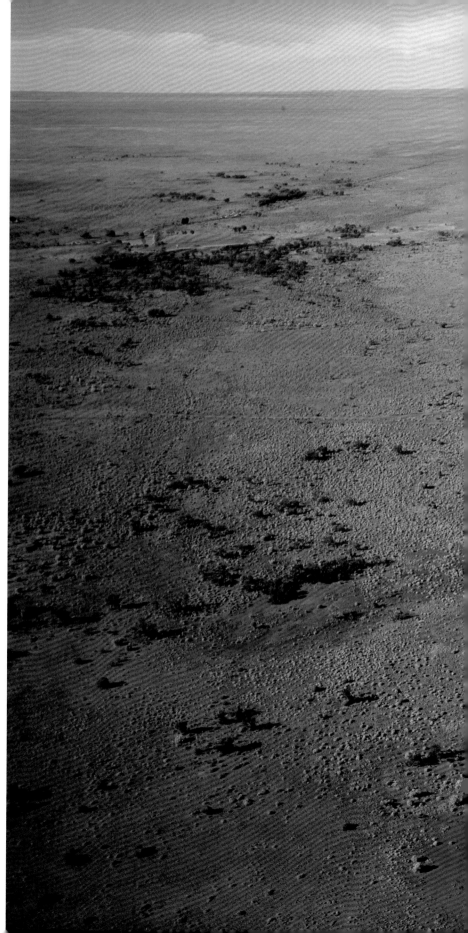

ABOVE Not far from the Walkers Crossing turn-off, about 100 kilometres south of Birdsville, the Birdsville Track has claimed another victim.

RIGHT Around an isolated homestead near Broken Hill in New South Wales, the Mundi Mundi Plains stretch to infinity.

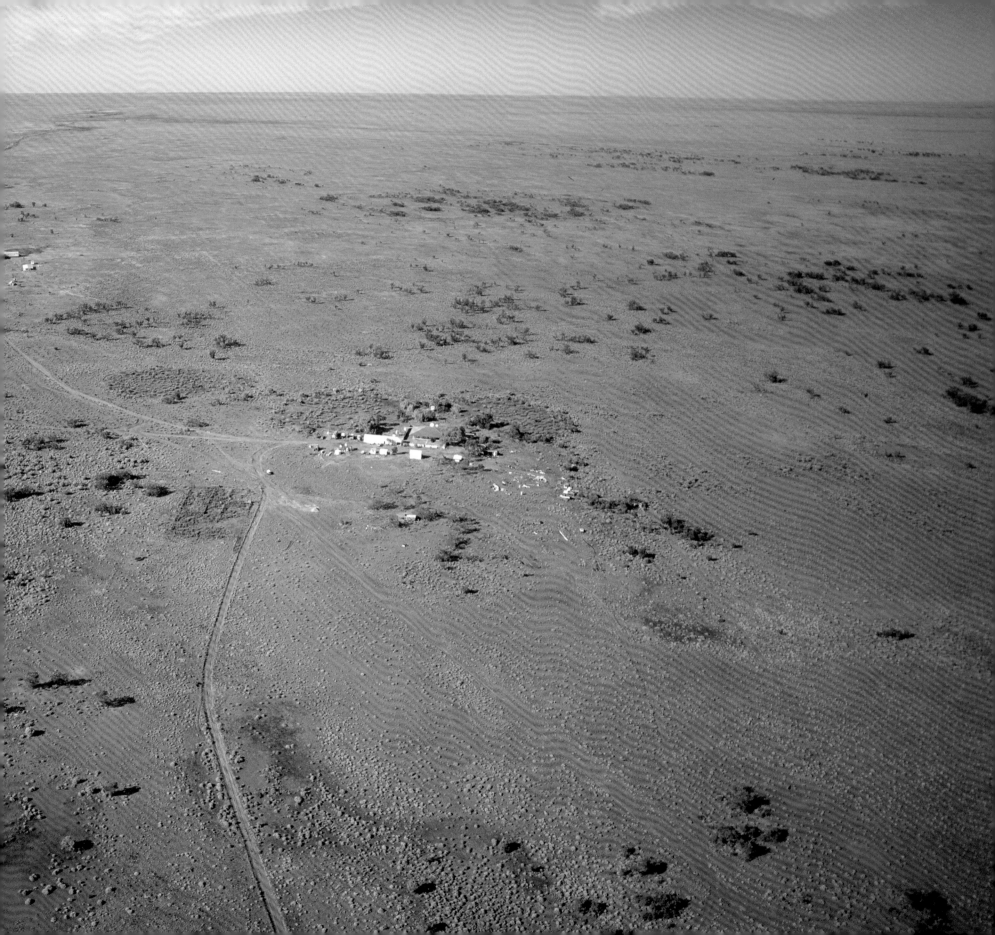

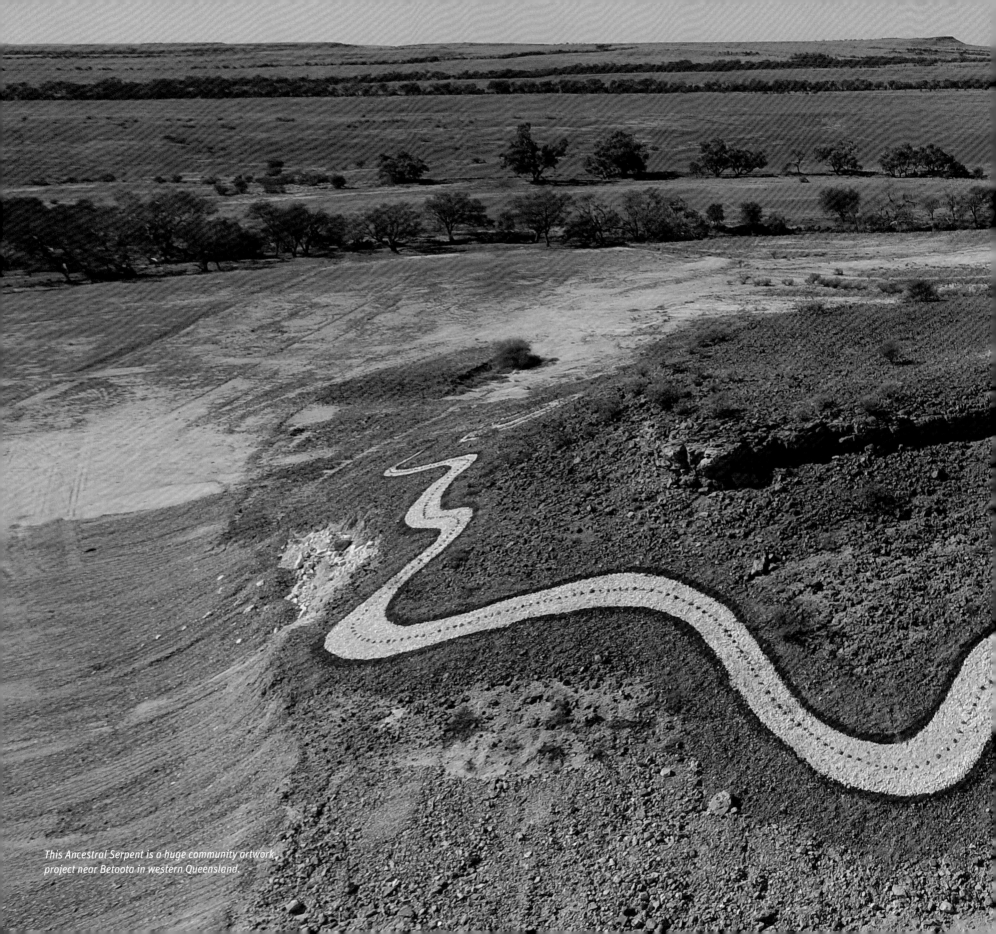

This Ancestral Serpent is a huge community artwork project near Betoota in western Queensland.

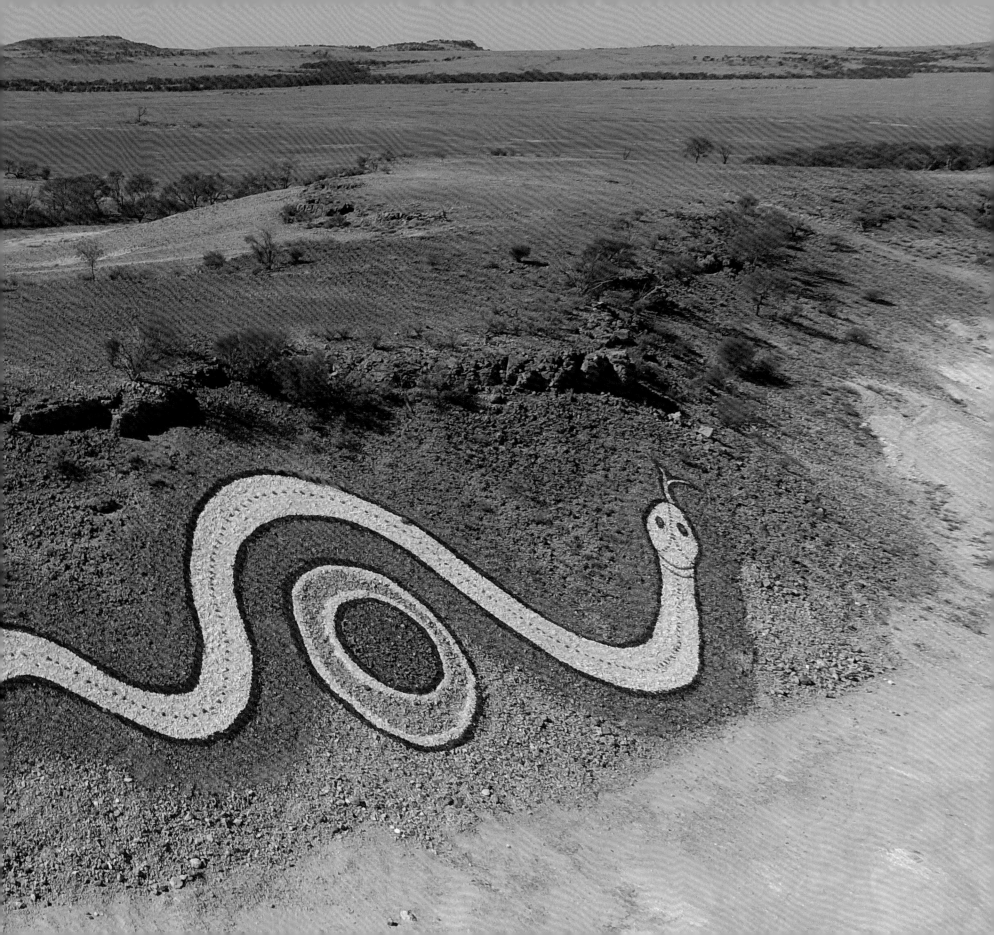

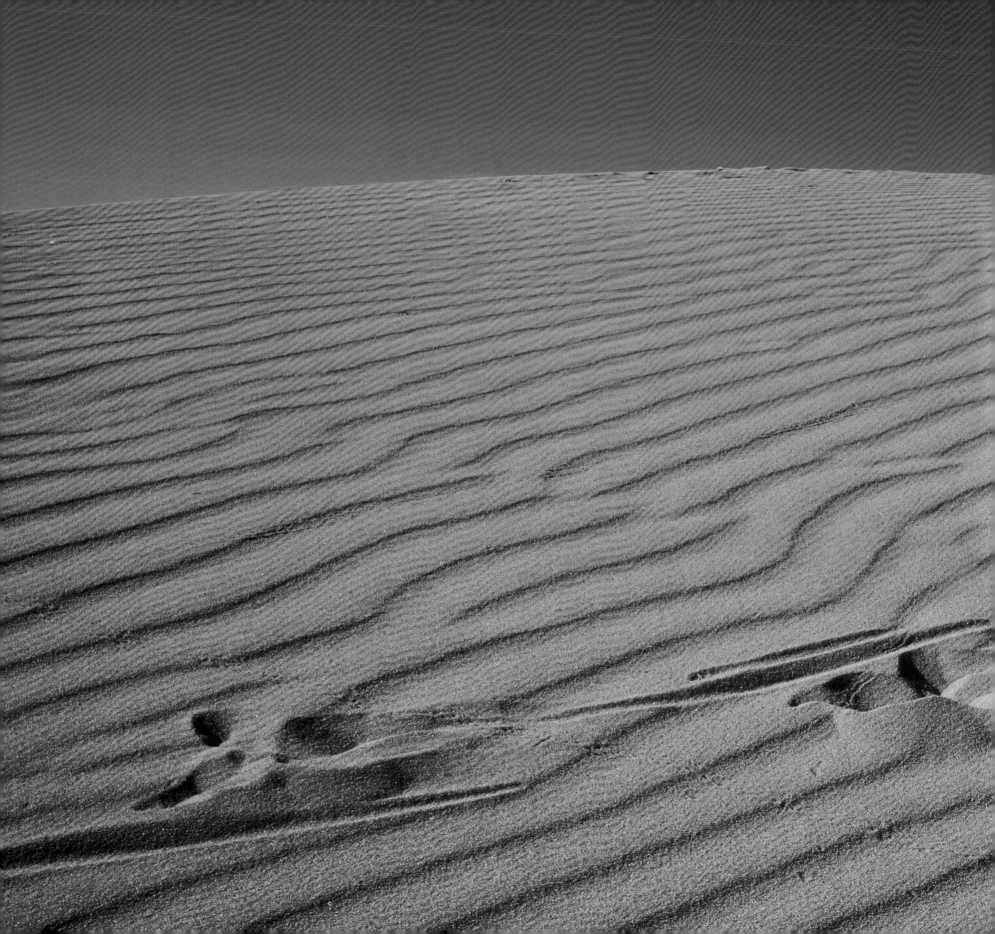

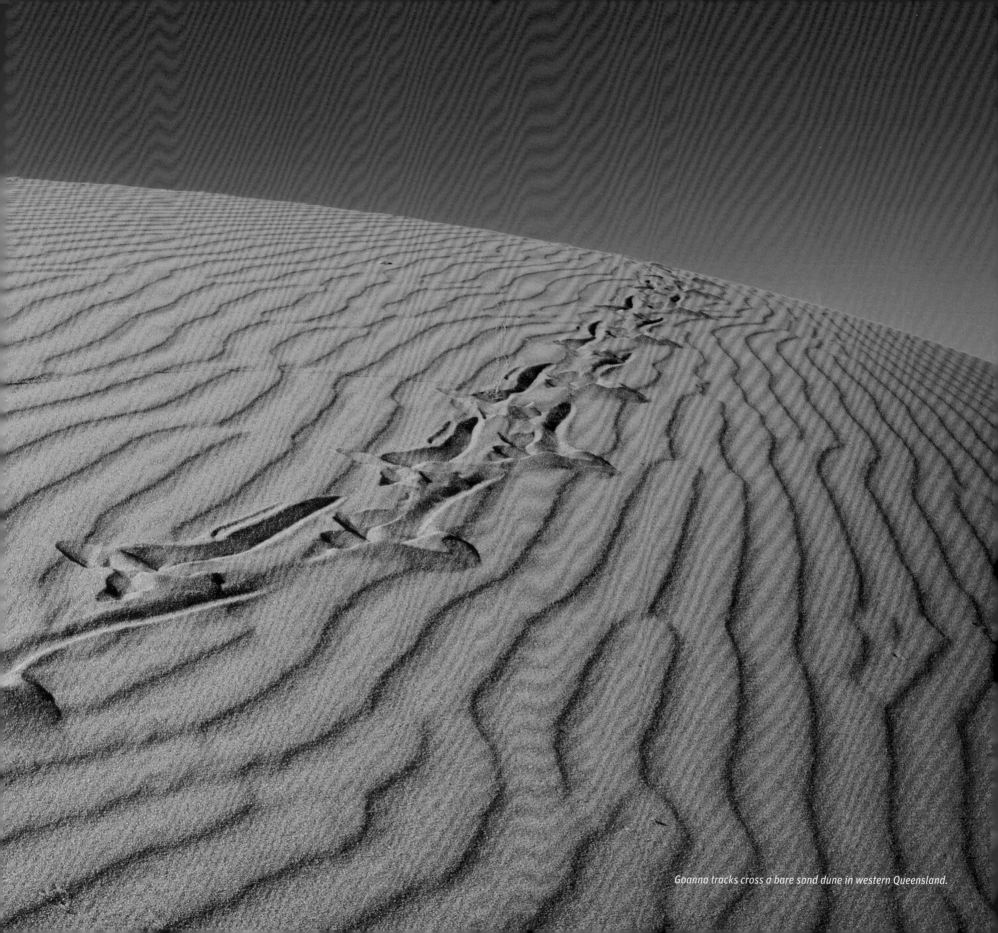

Goanna tracks cross a bare sand dune in western Queensland.

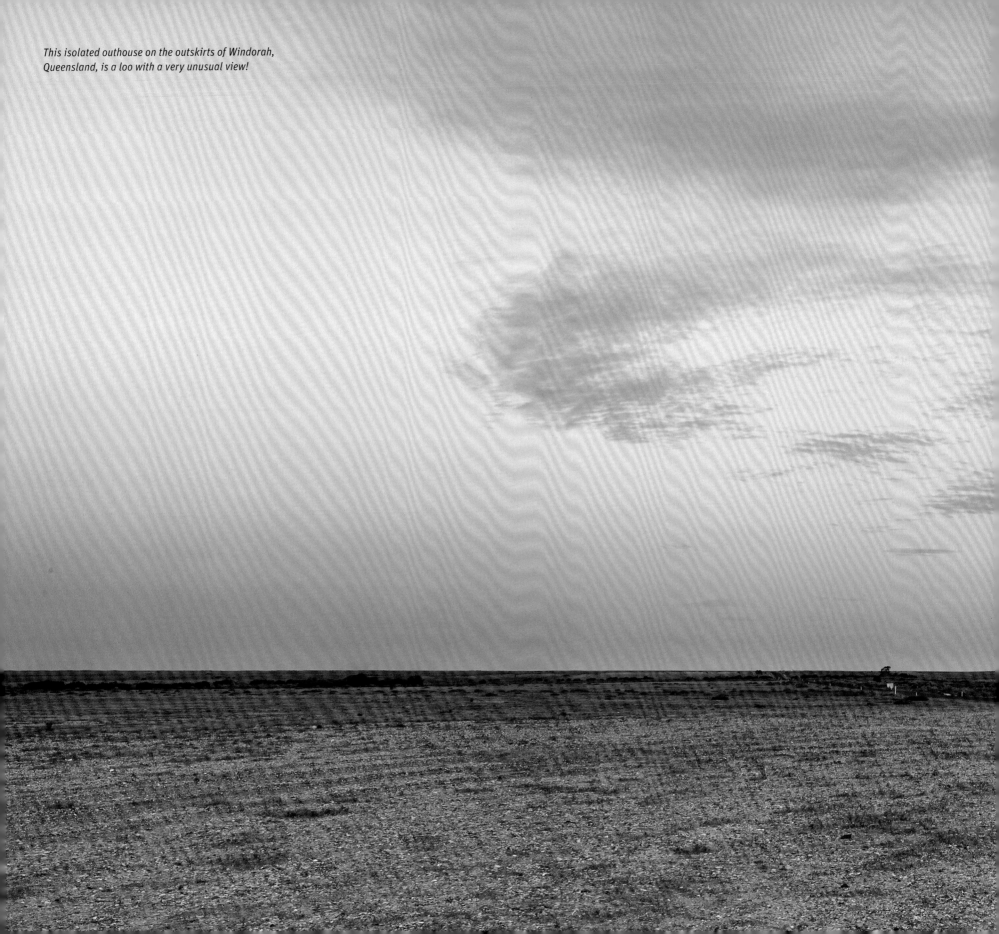

This isolated outhouse on the outskirts of Windorah, Queensland, is a loo with a very unusual view!

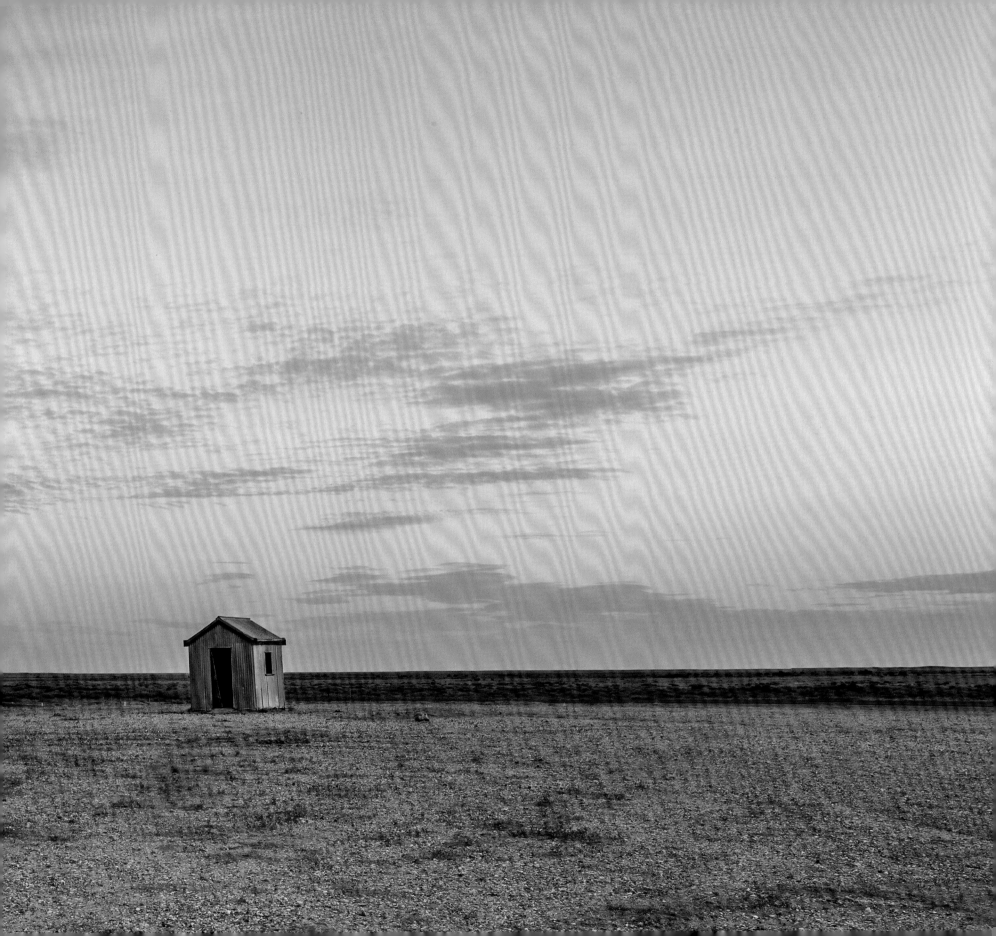

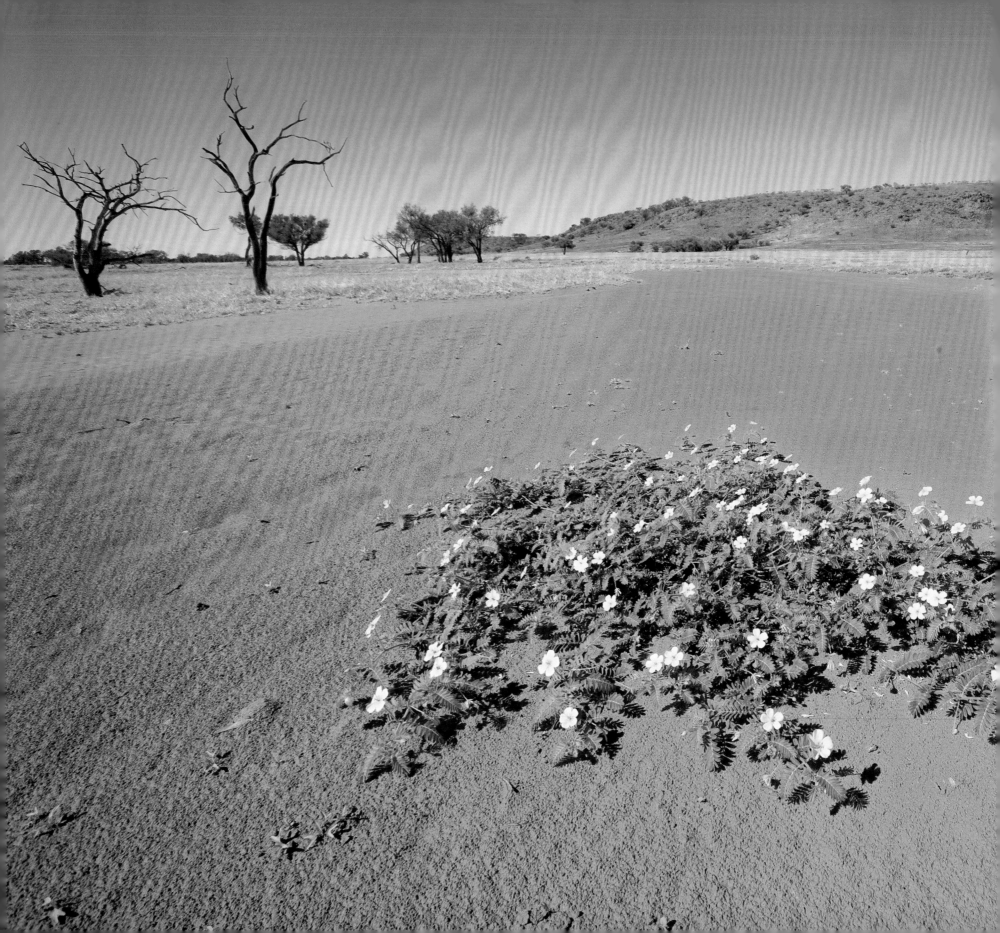

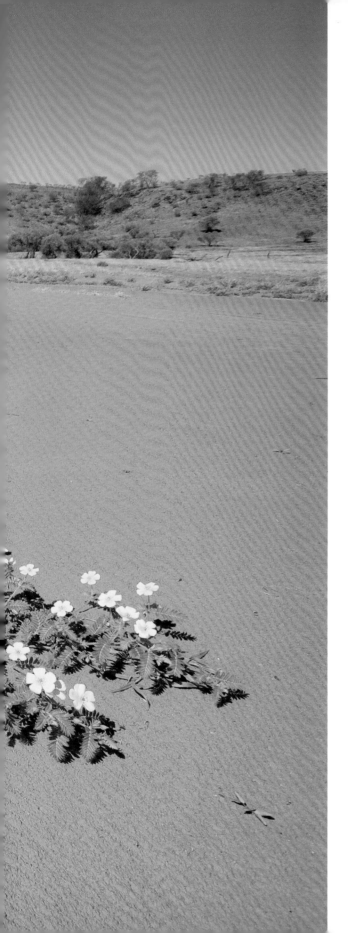

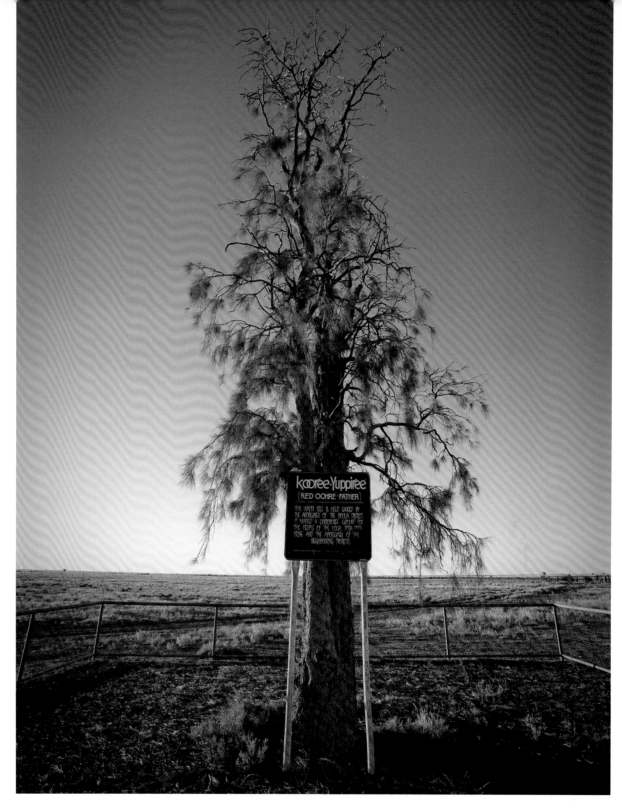

ABOVE The famous Corroboree Tree in Boulia, Queensland, is an example of the rare waddi tree, found only in this region.

LEFT Desert flowers burst into life in the most inhospitable places, such as here in the eastern Simpson Desert.

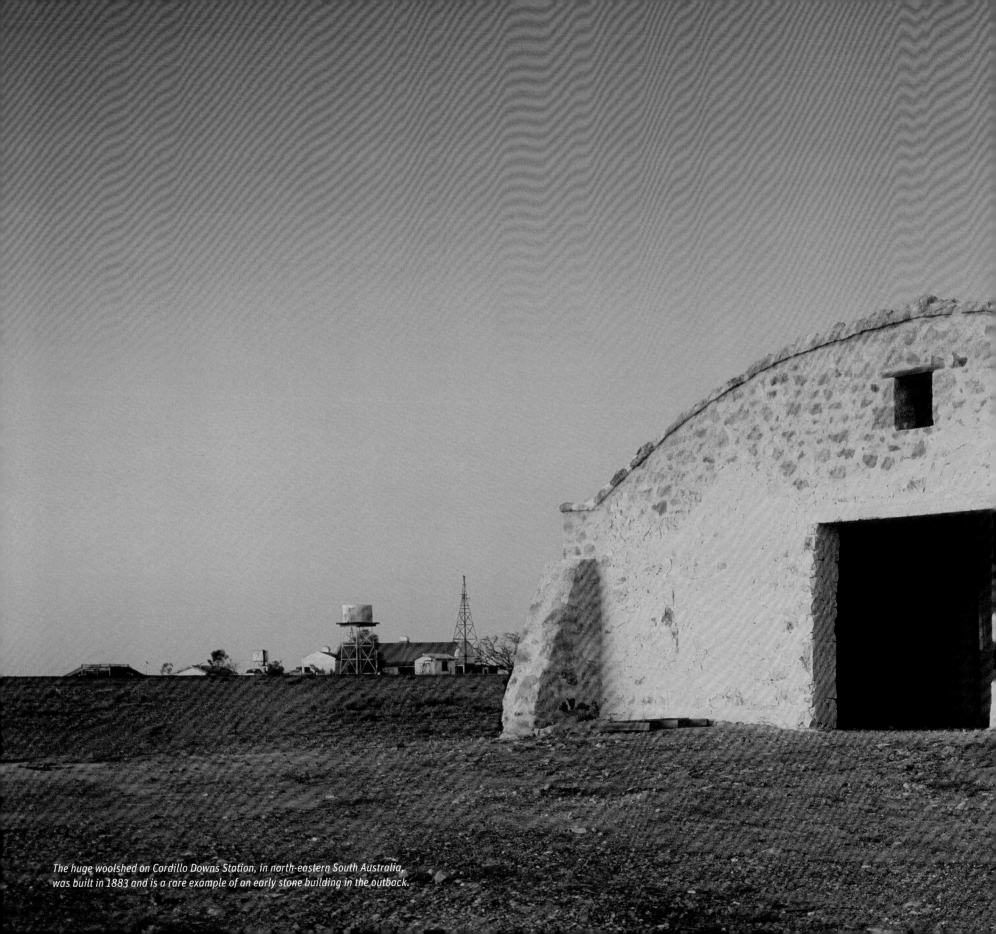

The huge woolshed on Cordillo Downs Station, in north-eastern South Australia, was built in 1883 and is a rare example of an early stone building in the outback.

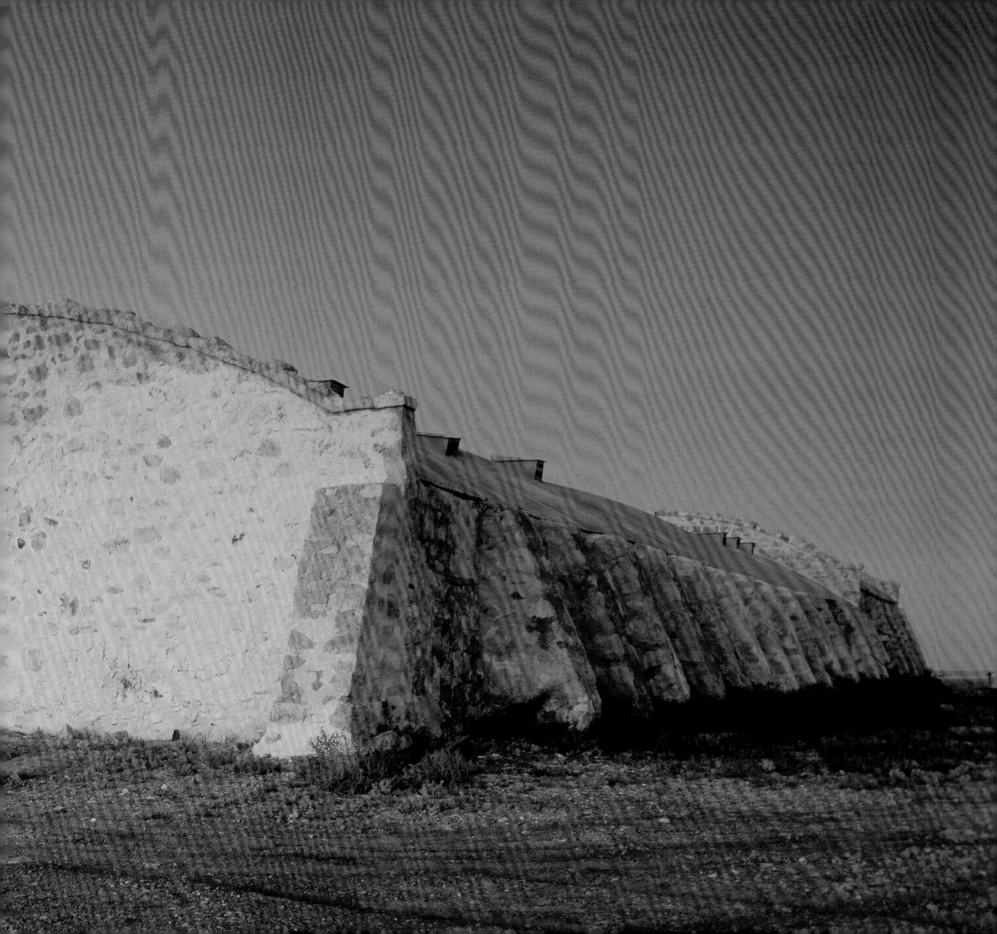

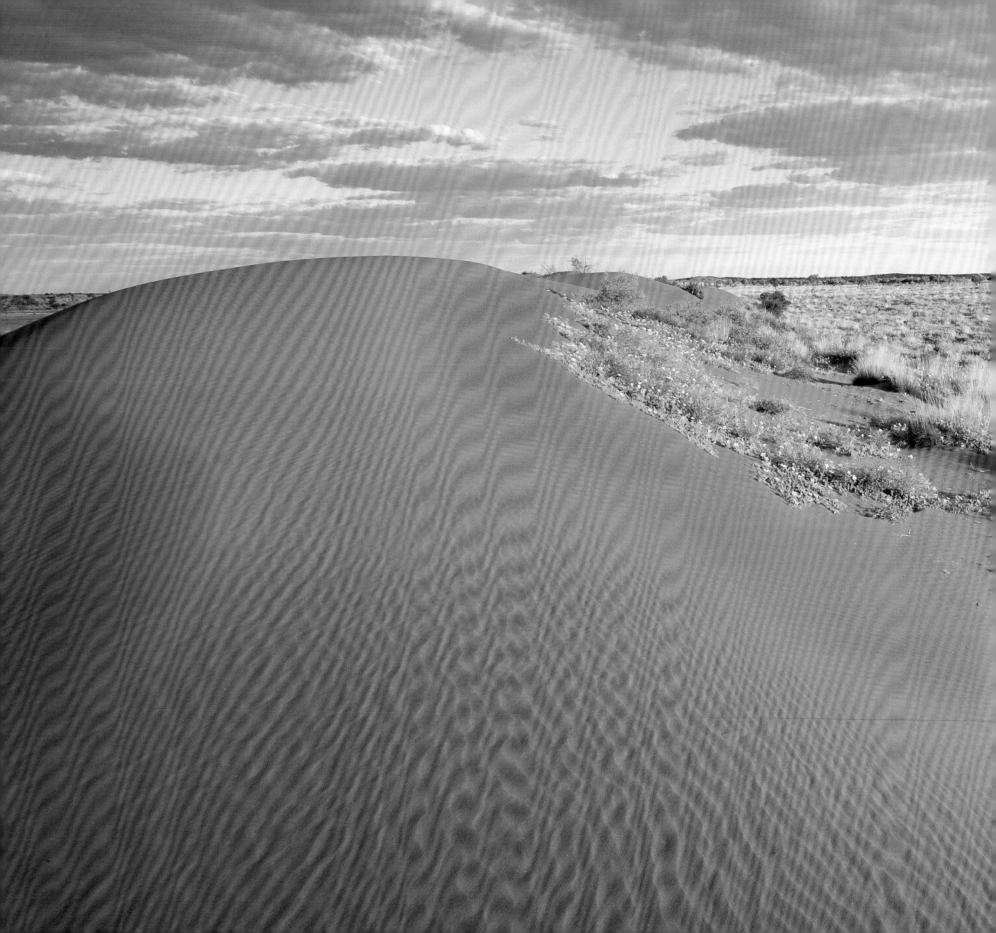

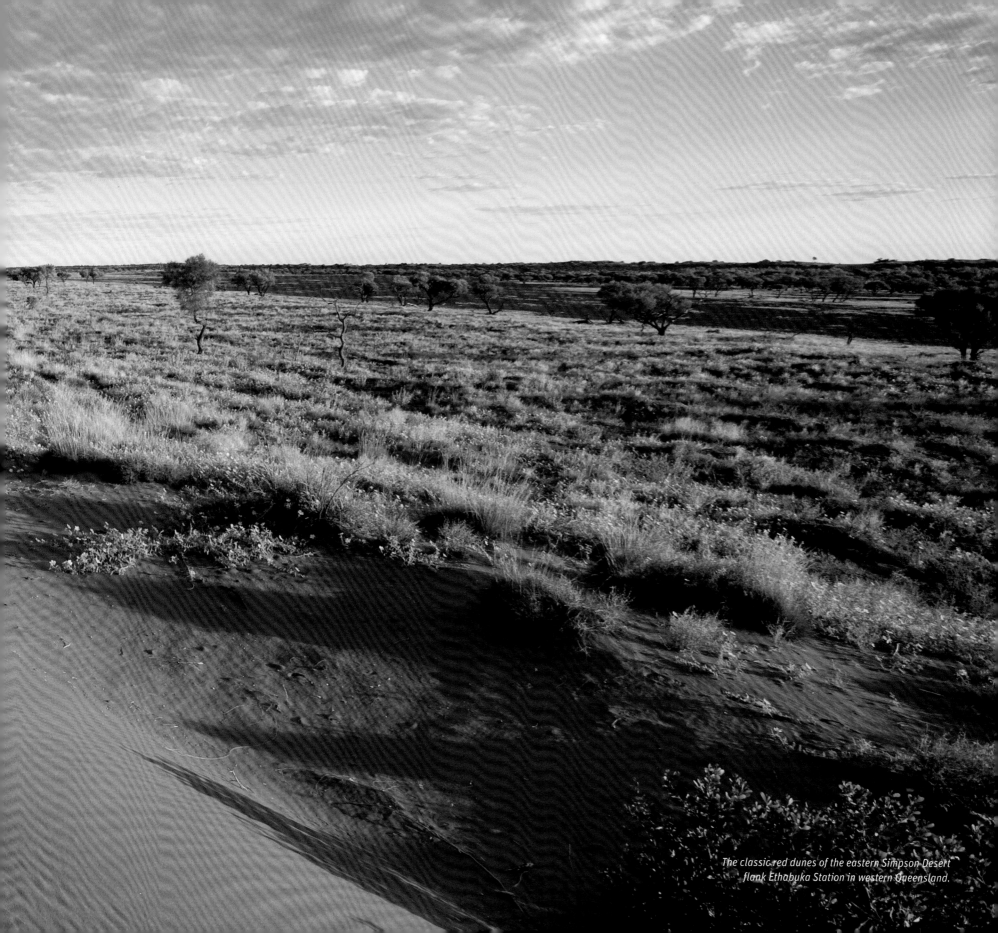

The classic red dunes of the eastern Simpson Desert flank Ethabuka Station in western Queensland.

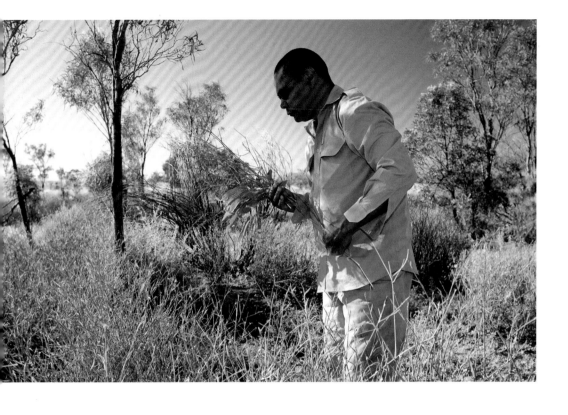

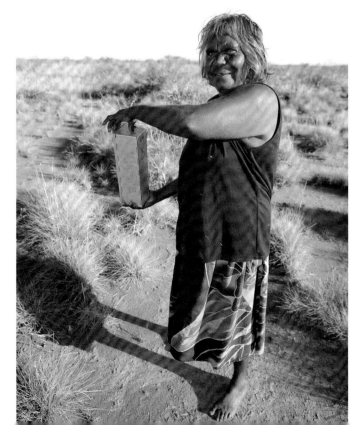

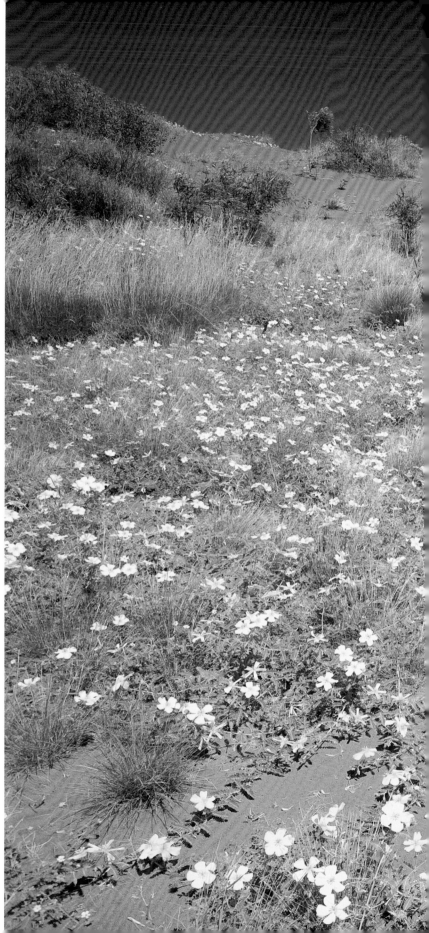

ABOVE AND RIGHT *Local Indigenous people take part in research at Cravens Peak Reserve in western Queensland.*

FAR RIGHT *Goatshead burr flowers rapidly after rain in the eastern Simpson Desert.*

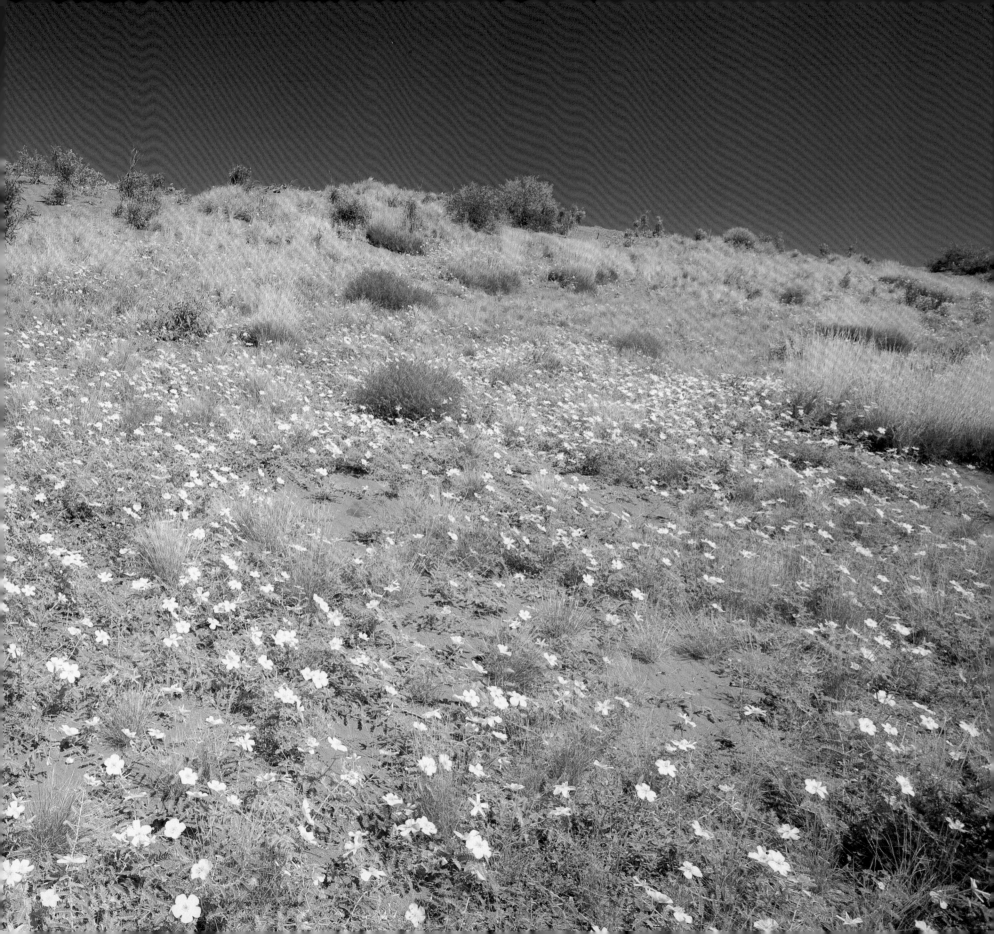

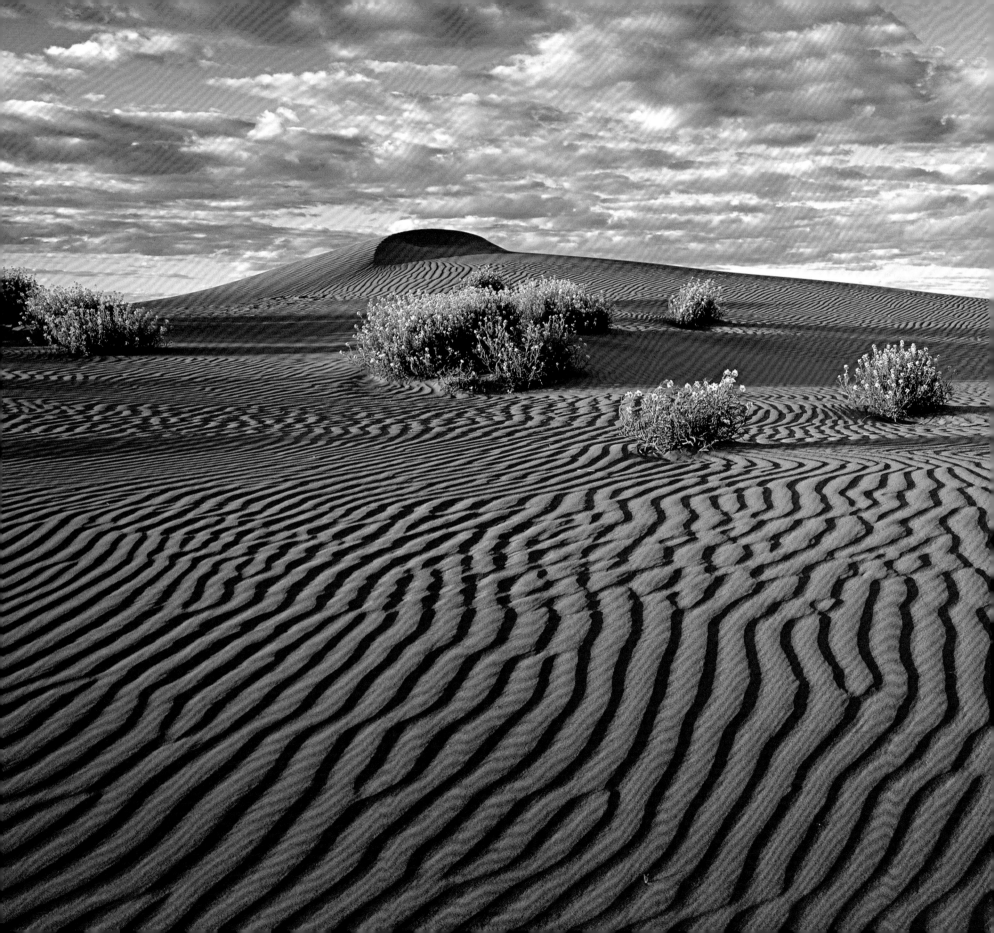

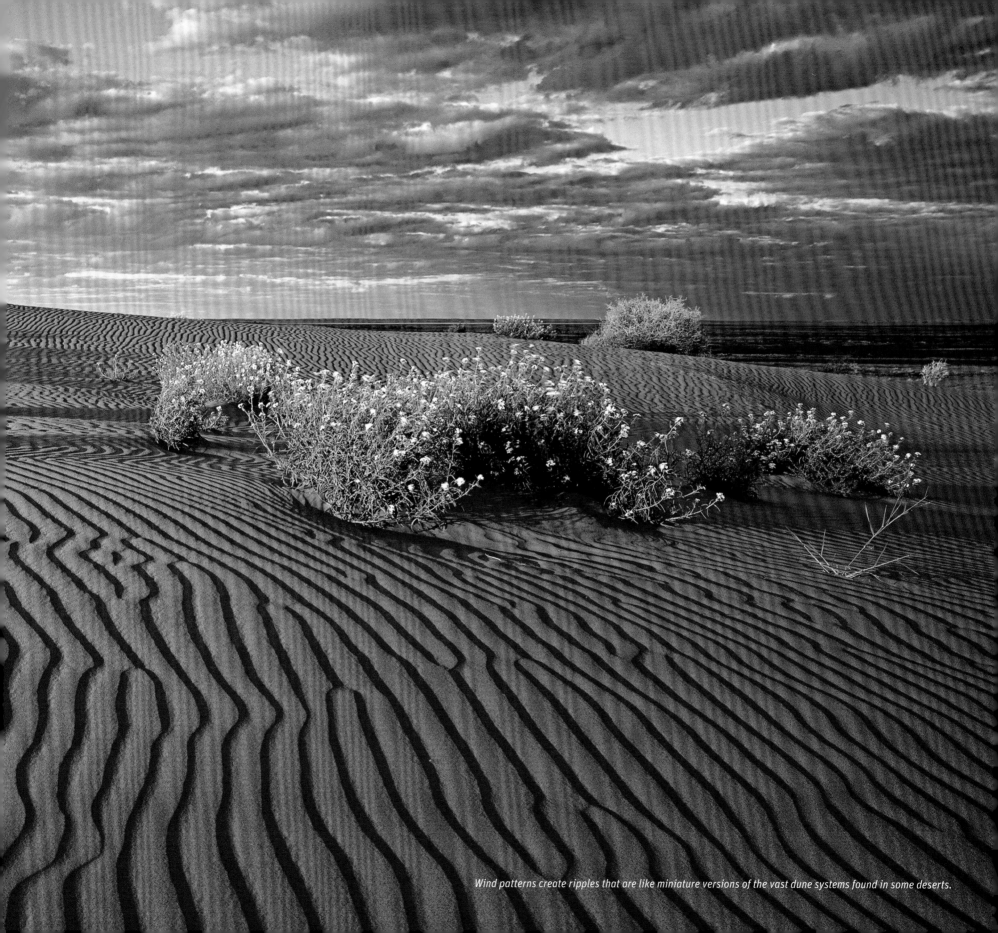

Wind patterns create ripples that are like miniature versions of the vast dune systems found in some deserts.

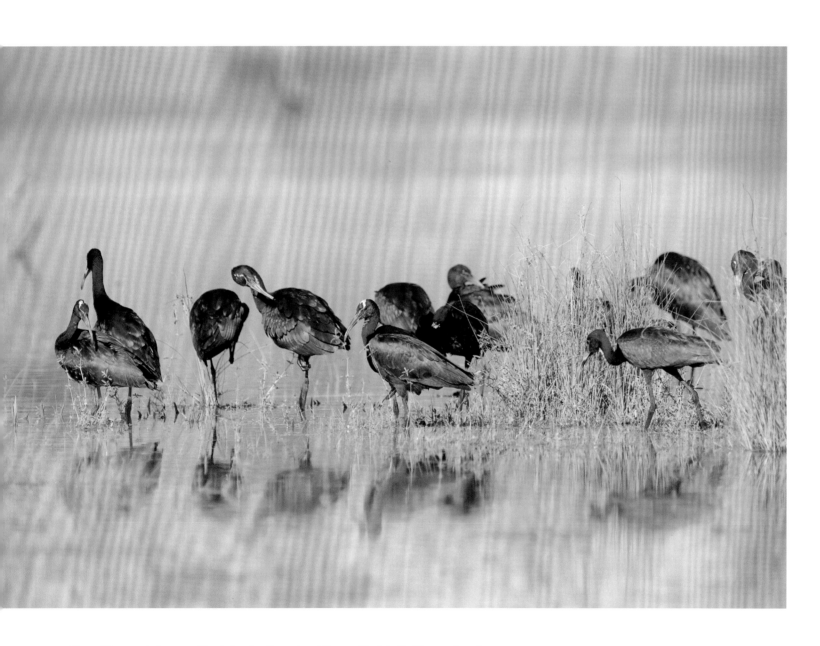

ABOVE *Glossy ibis move in for a good feed after flooding rains at Cravens Peak in the Simpson Desert.*

RIGHT *Brolgas take to the air at Ethabuka Station in the eastern Simpson Desert.*

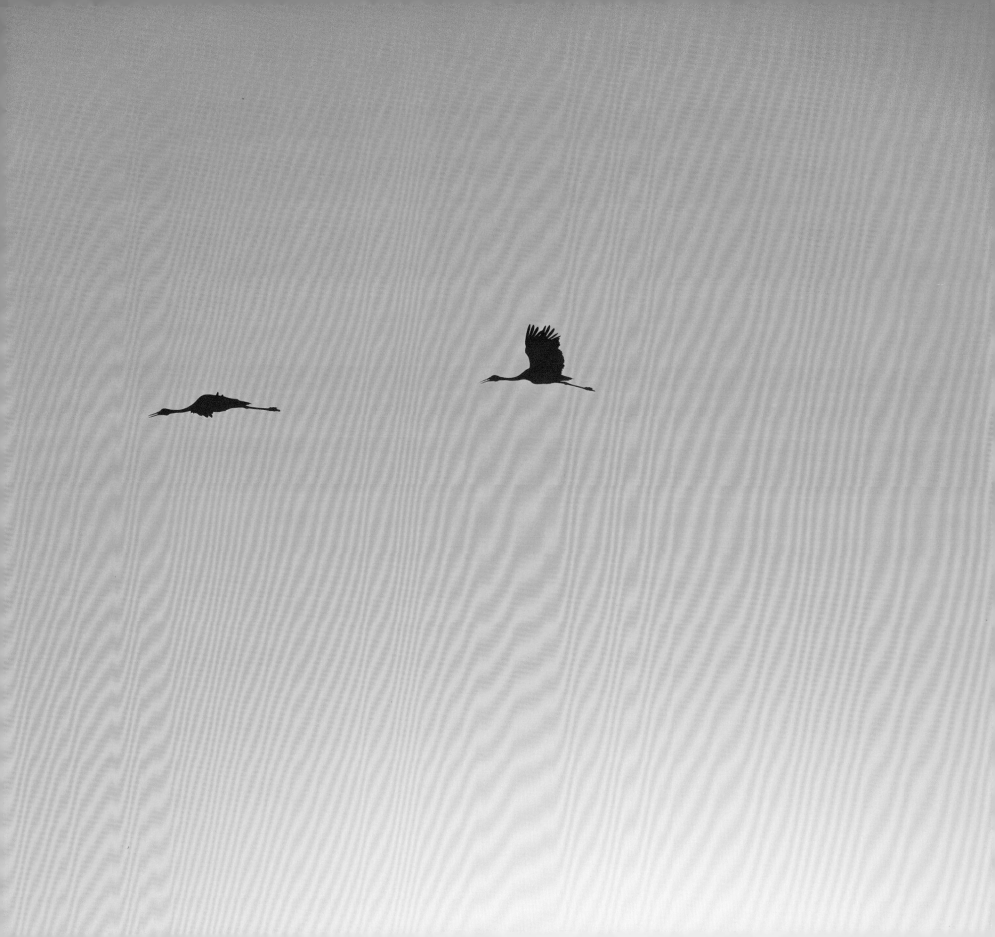

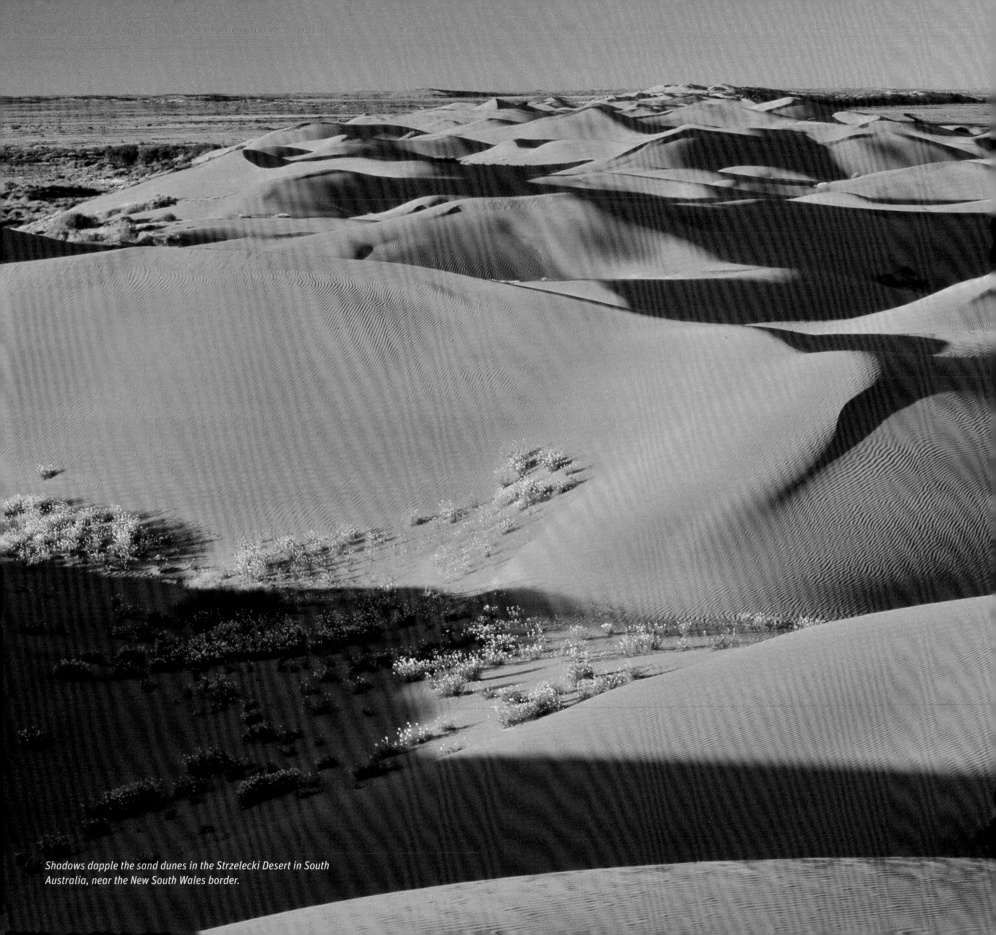

Shadows dapple the sand dunes in the Strzelecki Desert in South Australia, near the New South Wales border.

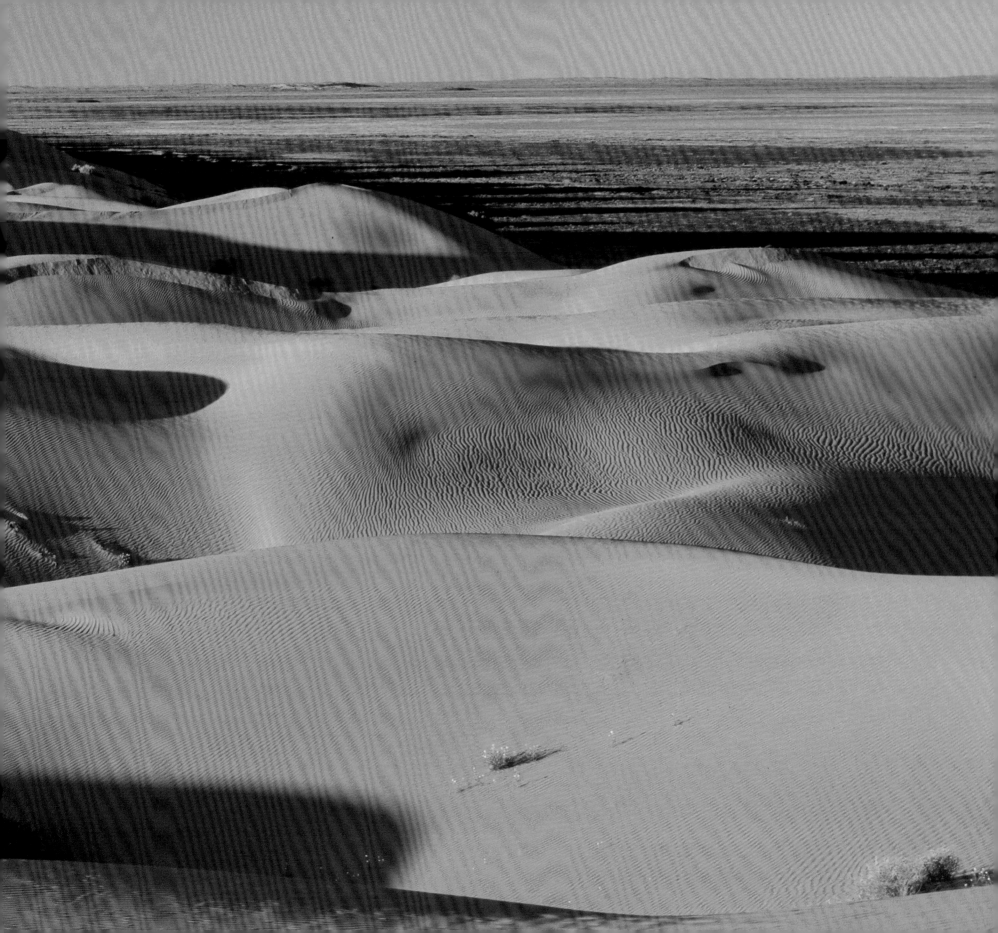

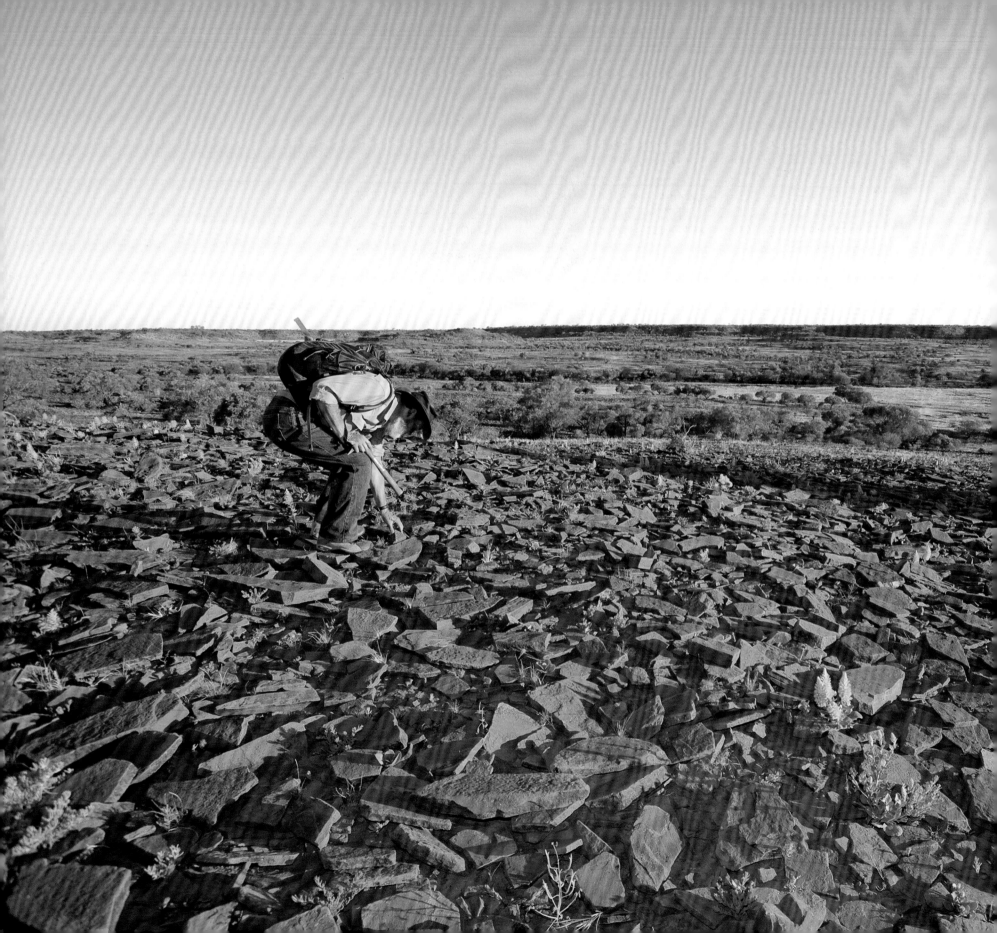

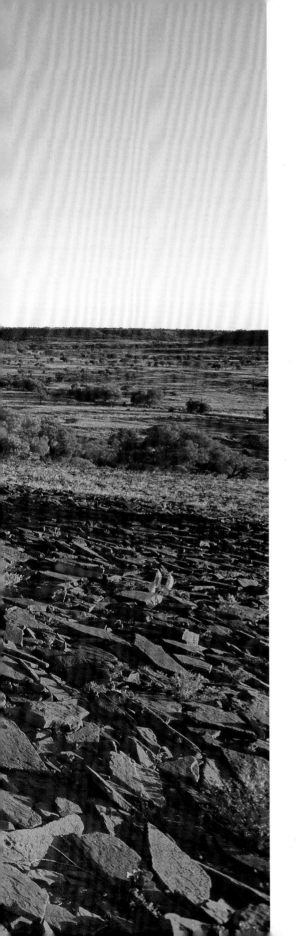

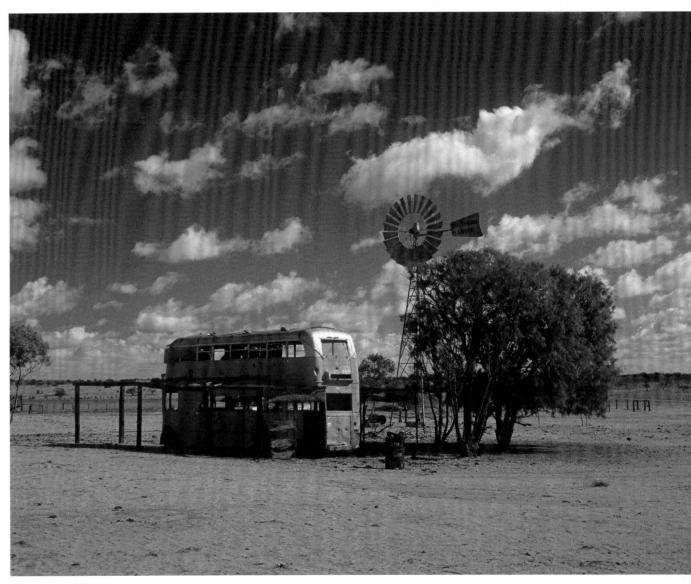

ABOVE *This old abandoned bus near Camerons Corner was once used as a chicken coop. One wonders how it got here.*

LEFT *Australia's ancient, arid centre provides geologists with enormous resources for research, as here at Cravens Peak, western Queensland.*

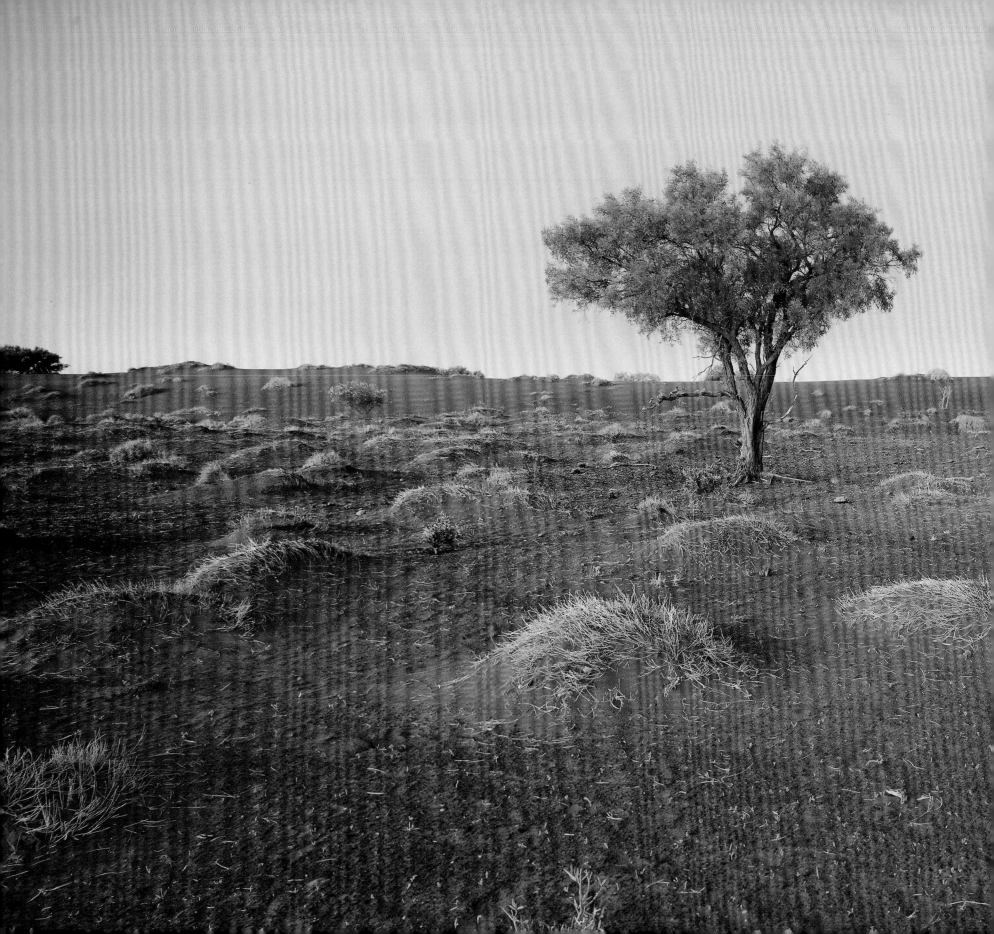

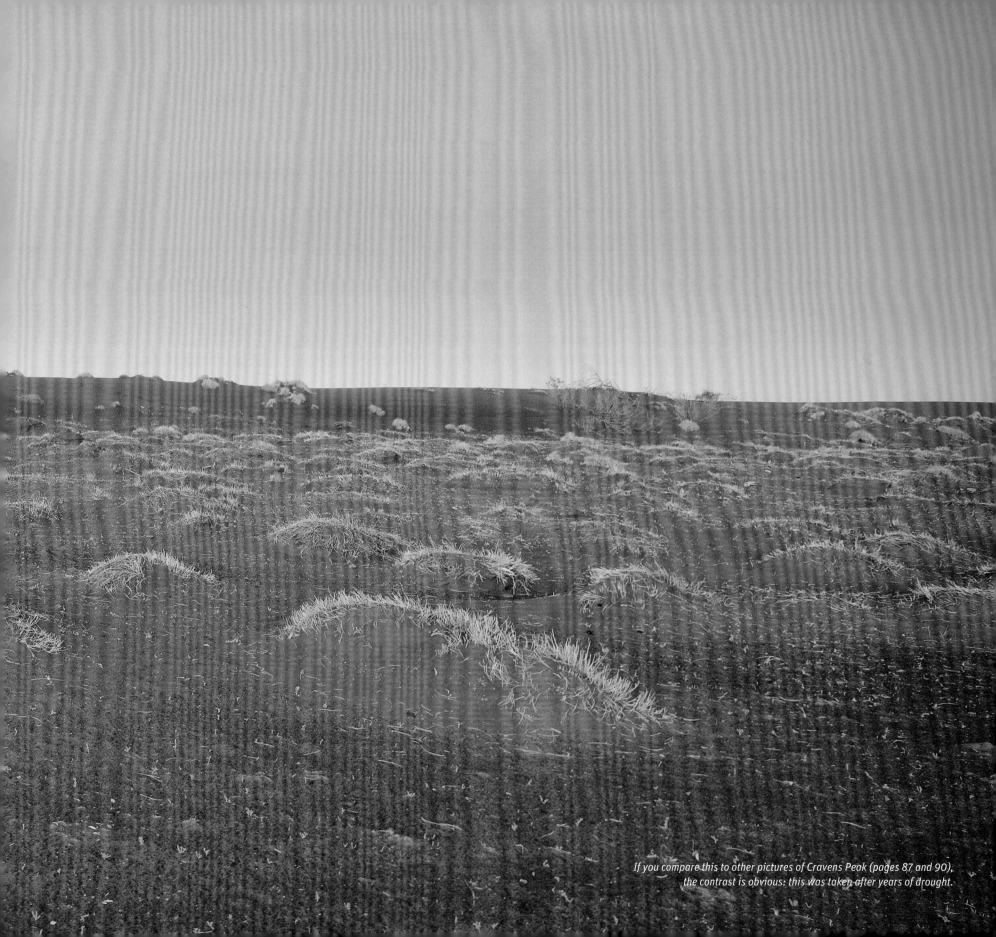

If you compare this to other pictures of Cravens Peak (pages 87 and 90), the contrast is obvious: this was taken after years of drought.

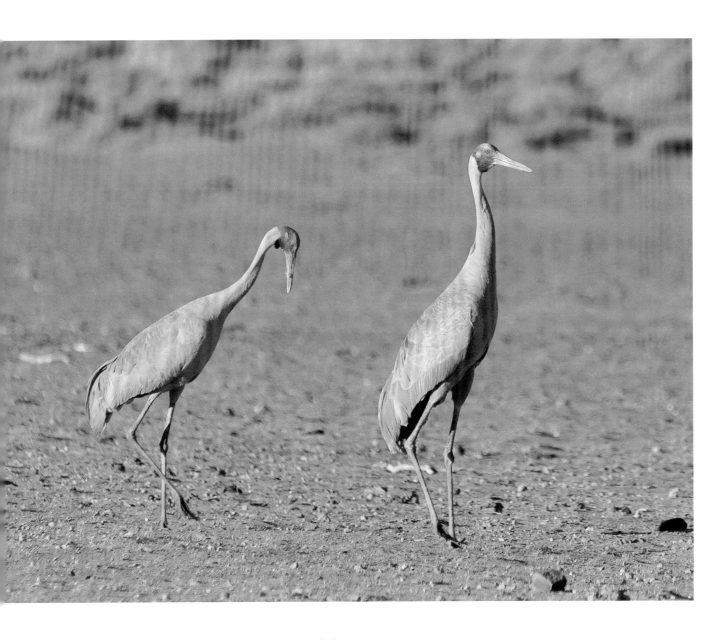

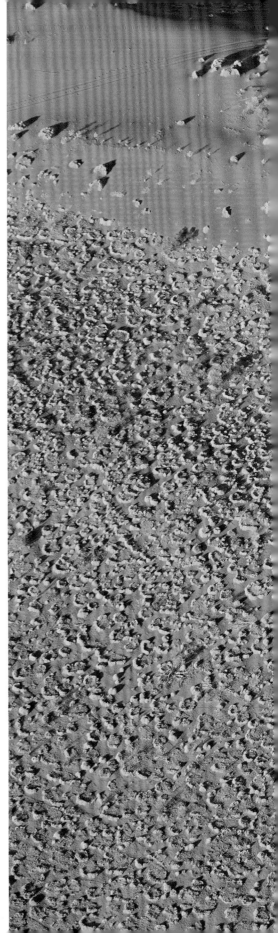

ABOVE Brolgas are frequently found in breeding pairs, even in the harshest desert environments.

RIGHT Viewed from the air, spinifex forms little doughnut shapes separated by bare sand.

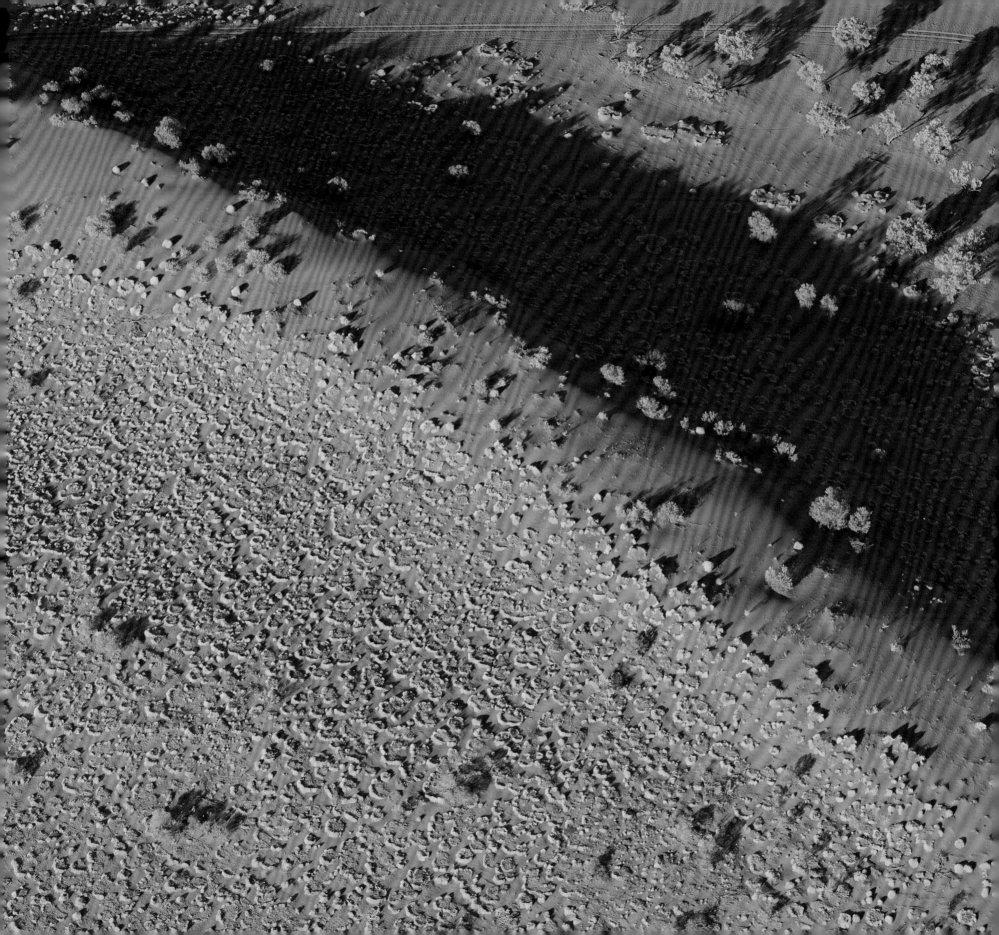

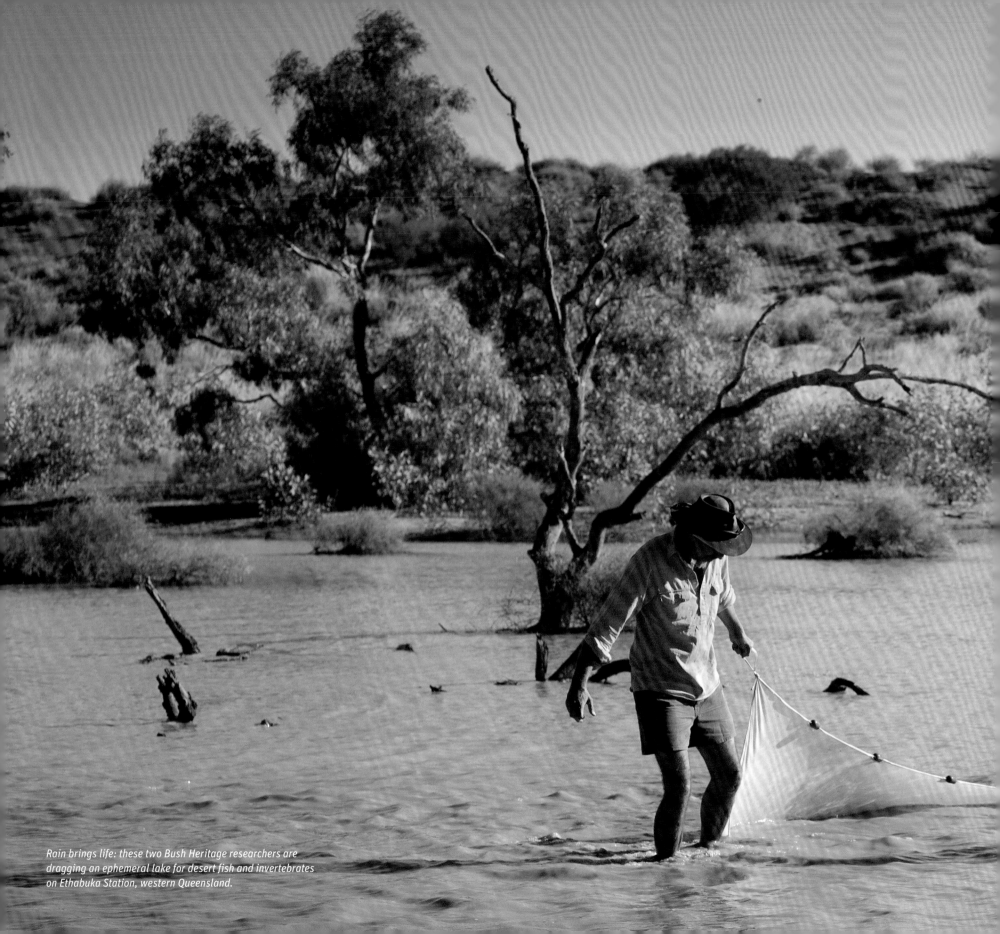

Rain brings life: these two Bush Heritage researchers are dragging an ephemeral lake for desert fish and invertebrates on Ethabuka Station, western Queensland.

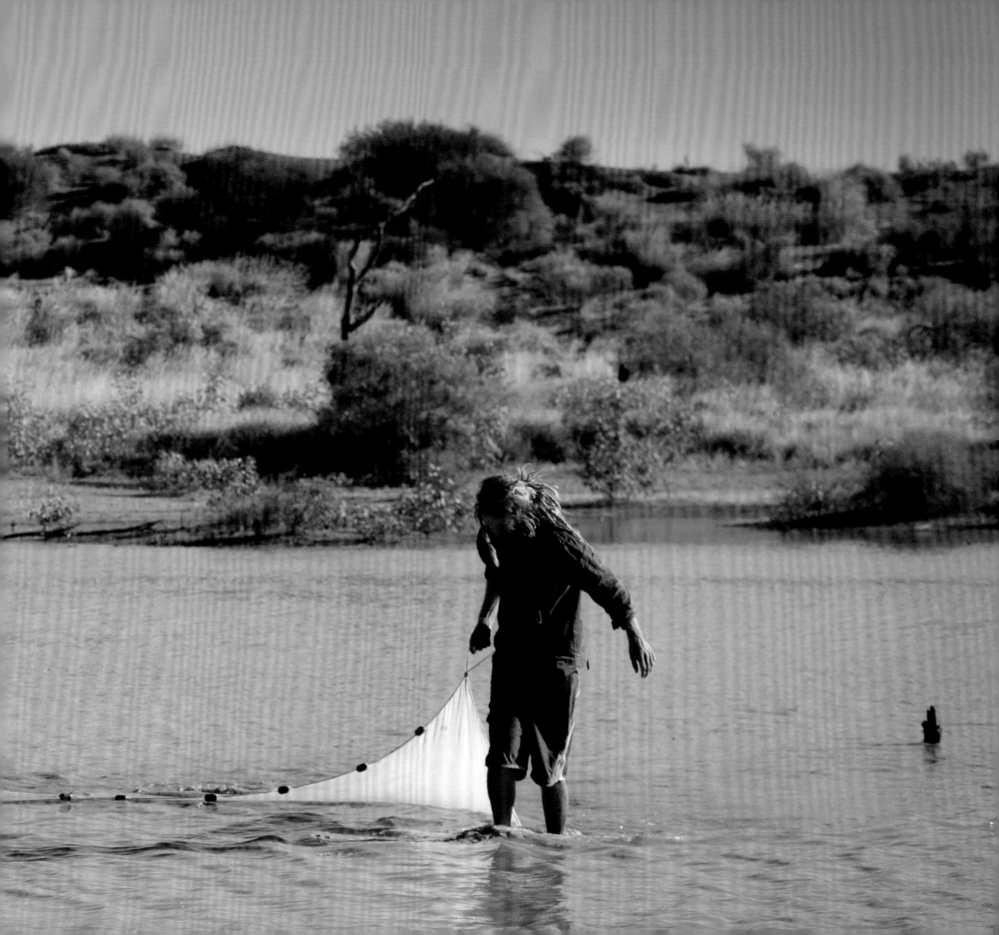

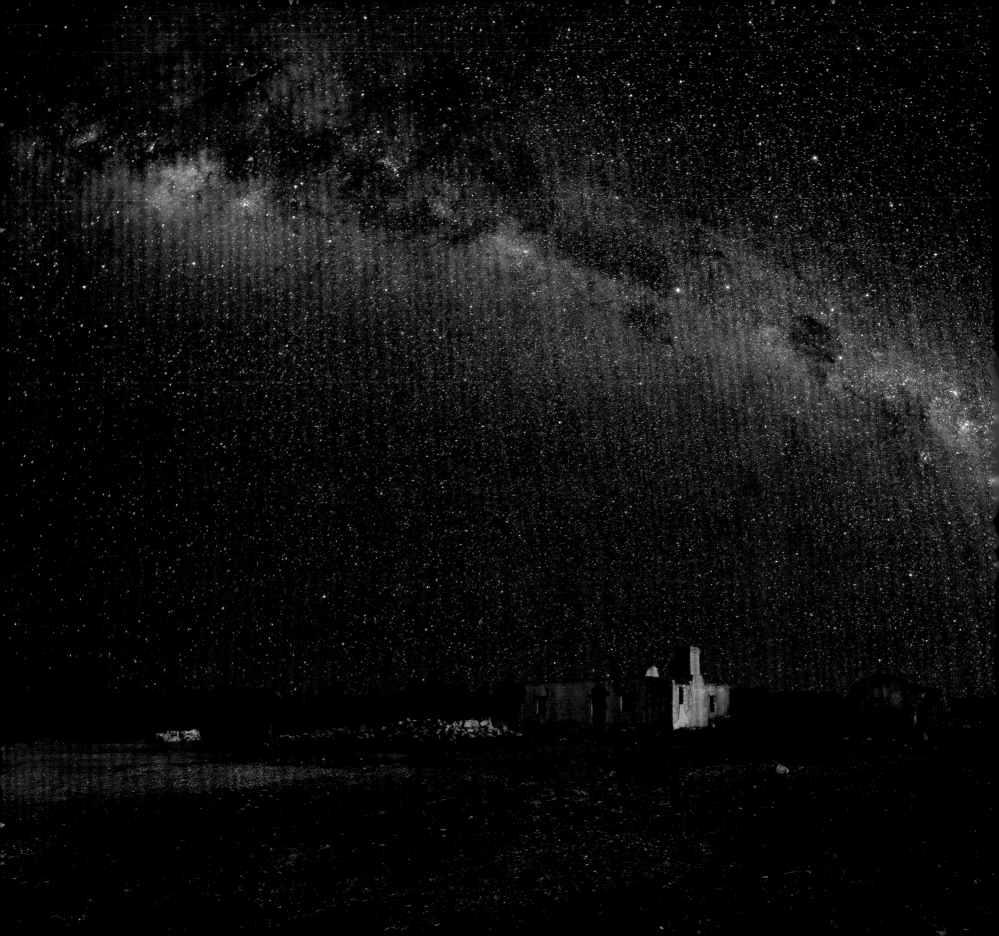

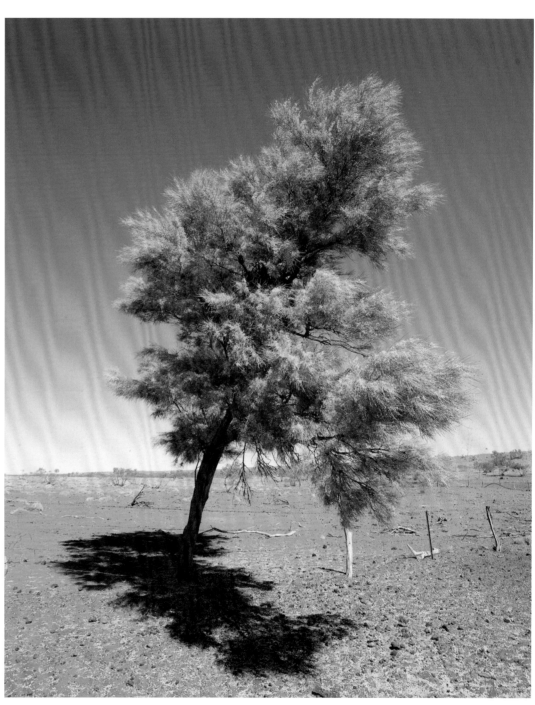

ABOVE Even in drought conditions, this tough old acacia tree still flowers profusely.

LEFT Incredibly clear skies reveal a multitude of stars over Cadelga Ruins on the northern edge of the Sturt Stony Desert.

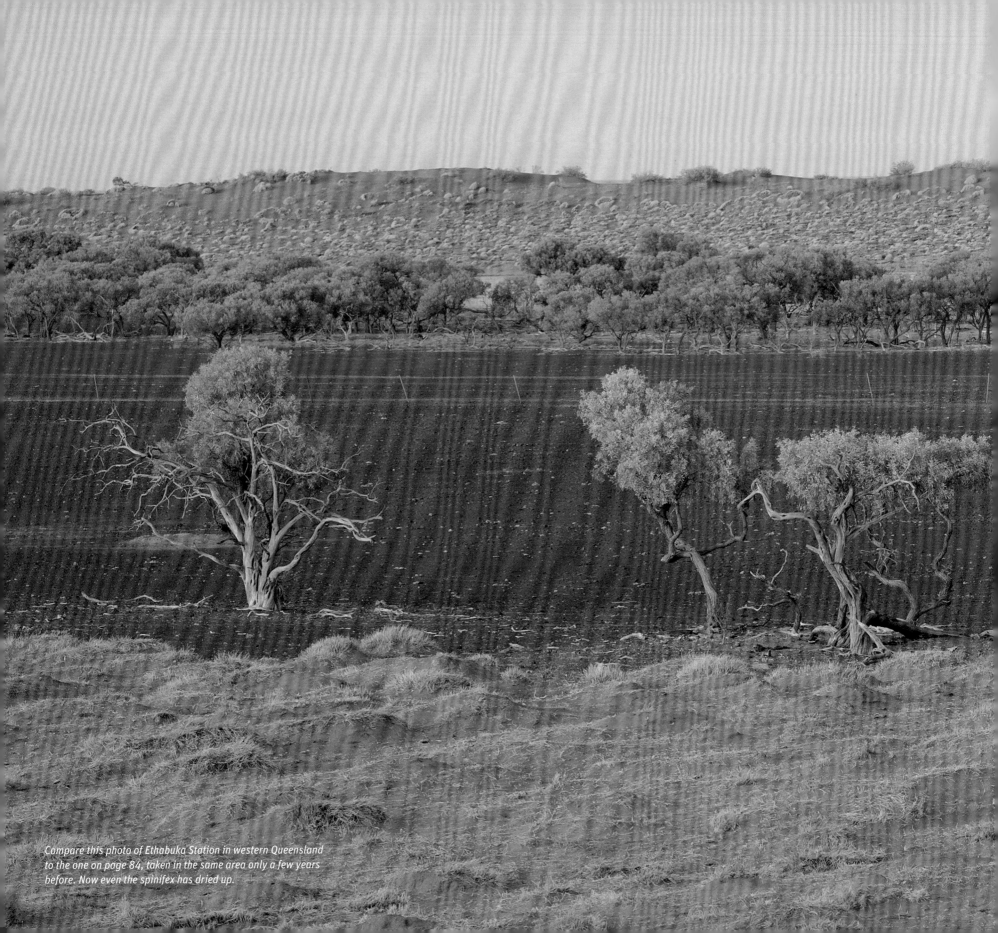

Compare this photo of Ethabuka Station in western Queensland to the one on page 84, taken in the same area only a few years before. Now even the spinifex has dried up.

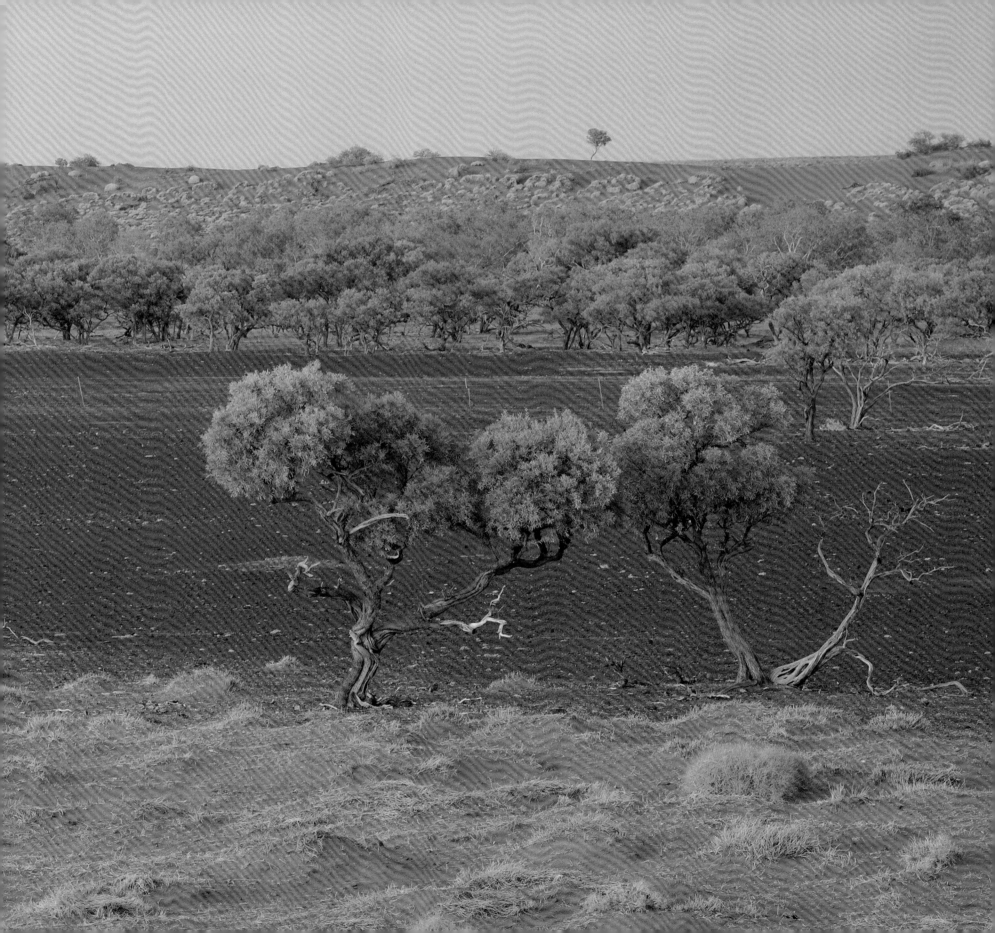

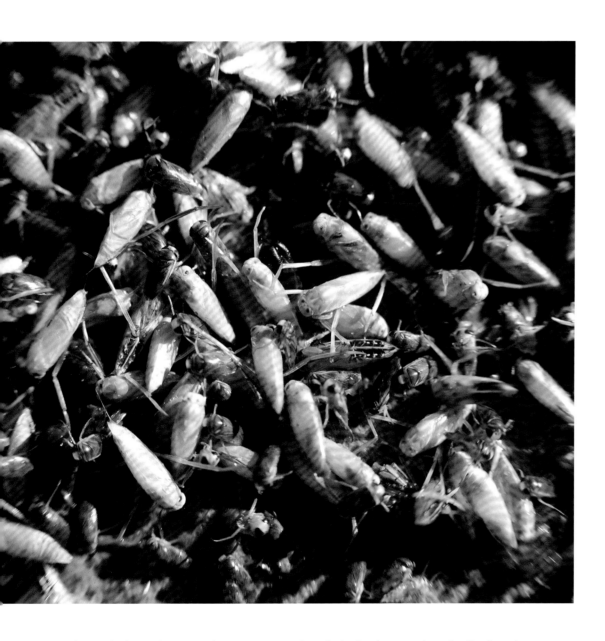

ABOVE Thousands of corixids, or 'waterboatmen', are sometimes dredged up by researchers after flooding rain at Ethabuka, western Queensland.

RIGHT A huge windmill pumps bore water to the surface at Boulia in far western Queensland.

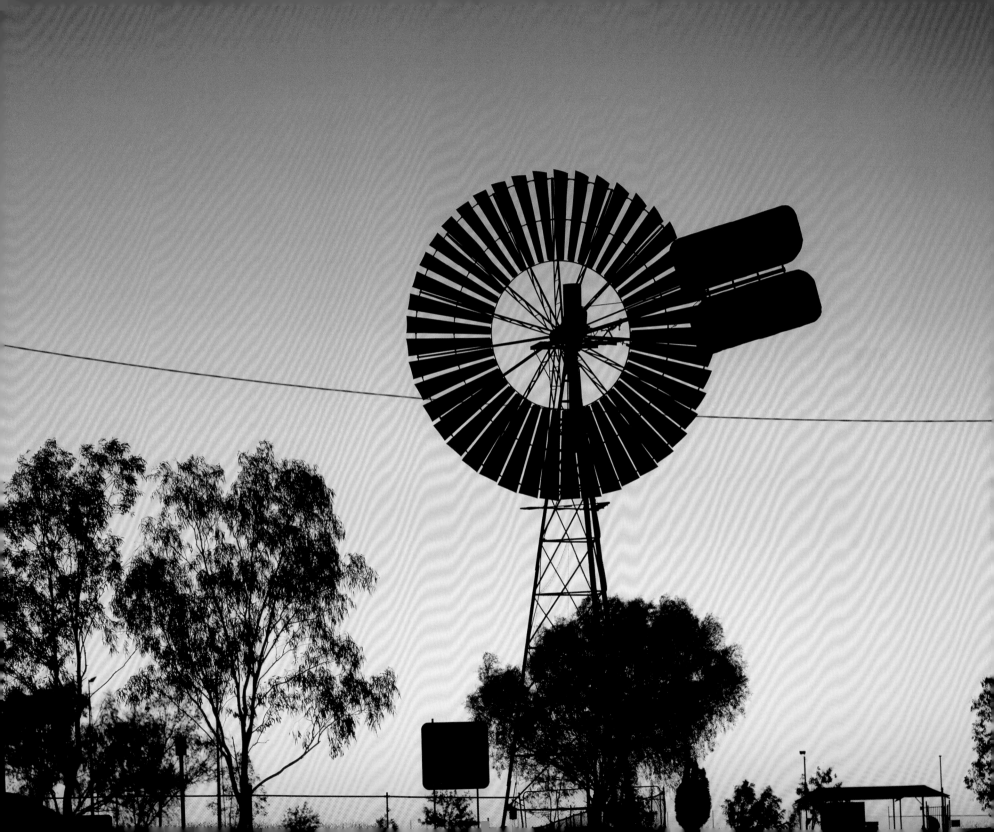

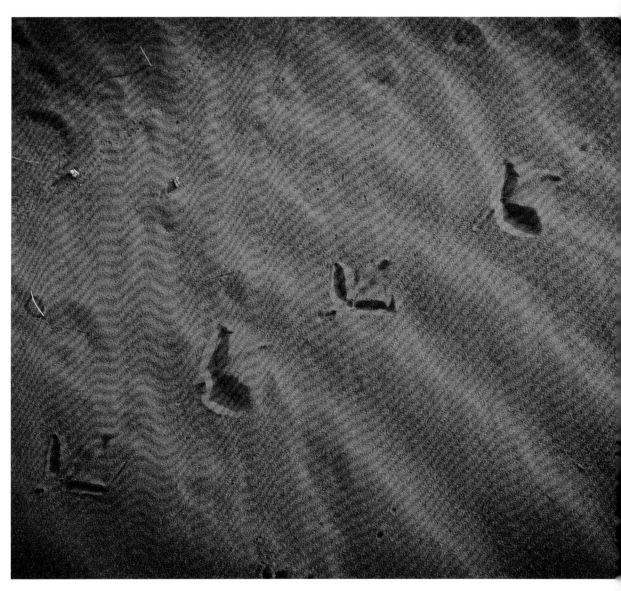

ABOVE *Bare sand retains clear signs of nocturnal visitors, in this case a small bird.*

LEFT *The Sturt Stony Desert lives up to its name: round stones known as 'gibbers' cover much of the ground.*

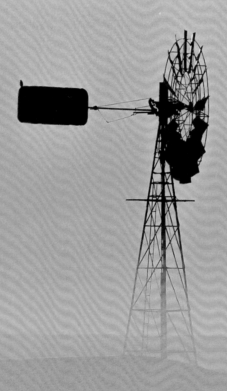

Dust storms like this one at Boulia, Queensland, are a frequent hazard in the desert, especially during drought.

Cravens Peak Reserve

As you travel west through Queensland's interior, the arid regions gradually give way to true deserts. The first of these is the Simpson Desert, with its vast dune systems. West of Boulia, right on the Northern Territory border, lies Cravens Peak Reserve, which encompasses the twin stations of Cravens Peak and Ethabuka. Both were originally cattle stations, but recently they have been de-stocked and allowed to regenerate, and since 2005 they have been managed by Bush Heritage, a privately funded NGO that operates a little bit like a national parks department, in that the preservation of the environment is the underlying motivation for the management of the land.

Cravens Peak Reserve covers 4400 square kilometres of red sand dunes and semi-arid plains. This is classic 'boom or bust' country. It's parched and barren for much of the time, but after rain the whole place springs to life as a surprisingly diverse range of creatures breed, flourish and then die off as the water gradually recedes.

Like so many desert regions, Cravens Peak rewards the careful observer. There are no spectacular cliffs or towering mountains, no waterfalls or old-growth forests. At first glance, it's mostly just nondescript scrub covering rust-red dunes. But look closely and you'll see tiny but exquisite flowers, a wide variety of birds and lots of animal tracks.

At night the creators of these tracks emerge. There are big populations of marsupials and reptiles – hopping mice, mulgaras, dunnarts, woma pythons, perenties, and so on. Bush Heritage researchers operate dead-fall traps during the night, as part of their regular surveys of local wildlife.

One of the most intriguing aspects of such an apparently 'dead' place is the way the inter-dunal flats flood and spring back to life after decent rains. You'd expect migratory birds to find the good waterholes, but there are also fish in these ephemeral lakes – no fewer than 33 species have been recorded. One of the researchers I met when visiting Ethabuka is a specialist in desert fish ecology; he told me that, although little is known about them, fish are a significant part of the local food chain. It felt distinctly odd to be entering the edge of the Simpson Desert armed with large fishing nets!

...tiny but exquisite flowers, a wide variety of birds and lots of animal tracks

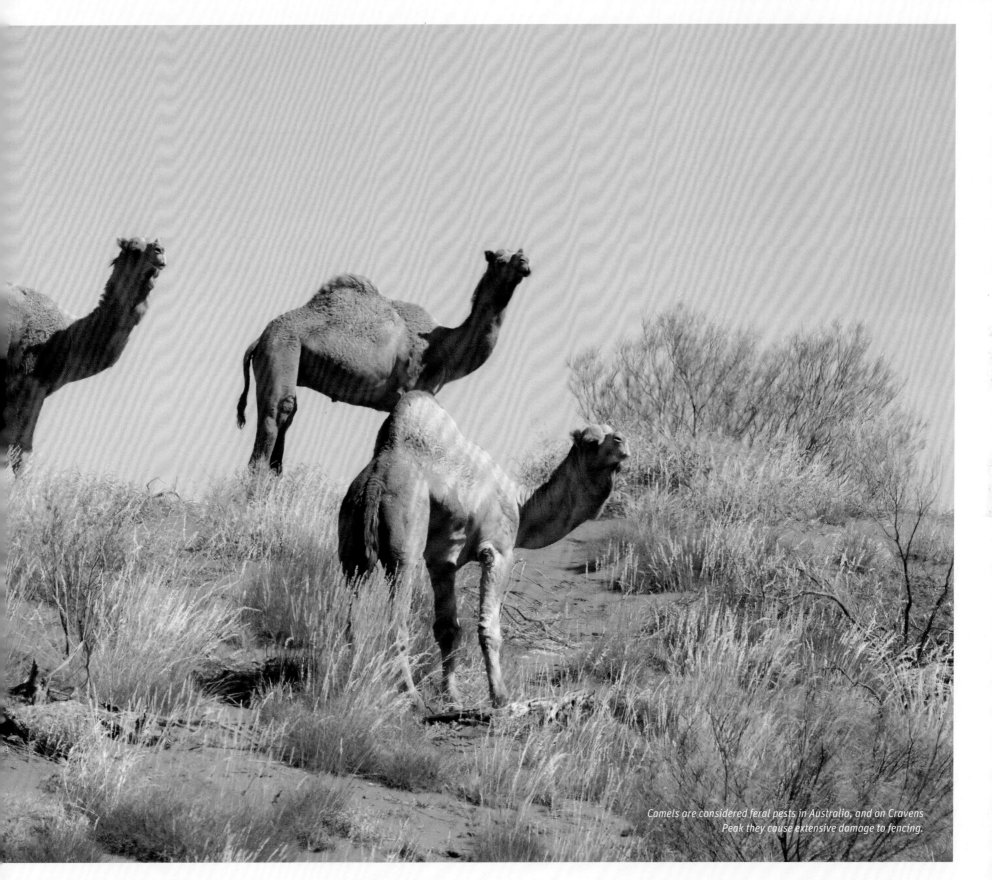

Camels are considered feral pests in Australia, and on Cravens Peak they cause extensive damage to fencing.

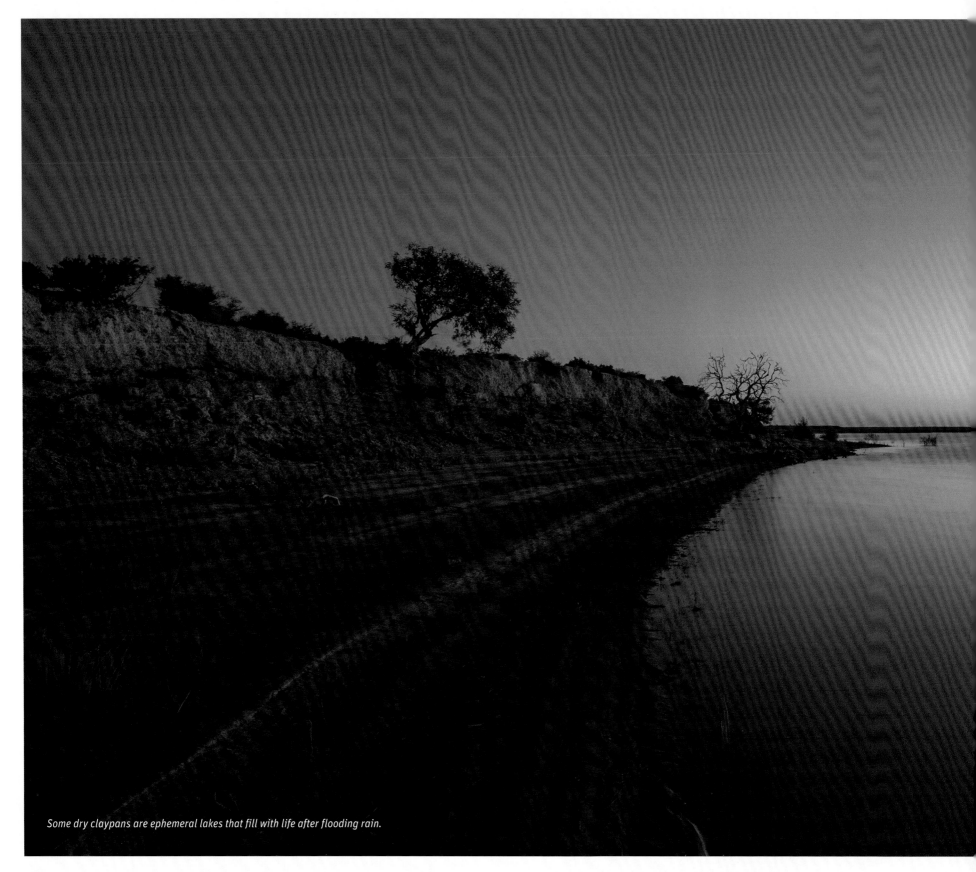

Some dry claypans are ephemeral lakes that fill with life after flooding rain.

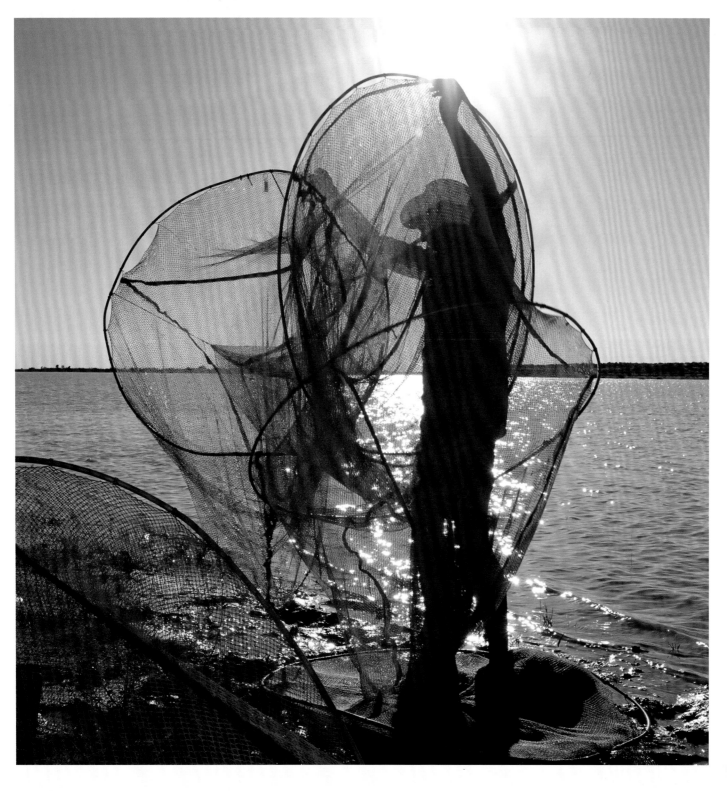

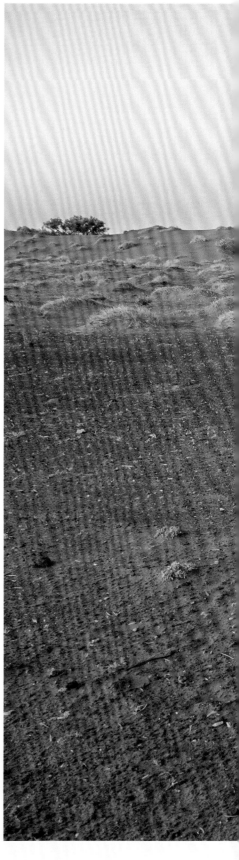

ABOVE *After heavy rain, in an almost miraculous ecological event, huge numbers of freshwater fish appear in desert lakes.*

RIGHT *During dry spells, it's hard to imagine that anything can survive here, but nature will always find a way.*

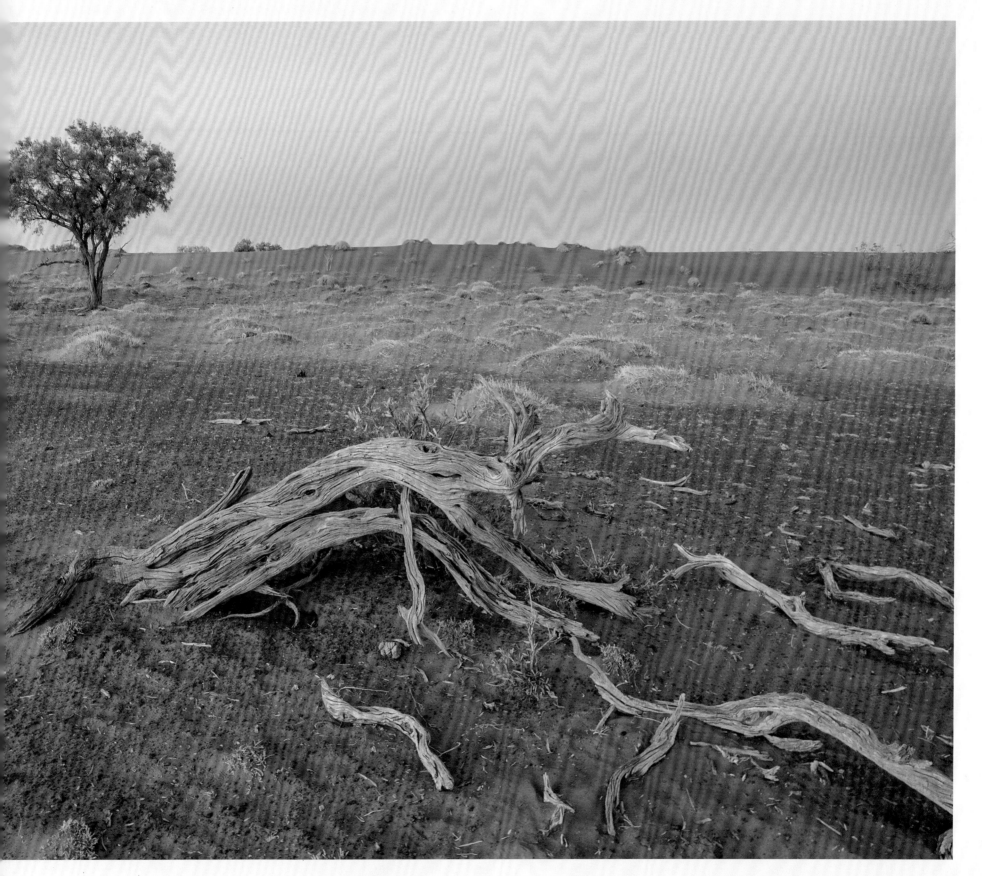

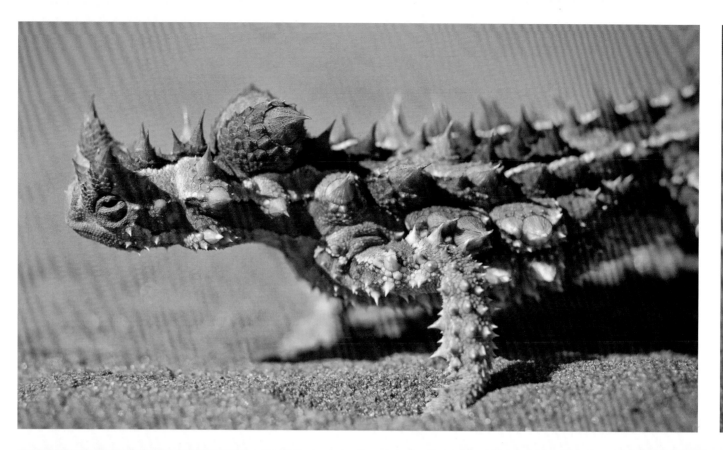

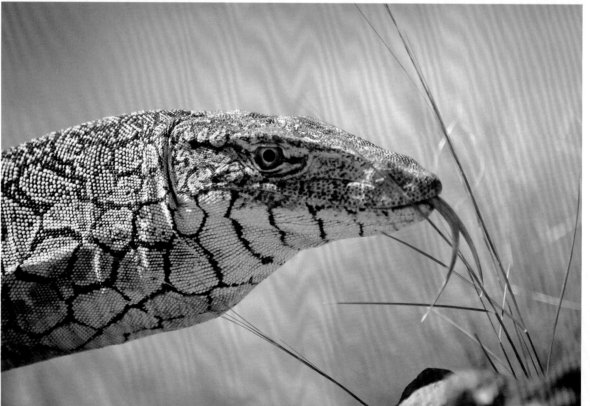

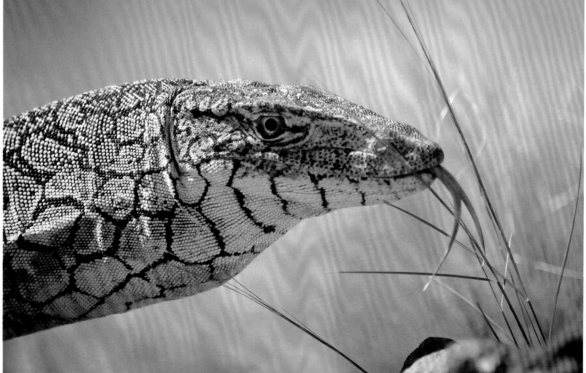

For such an apparently barren area, the Simpson Desert is teeming with wildlife – if you know where to look.
CLOCKWISE FROM TOP LEFT
A thorny devil; a dunnart; sedges on Ethabuka Station after rain; a tadpole shrimp; and a perentie lizard.

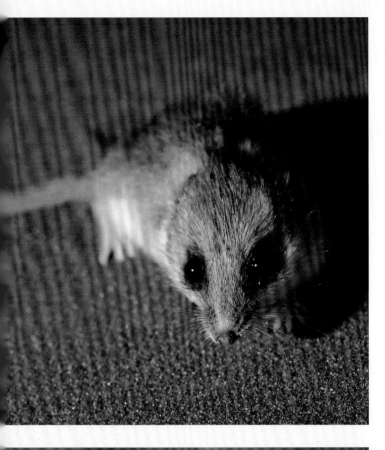

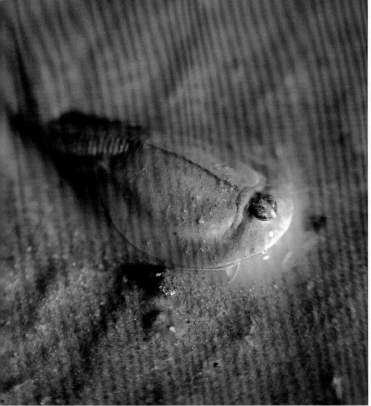

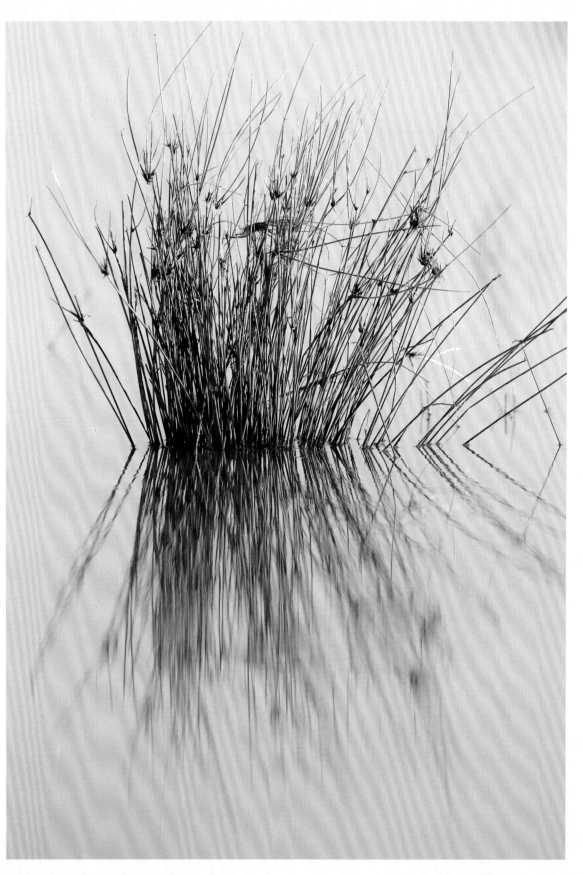

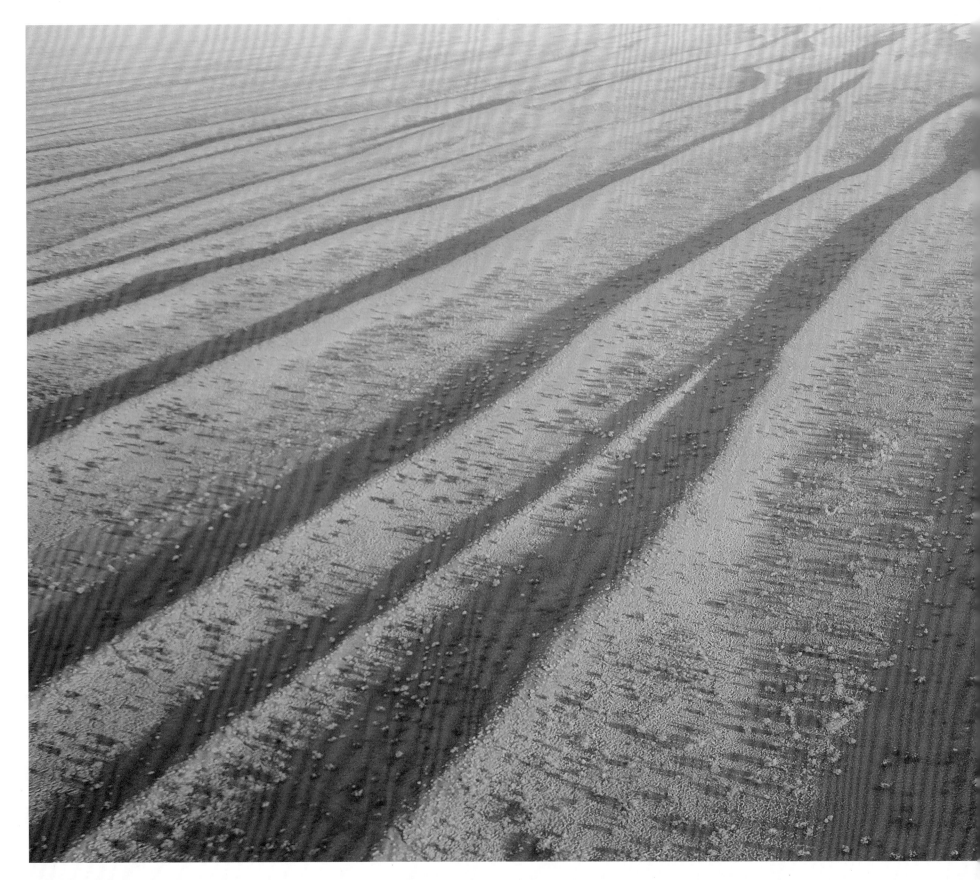

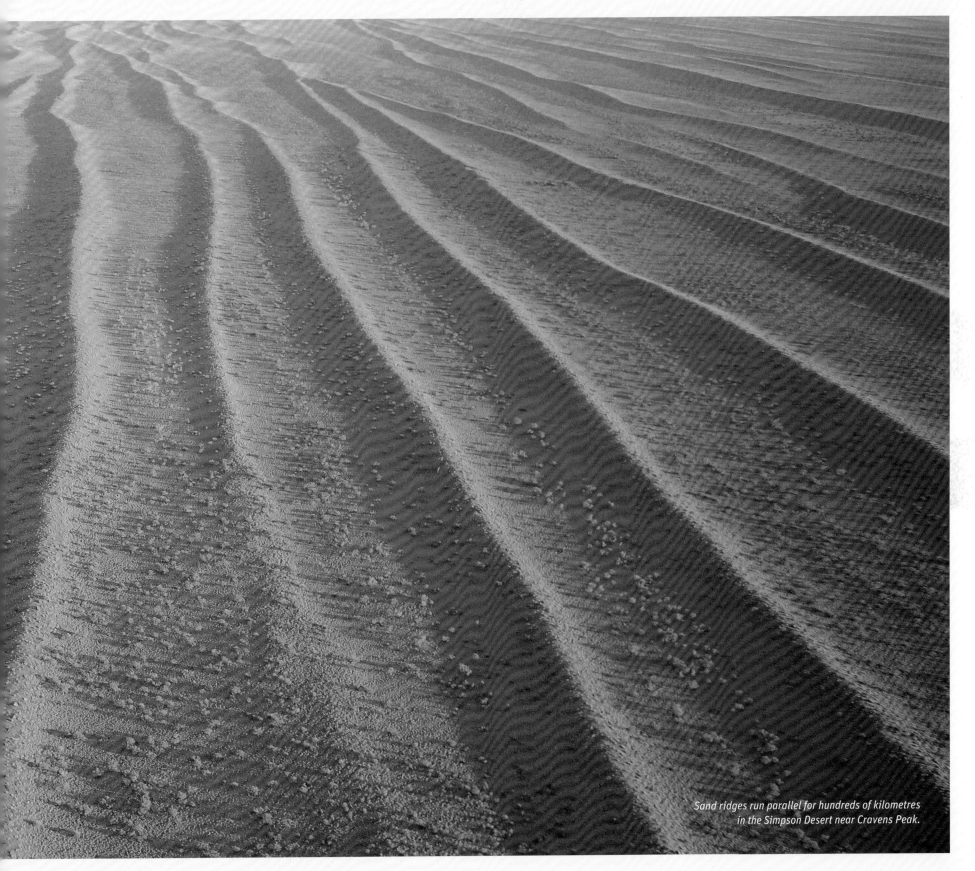

Sand ridges run parallel for hundreds of kilometres in the Simpson Desert near Cravens Peak.

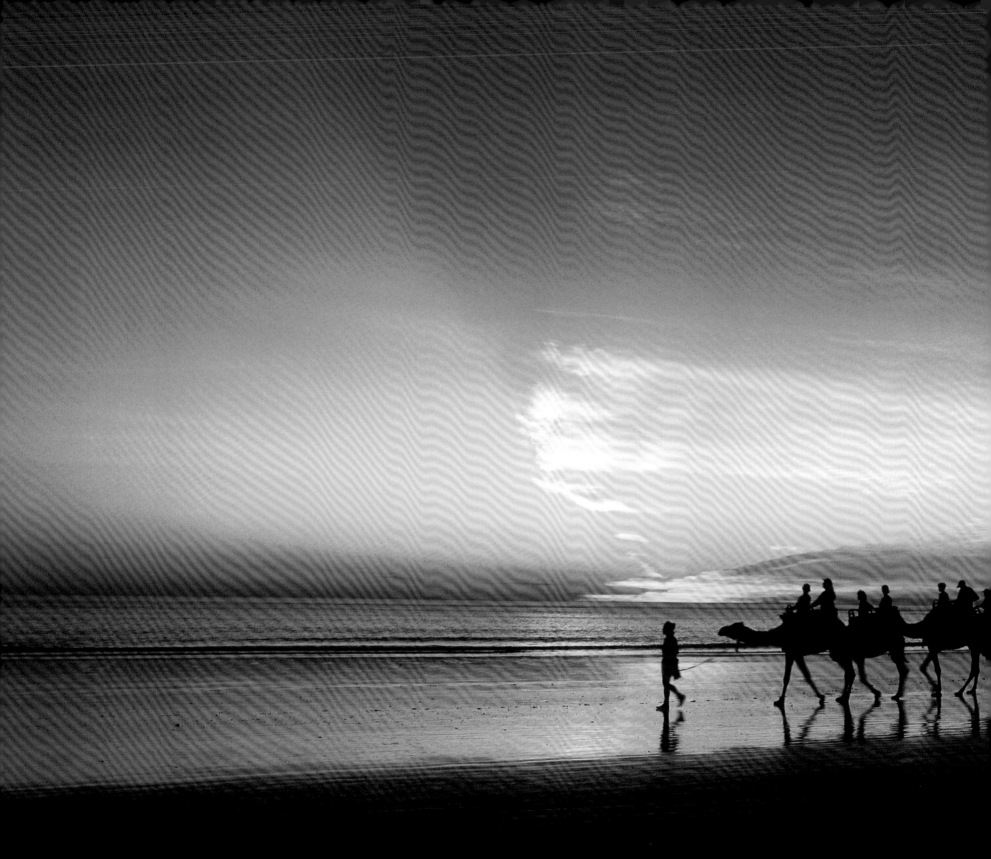

The desert meets the sea along the Western Australian coastline south of Broome.
How appropriate to take a 'ship-of-the-desert' ride here, along Cable Beach!

WEST

WESTERN AUSTRALIA COVERS 2.5 million square kilometres, an area only a little smaller than Argentina. Two-thirds of the state is classified as arid, and six of the ten named Australian deserts lie within or across its borders.

Not surprisingly therefore, Western Australia is a very sparsely populated state, with the majority of the 2.5 million inhabitants occupying the fertile south-west corner. On average there is about one human being per square kilometre, which makes Western Australia one of the least densely populated places on Earth.

So it's big and barren, but it also includes some of the most striking and remote of Australia's amazing landscapes, and when I look back at my photo collection I see that I have a disproportionate number of images of Western Australia, taken over many visits. I guess I must really like the place!

One particular experience sprang to mind as I looked though my images for this book. I was working on another book for this same publisher, called *Explore Australia by Four Wheel Drive*, shooting images and creating trek notes for the second edition. I was passing through the hottest place in Australia, Marble Bar, heading for the coast and Highway One up to Broome. I noticed on the maps that there was a back road that cut off a big corner of the highway, via the mostly deserted old iron-ore-mining town of Shay Gap and a break in the ranges called Kitty's Gap.

Because it was getting towards dusk, I thought I'd camp the night at Kitty's Gap, which turned out to be a pleasant spot near some rocky ridges. I set up a campfire and took some photos – what we'd now call 'selfies', but slightly more sophisticated in that they involved a tripod, a self-timer and a lot of running (I was on my own, you see).

After that, I settled down for the night and realised it was utterly still: there was not the tiniest breath of wind, not a cloud in the sky, no sound whatsoever and no moon either. It's funny what you remember, because this was back in the early 1990s, 20 years ago at least. But I clearly remember the dead weight of silence and this delightful frisson of being

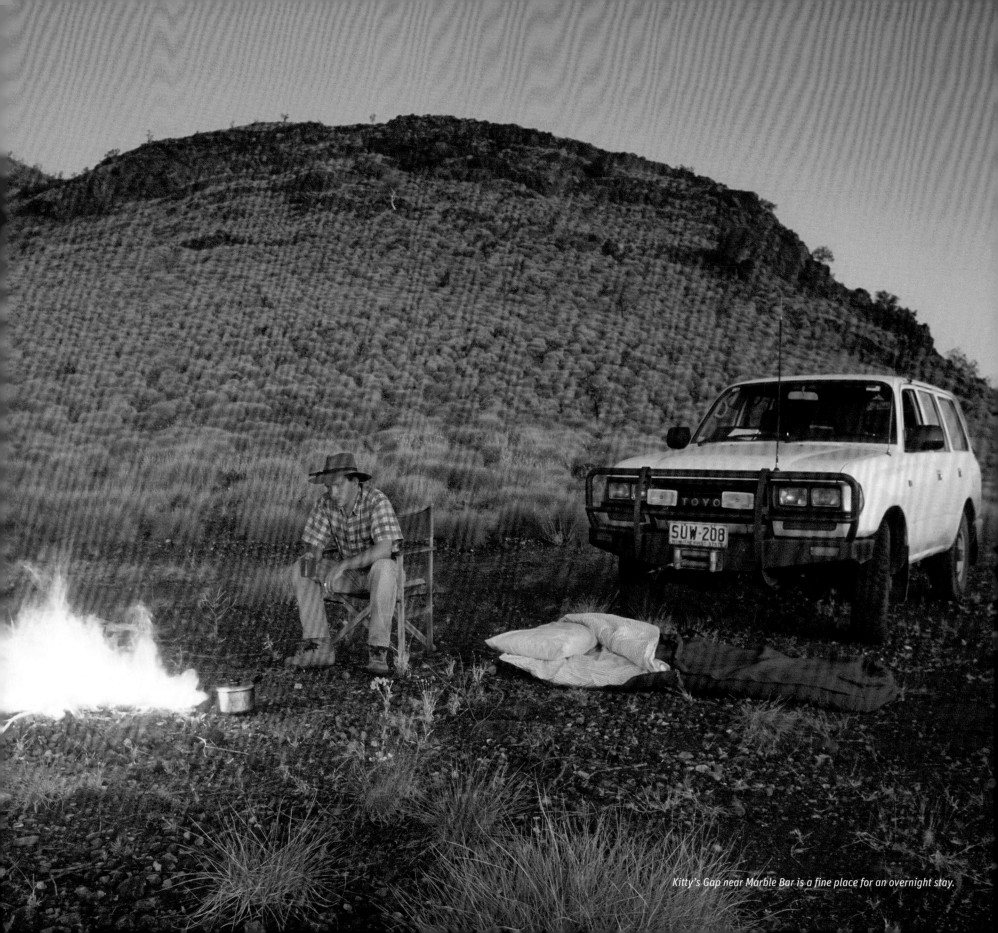

Kitty's Gap near Marble Bar is a fine place for an overnight stay.

completely alone – there would have been no-one within a hundred kilometres – and I loved it.

Since then, I have spent a lot more time travelling the wilds of Western Australia, sometimes alone, but mostly, these days, with my wife. And I still enjoy that sensation of remoteness – something Western Australia has in spades.

RIGHT The black kite is a common sight in the arid regions of Australia.

BELOW Crested pigeons puff up their feathers to keep warm on a cold morning.

CENTRE RIGHT A dragonfly clings to a reed stem at Jirndawurrunha Pool, Millstream–Chichester National Park, Pilbara.

FAR RIGHT A willie wagtail perches on a kangaroo in Millstream–Chichester National Park, Pilbara.

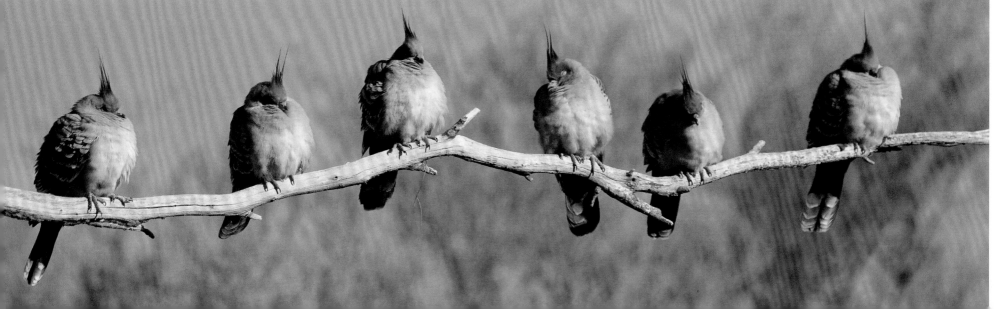

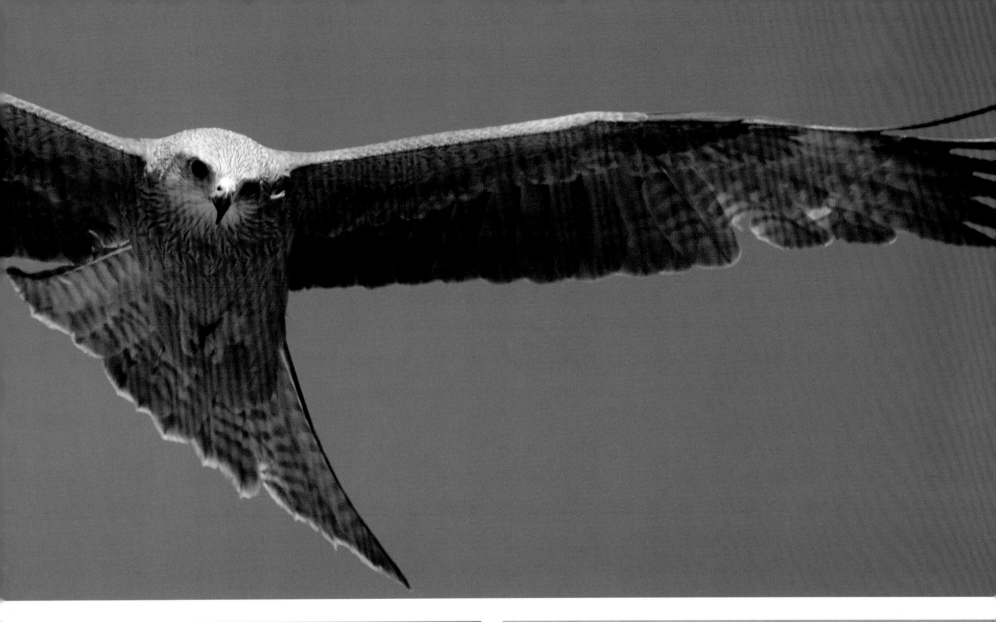

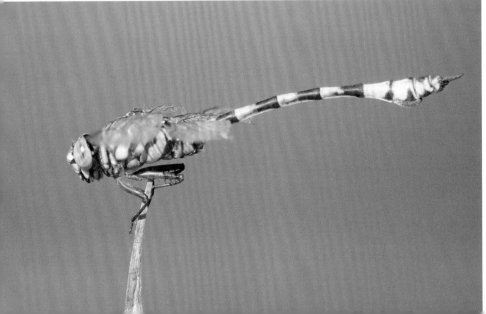

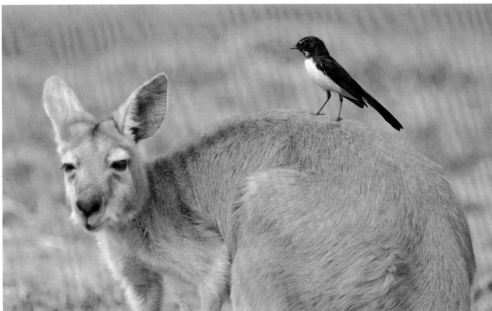

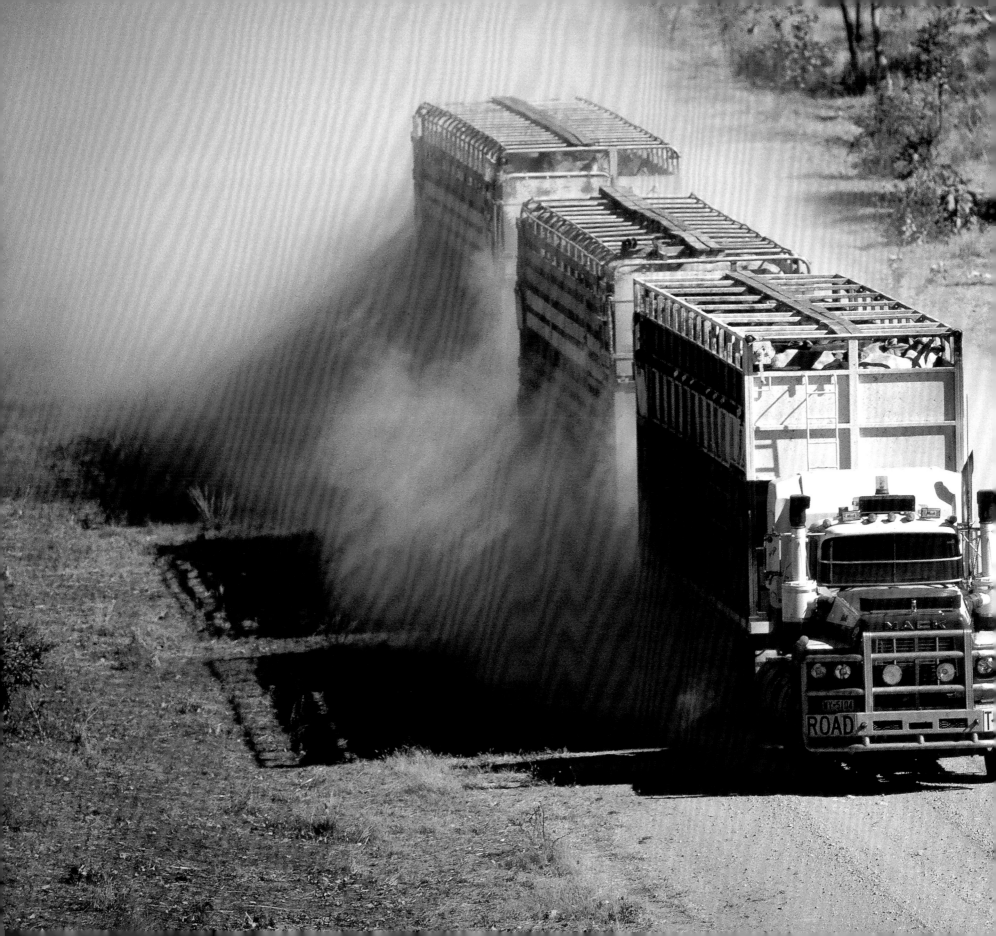

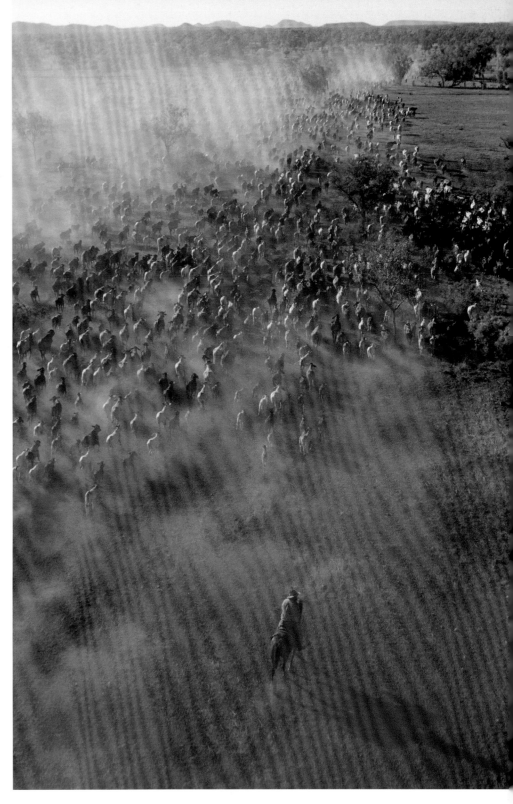

ABOVE On many outback stations, mustering is still done the old way – on horseback.

LEFT These days, the most efficient way to get cattle out of remote stations is on huge road trains, which can be up to 50 metres long.

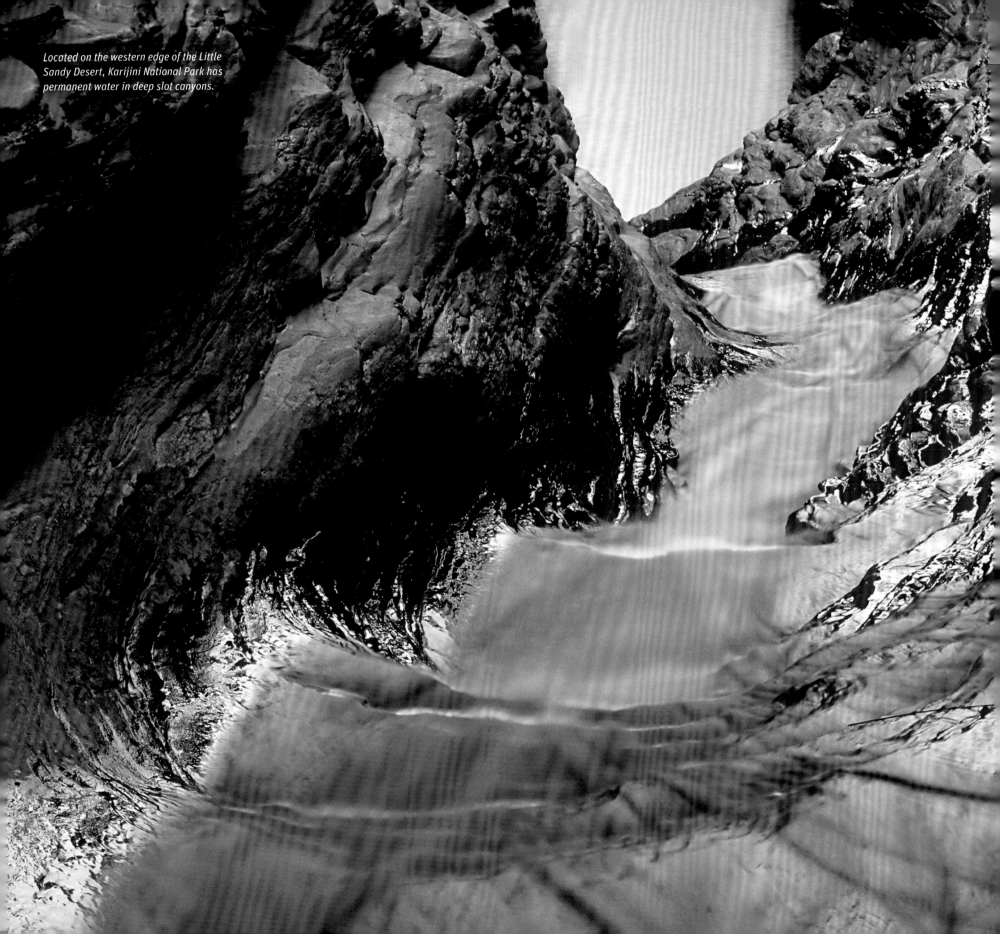

Located on the western edge of the Little Sandy Desert, Karijini National Park has permanent water in deep slot canyons.

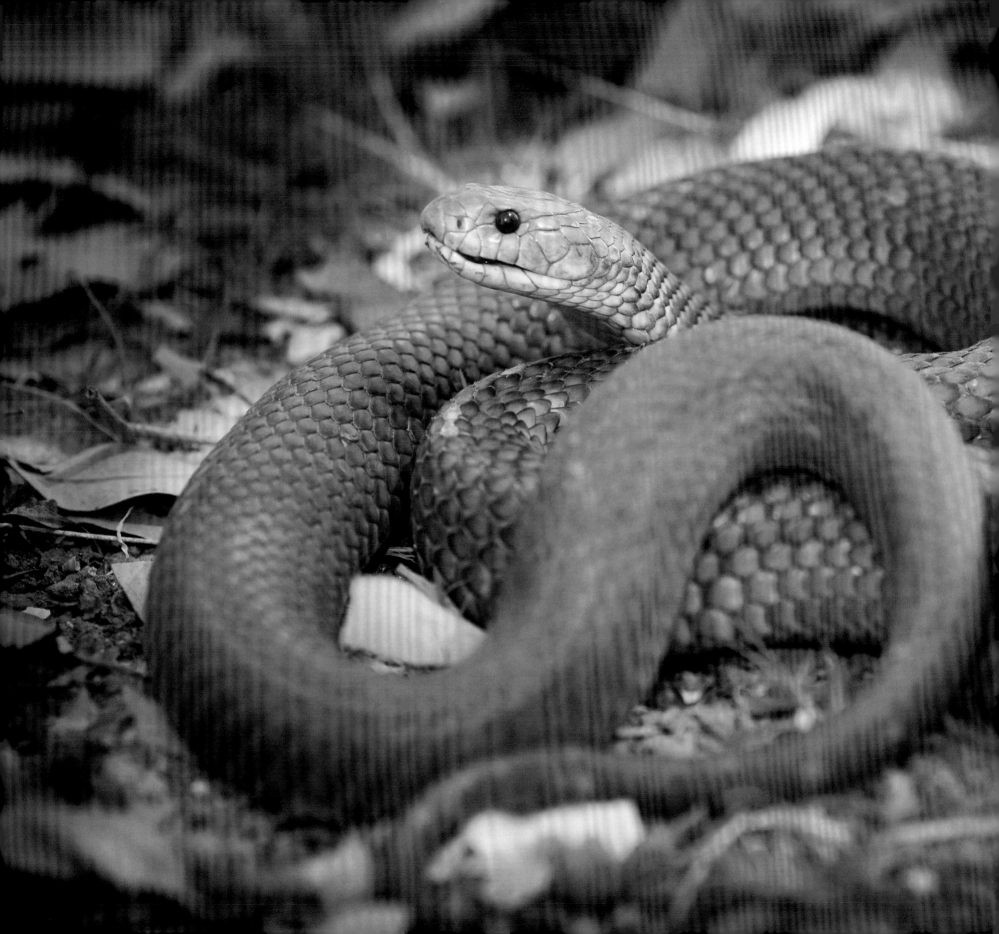

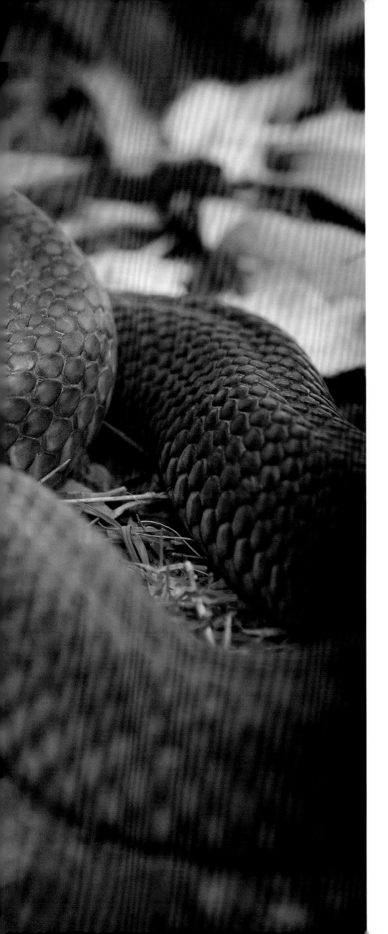

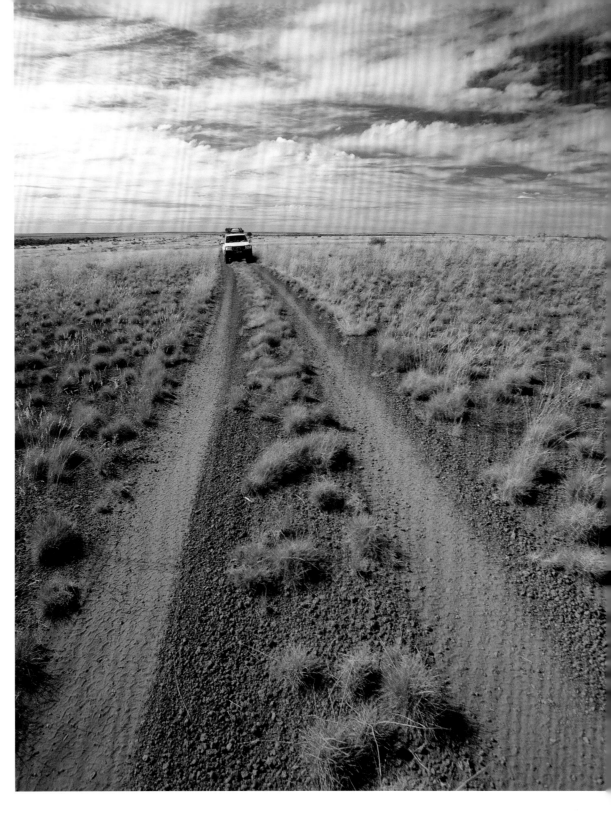

ABOVE *The old Gunbarrel Highway crosses the Gibson Desert in one of the most remote parts of Western Australia.*

LEFT *The western brown snake is one of the more dangerous residents of the desert, and quite common elsewhere too.*

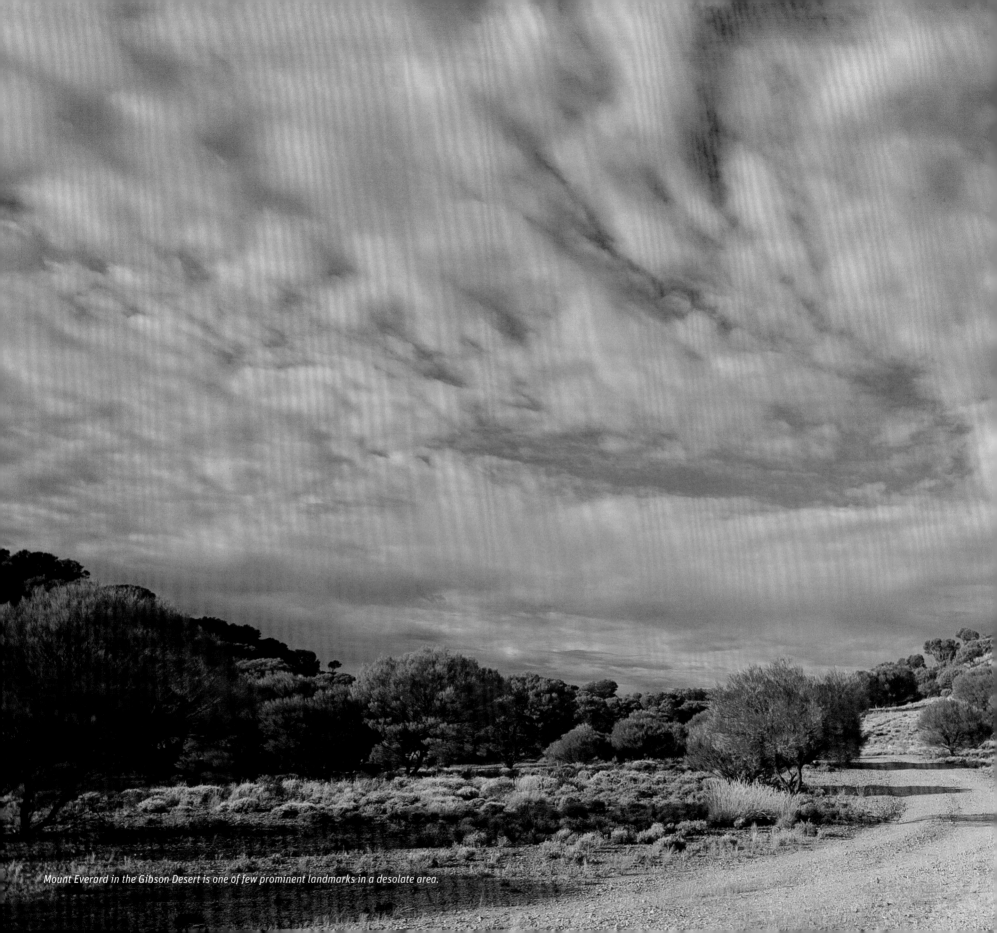
Mount Everard in the Gibson Desert is one of few prominent landmarks in a desolate area.

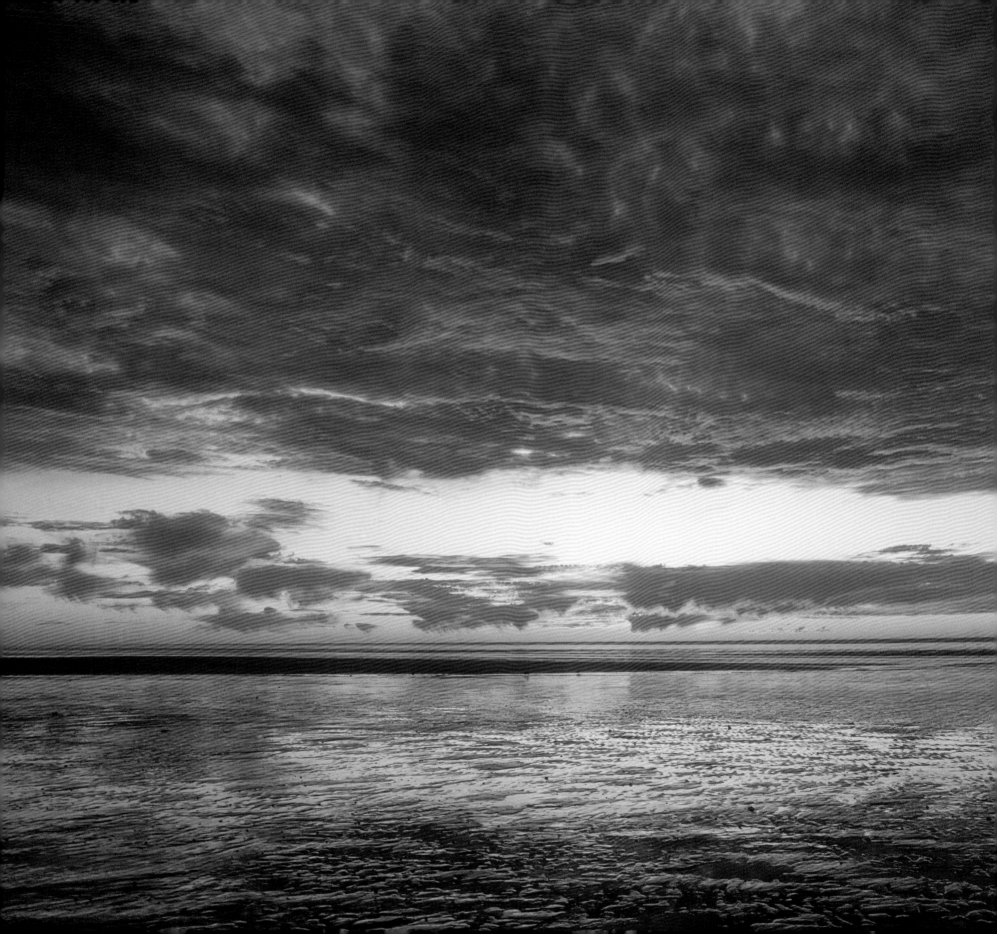

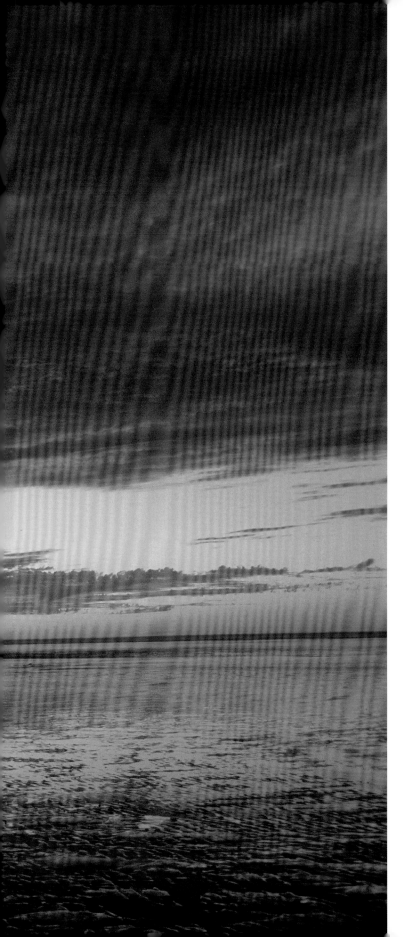

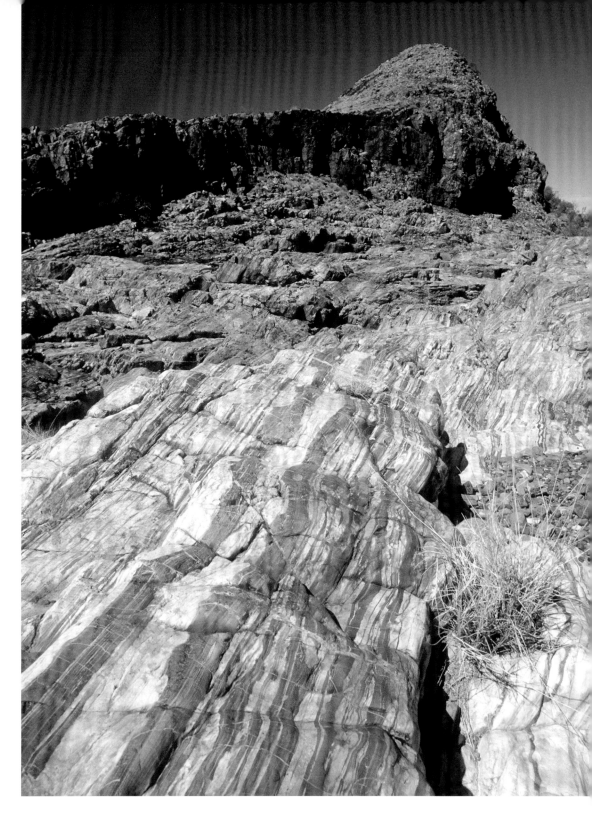

ABOVE *The town of Marble Bar in the Pilbara is named after this marble-like rock – actually a type of jasper – found in the nearby Coongan River.*

LEFT *Eighty Mile Beach forms the north-western edge of the Great Sandy Desert.*

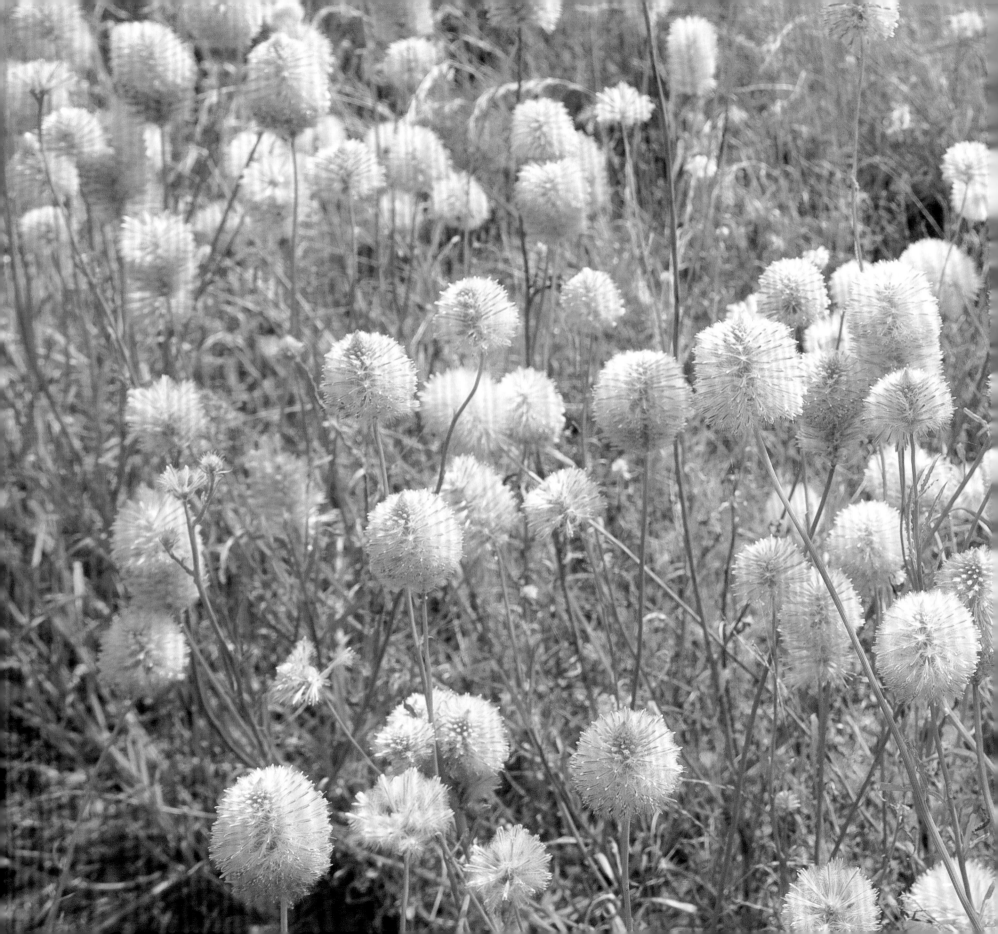

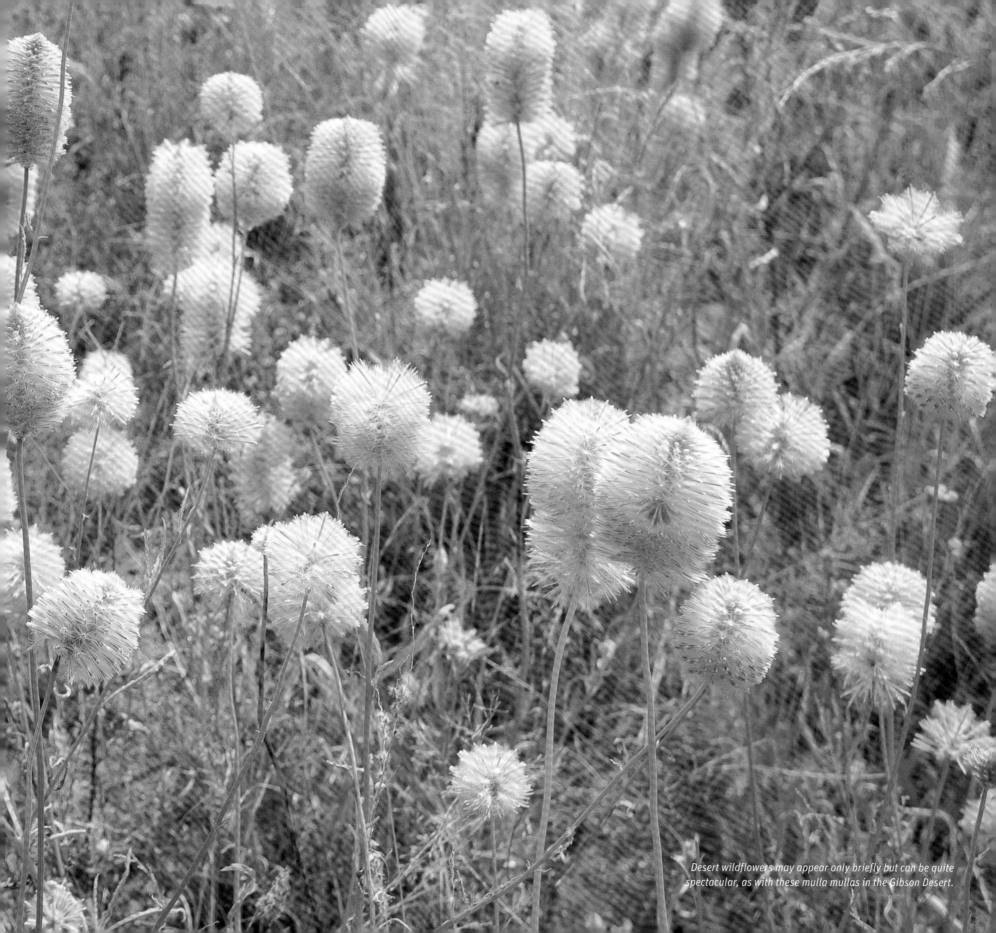

Desert wildflowers may appear only briefly but can be quite spectacular, as with these mulla mullas in the Gibson Desert.

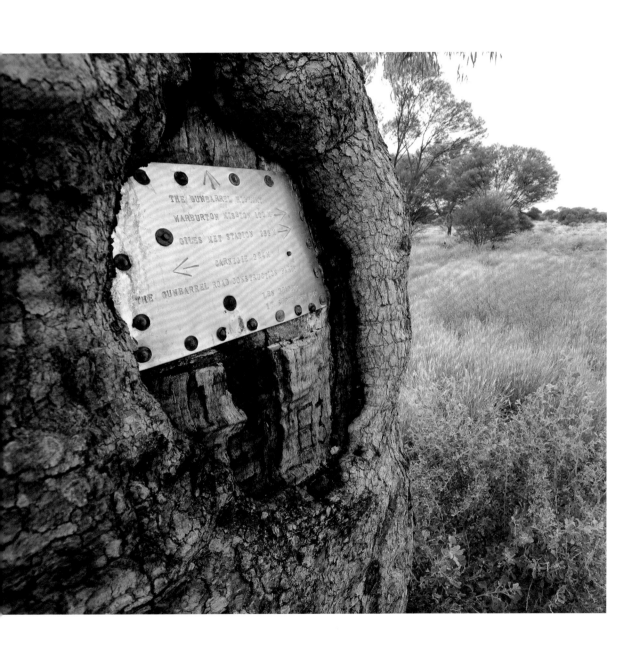

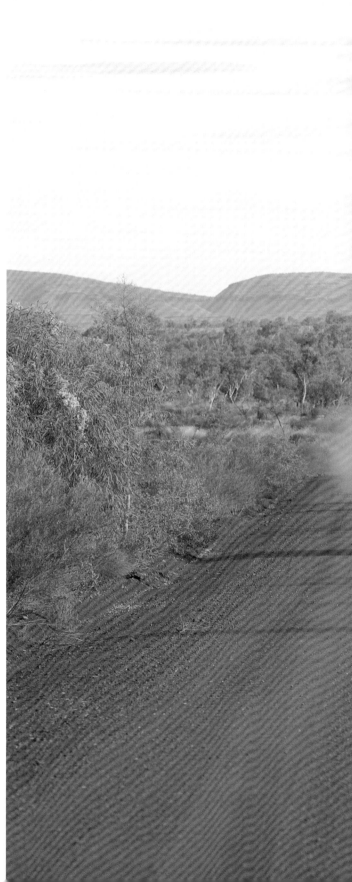

ABOVE Len Beadell left this plaque on the Gunbarrel Highway back in the late 1950s, when he was surveying for the military.

RIGHT Some outback roads, like the Gunbarrel Highway, can be surprisingly well maintained and smooth – at least in places.

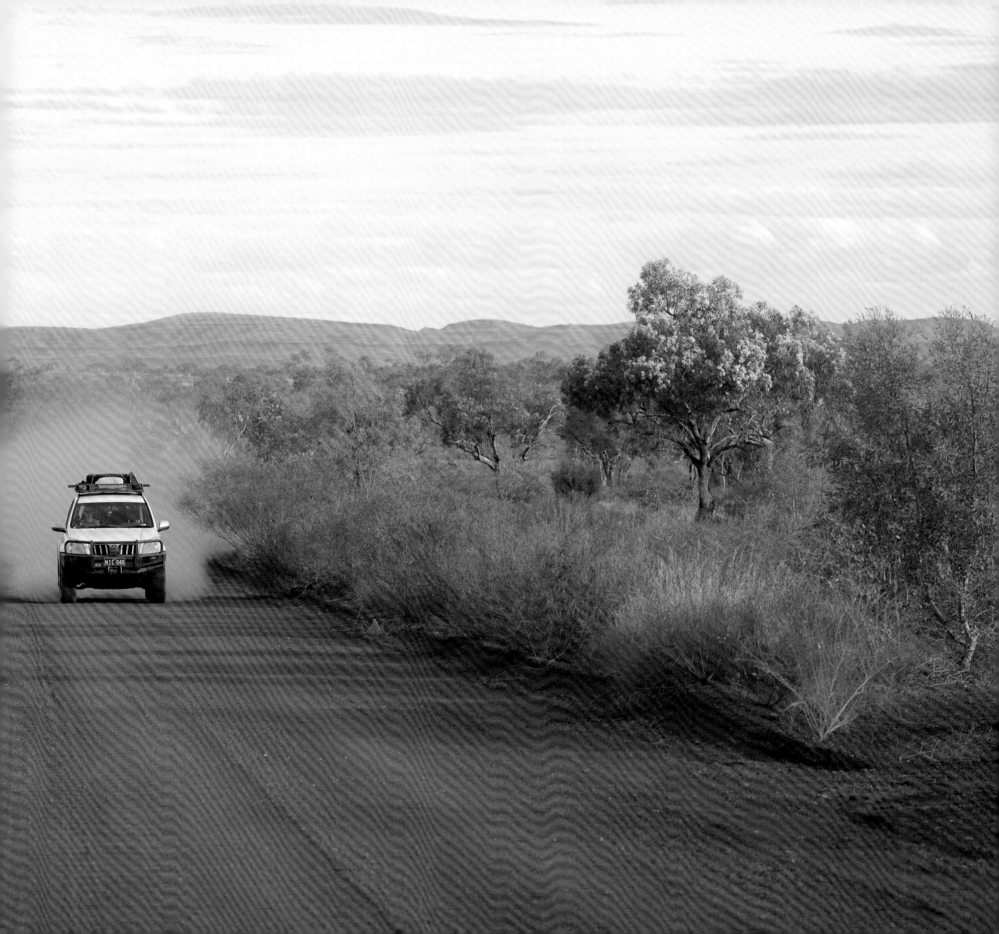

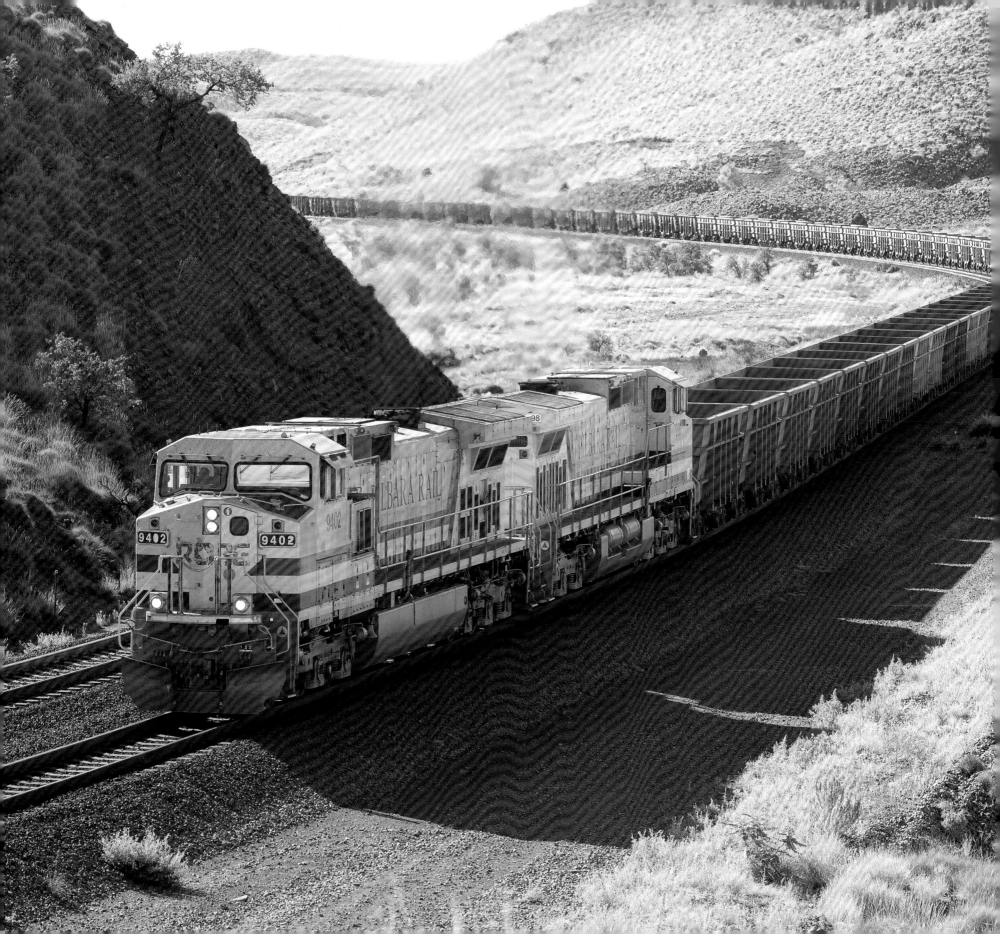

ABOVE *The small desert oasis of Millstream, in the Pilbara, is fed by permanent freshwater springs of amazing clarity.*

LEFT *The massive iron ore mines of the Pilbara require enormous trains to carry the ore to the coastal ports.*

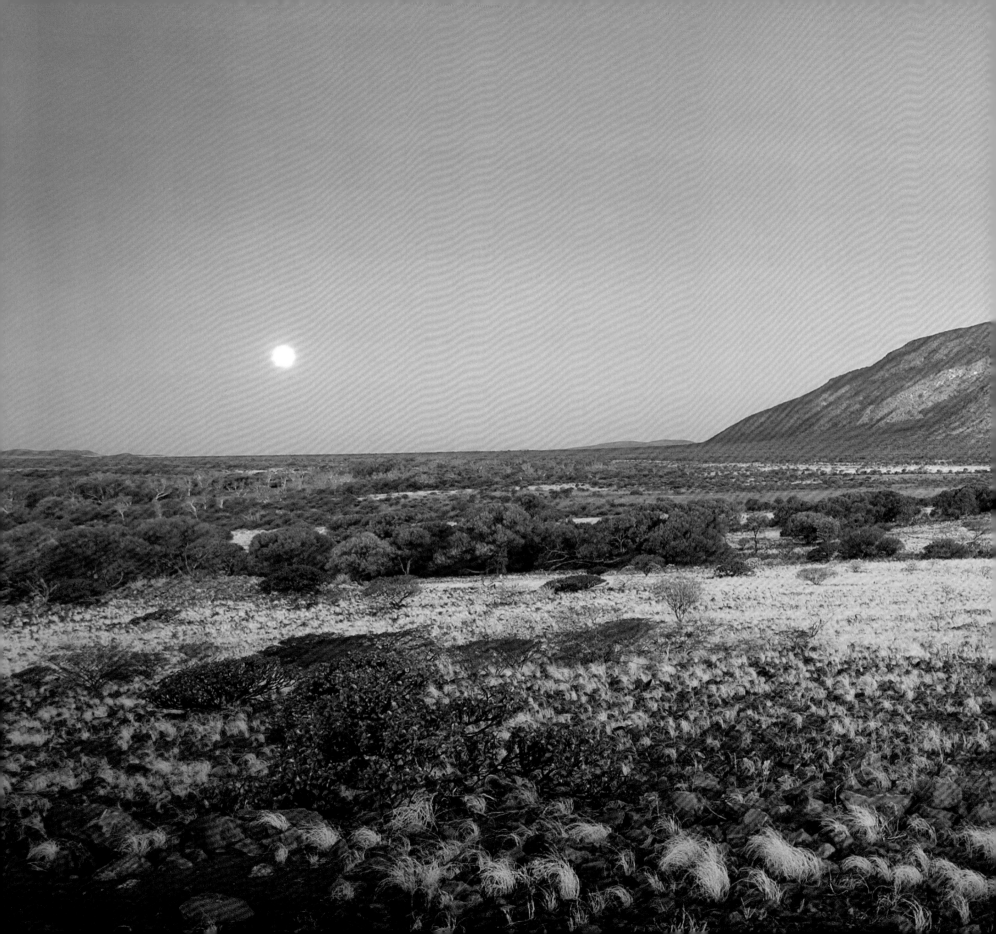

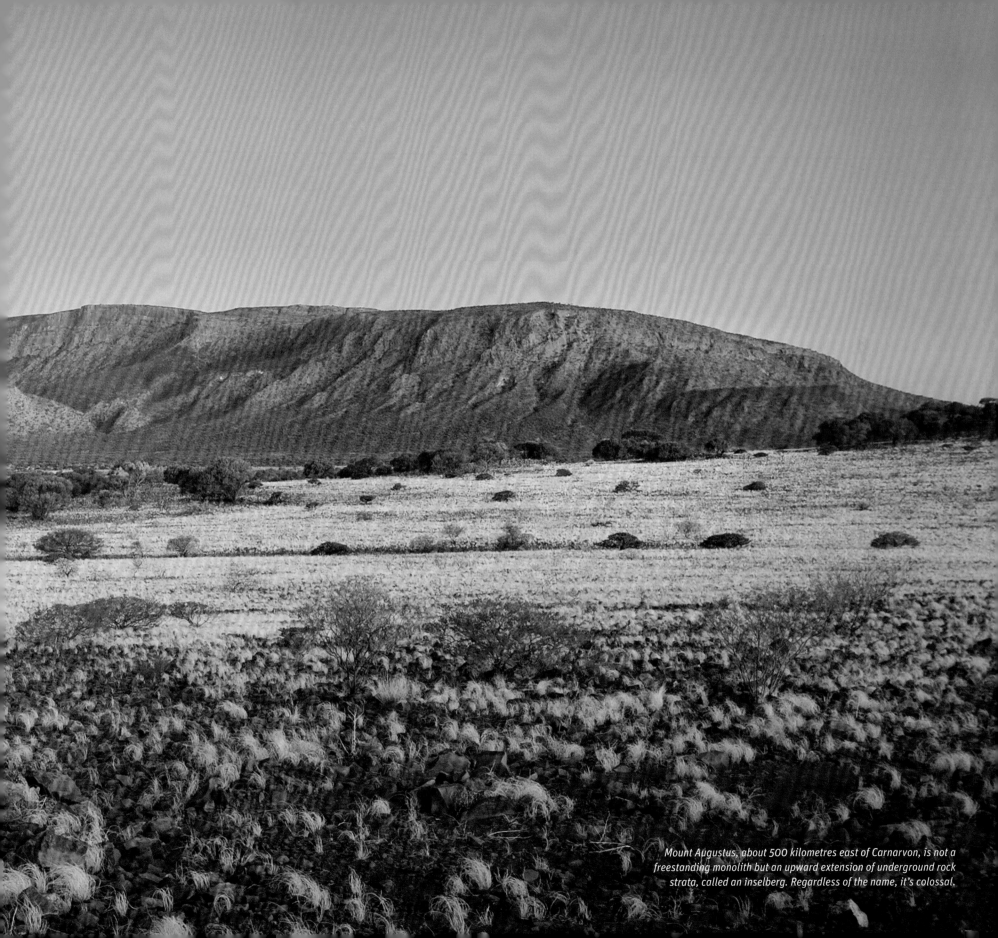

Mount Augustus, about 500 kilometres east of Carnarvon, is not a freestanding monolith but an upward extension of underground rock strata, called an inselberg. Regardless of the name, it's colossal.

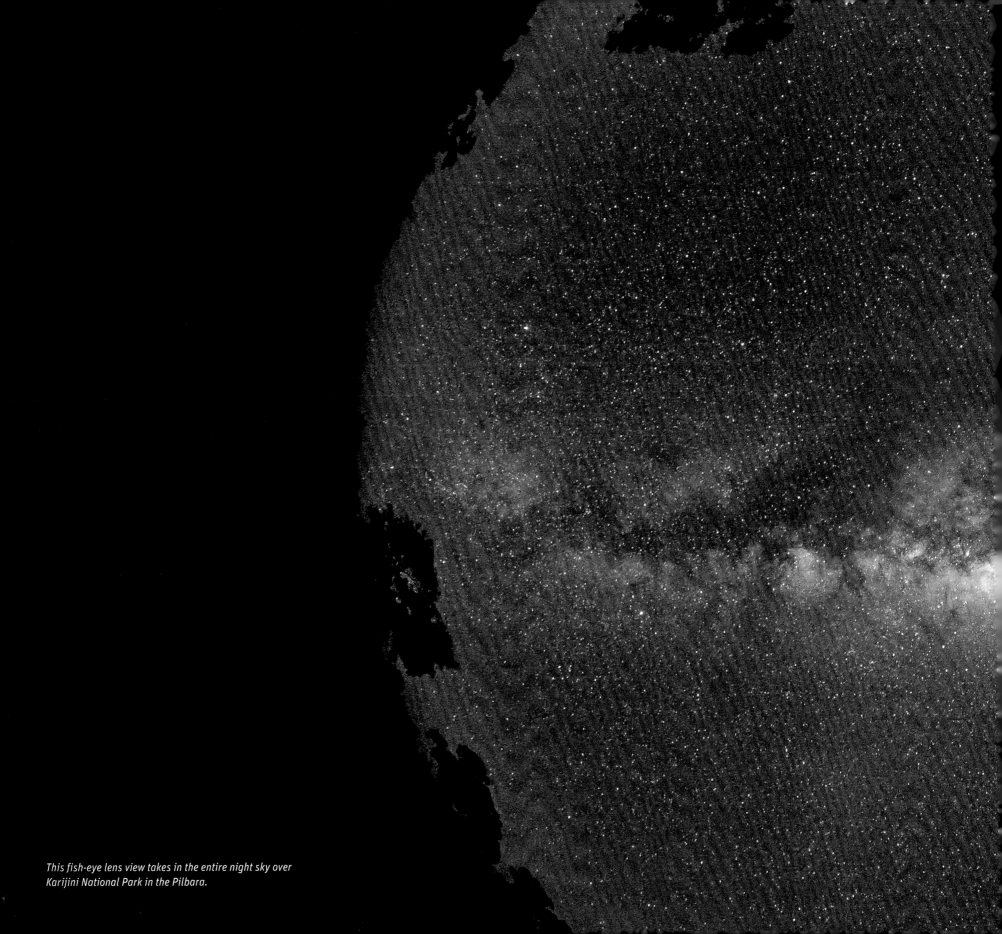

This fish-eye lens view takes in the entire night sky over Karijini National Park in the Pilbara.

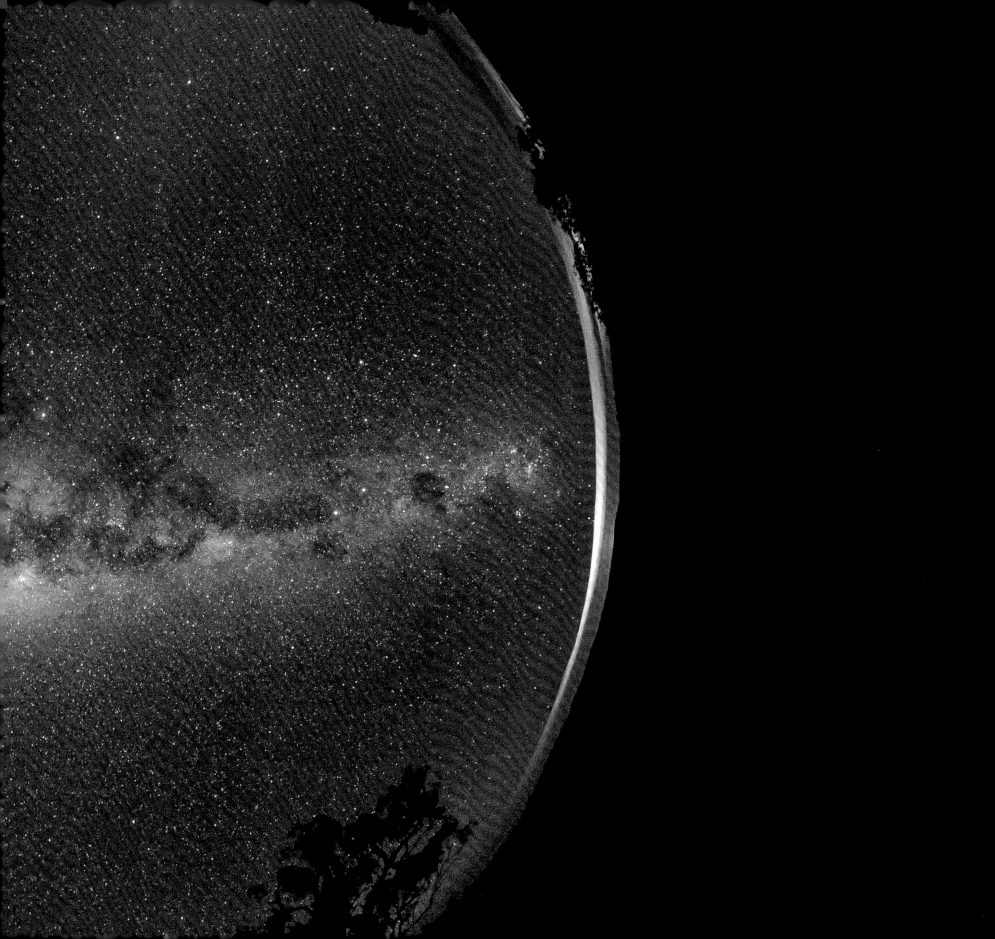

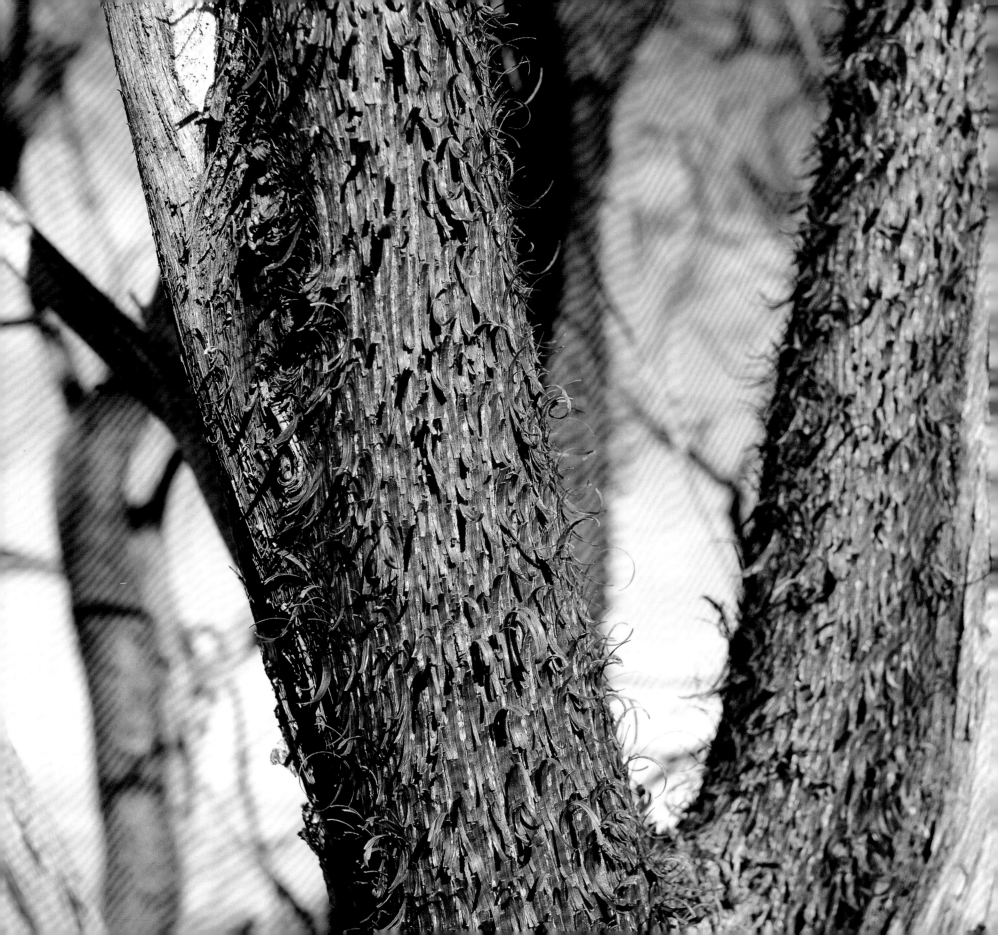

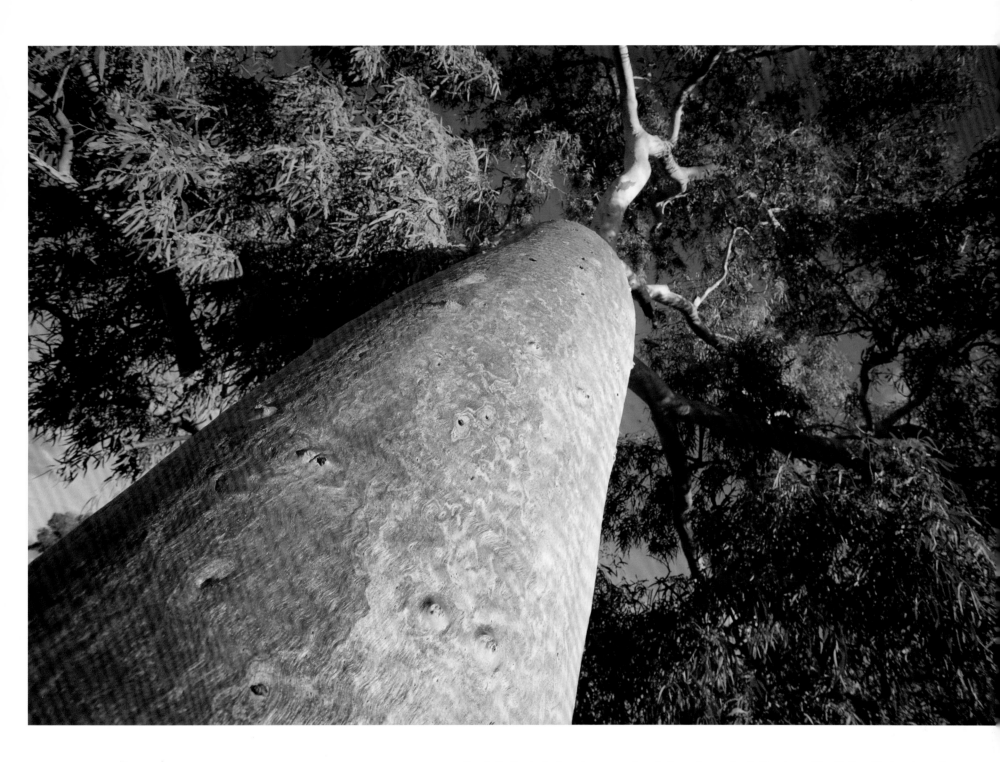

ABOVE *The distinctive bark of a salmon gum glows in the early morning light on Lorna Glen Station, Western Australia.*

OPPOSITE *A close-up of a red mulga tree in the western Little Sandy Desert reveals its coarse, almost bristly bark.*

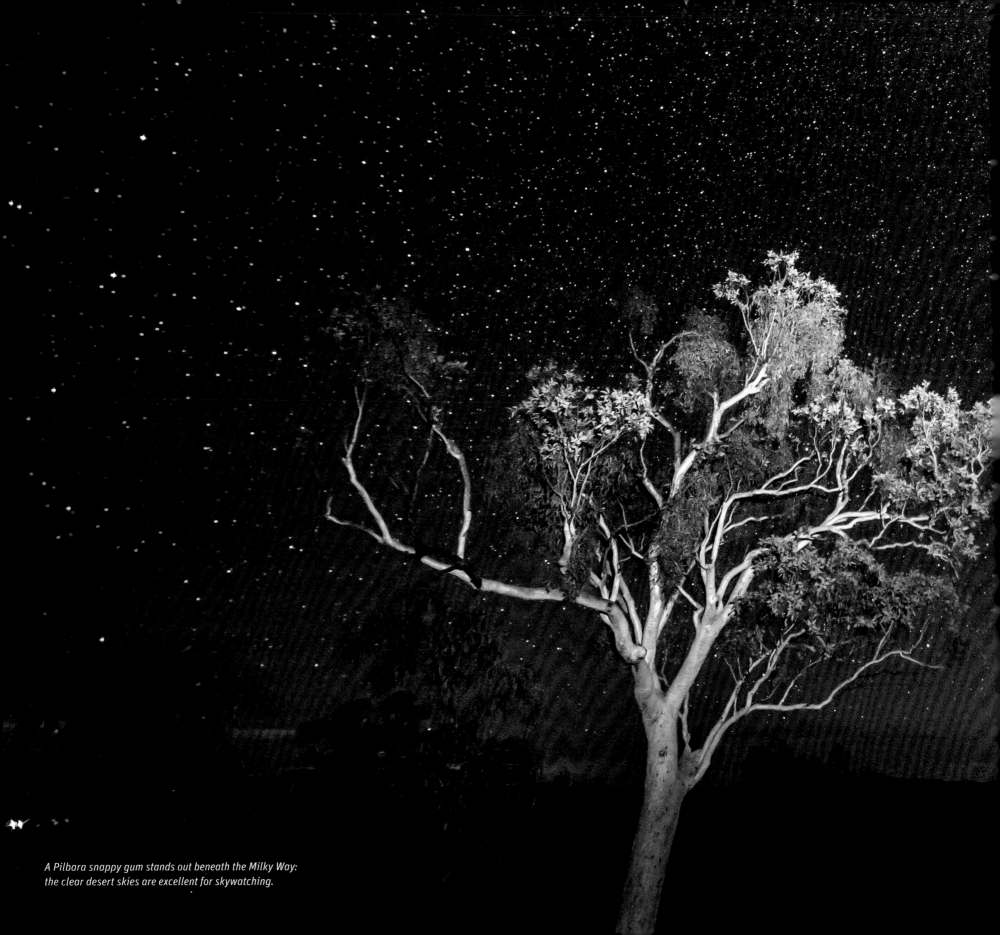

A Pilbara snappy gum stands out beneath the Milky Way:
the clear desert skies are excellent for skywatching.

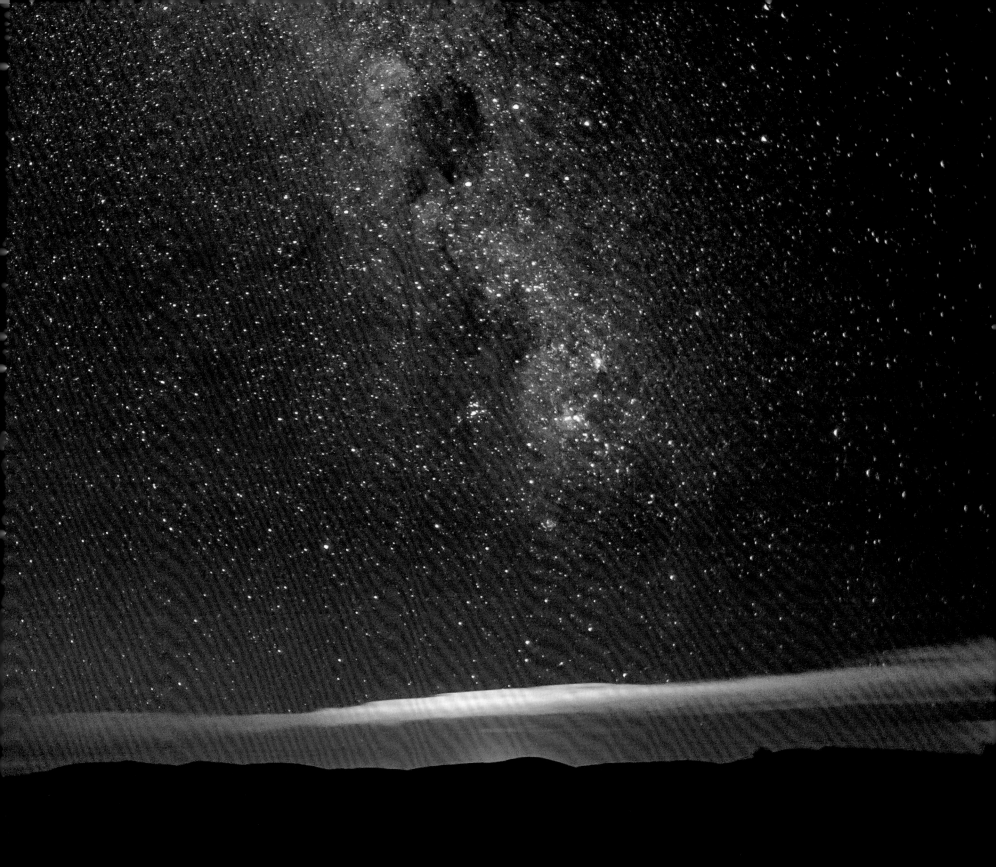

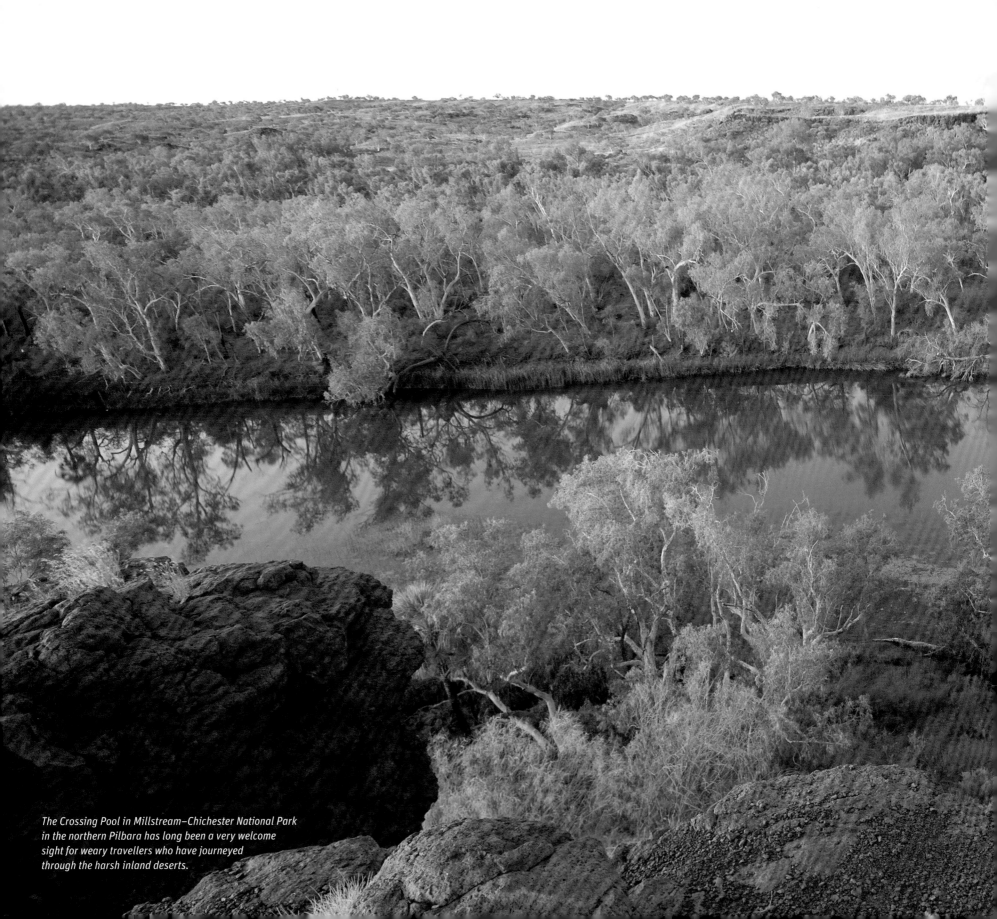

The Crossing Pool in Millstream–Chichester National Park in the northern Pilbara has long been a very welcome sight for weary travellers who have journeyed through the harsh inland deserts.

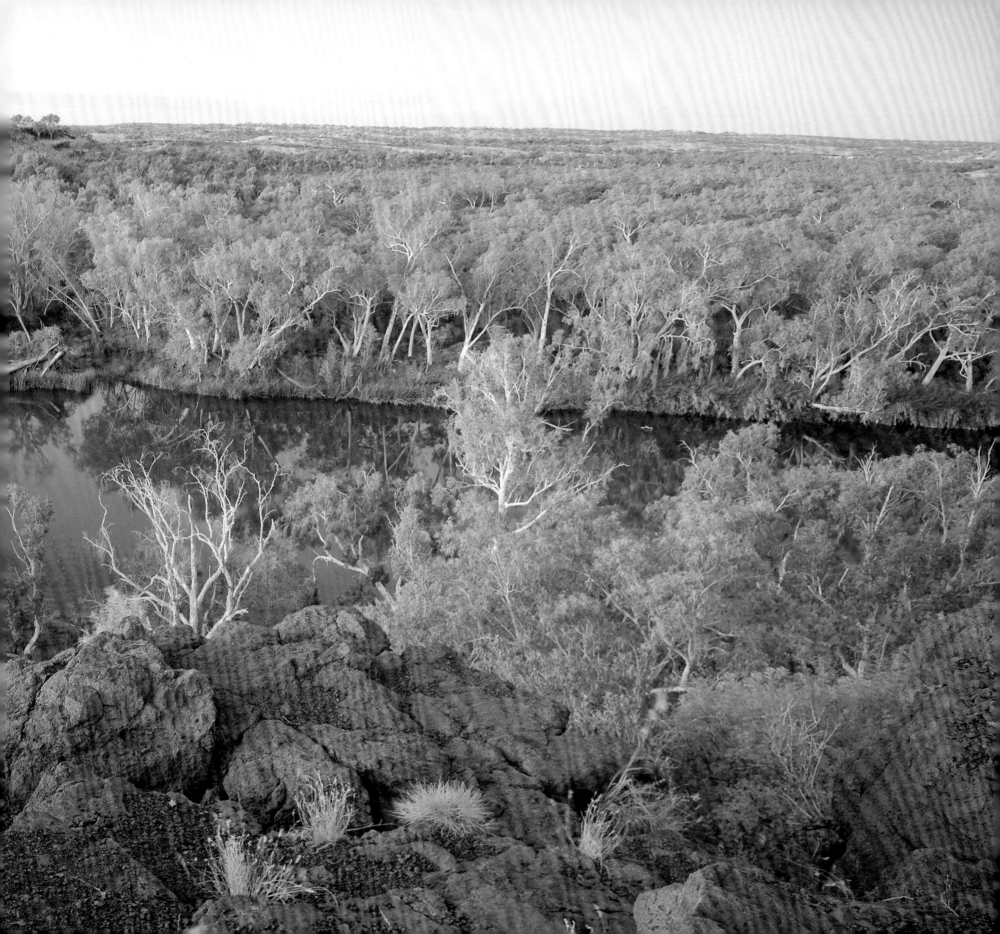

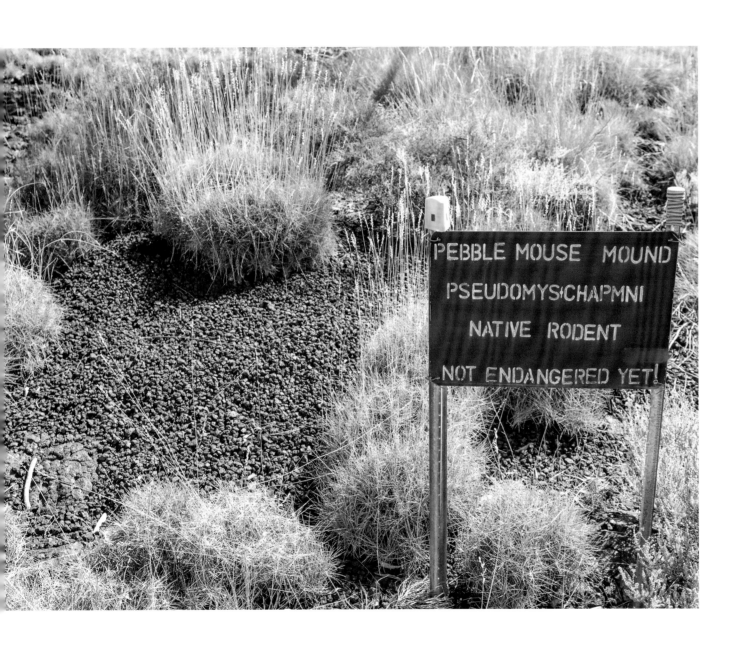

PEBBLE MOUSE MOUND
PSEUDOMYS·CHAPMNI
NATIVE RODENT
NOT ENDANGERED YET!

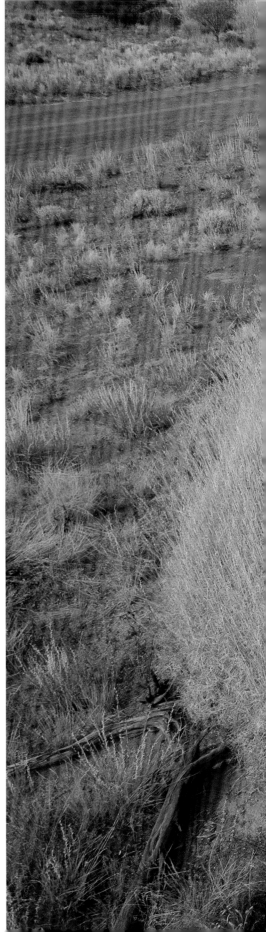

ABOVE *The pebble mound mouse builds huge piles of small rocks around its burrow – hence its charming name.*

RIGHT *Distinctive doughnut-shaped clumps of spinifex, seen here in the Gibson Desert, form as the plant grows outward and the centre dies off.*

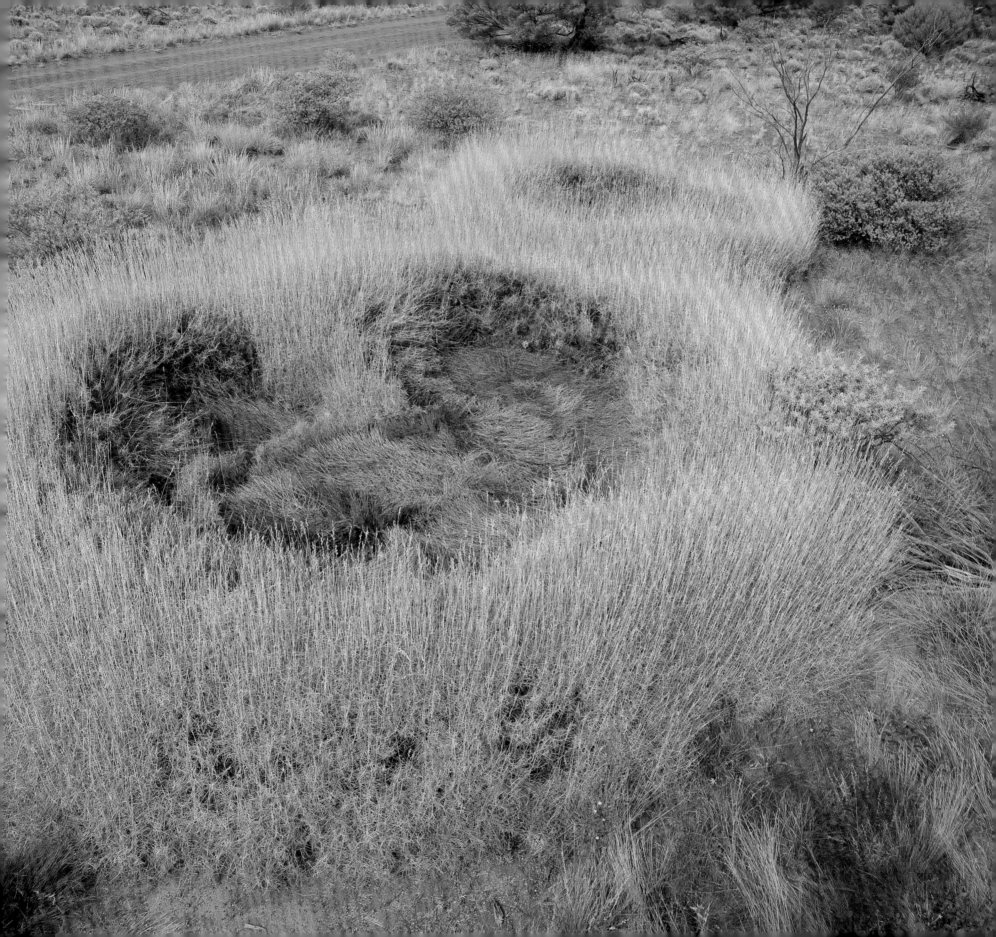

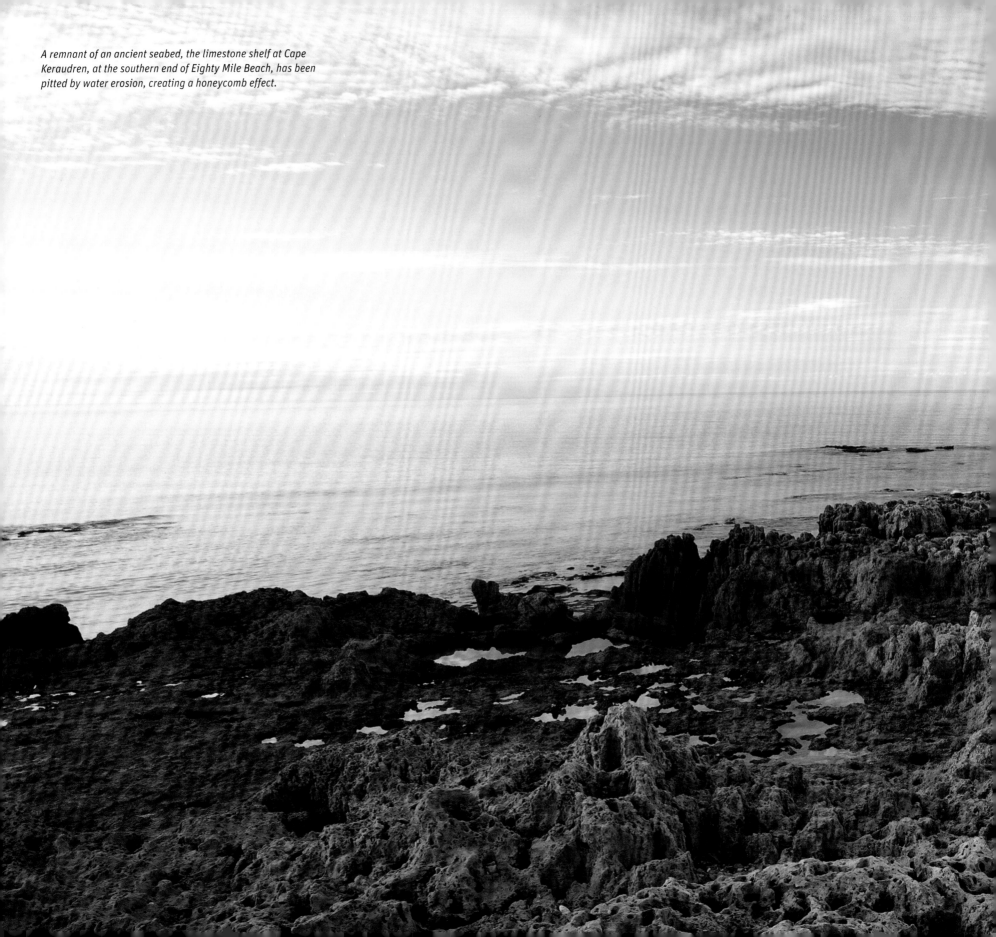

A remnant of an ancient seabed, the limestone shelf at Cape Keraudren, at the southern end of Eighty Mile Beach, has been pitted by water erosion, creating a honeycomb effect.

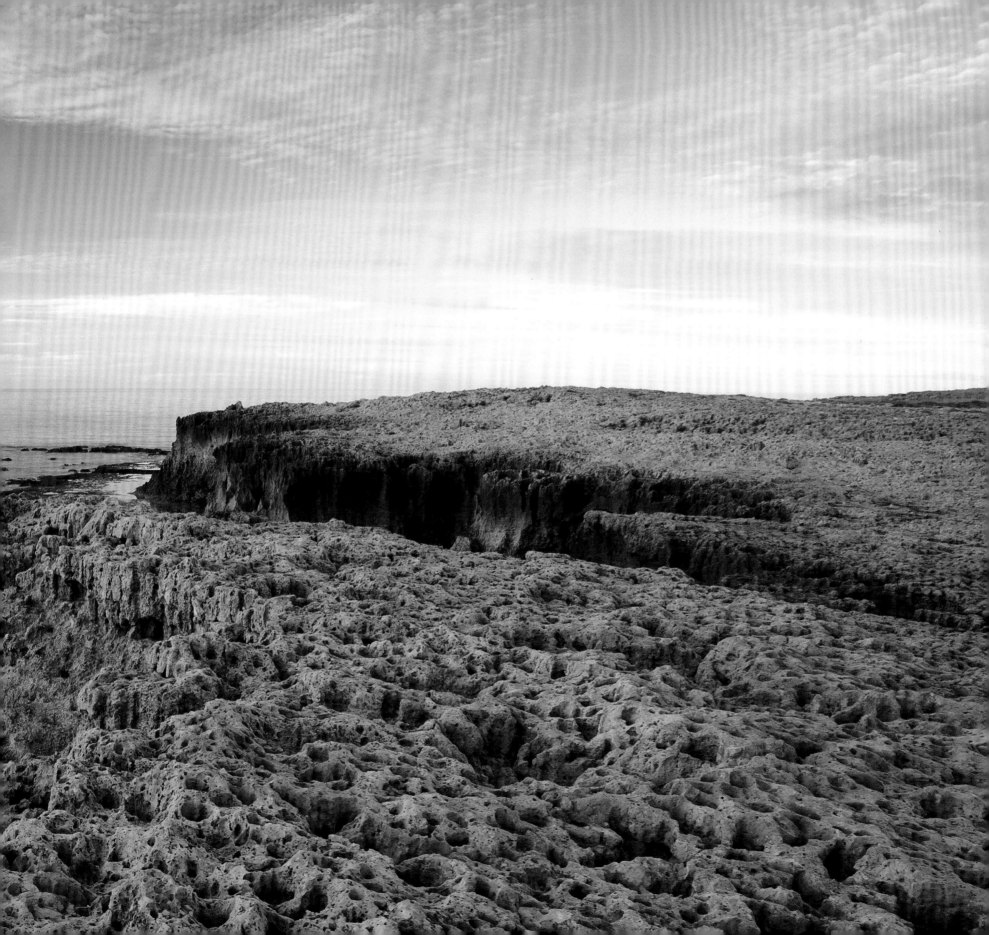

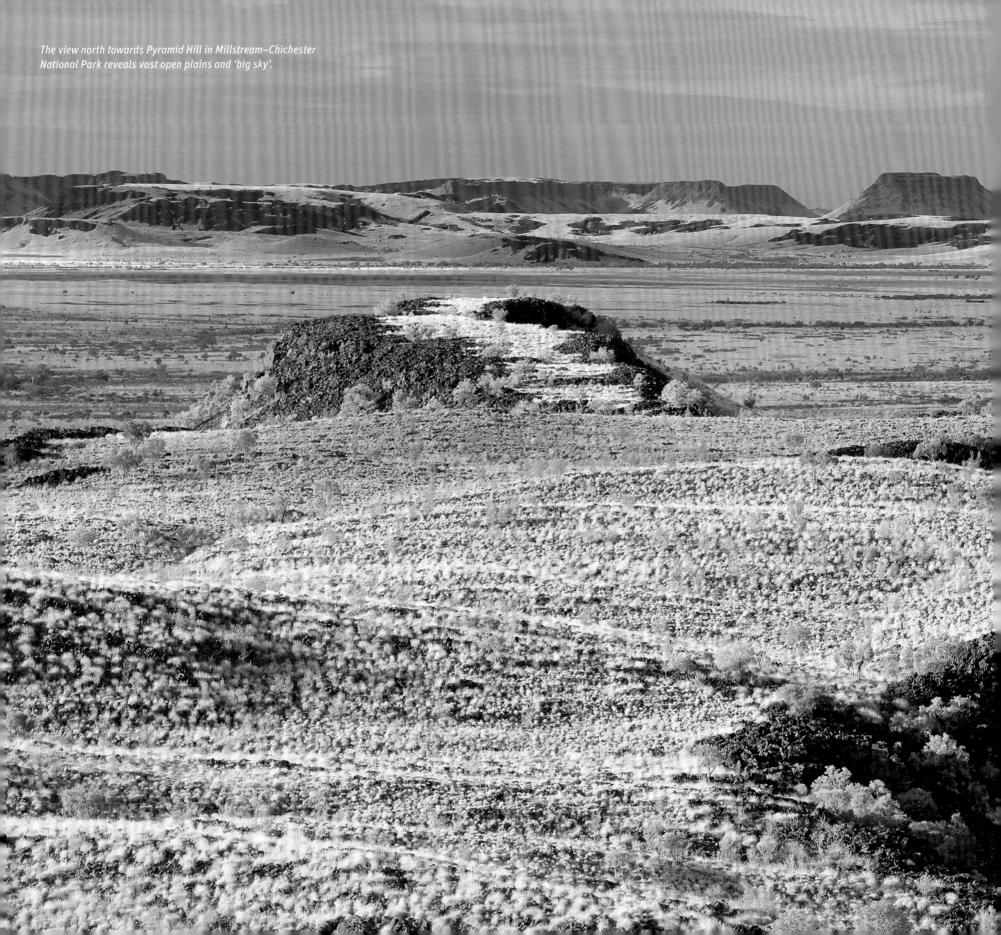

The view north towards Pyramid Hill in Millstream–Chichester National Park reveals vast open plains and 'big sky'.

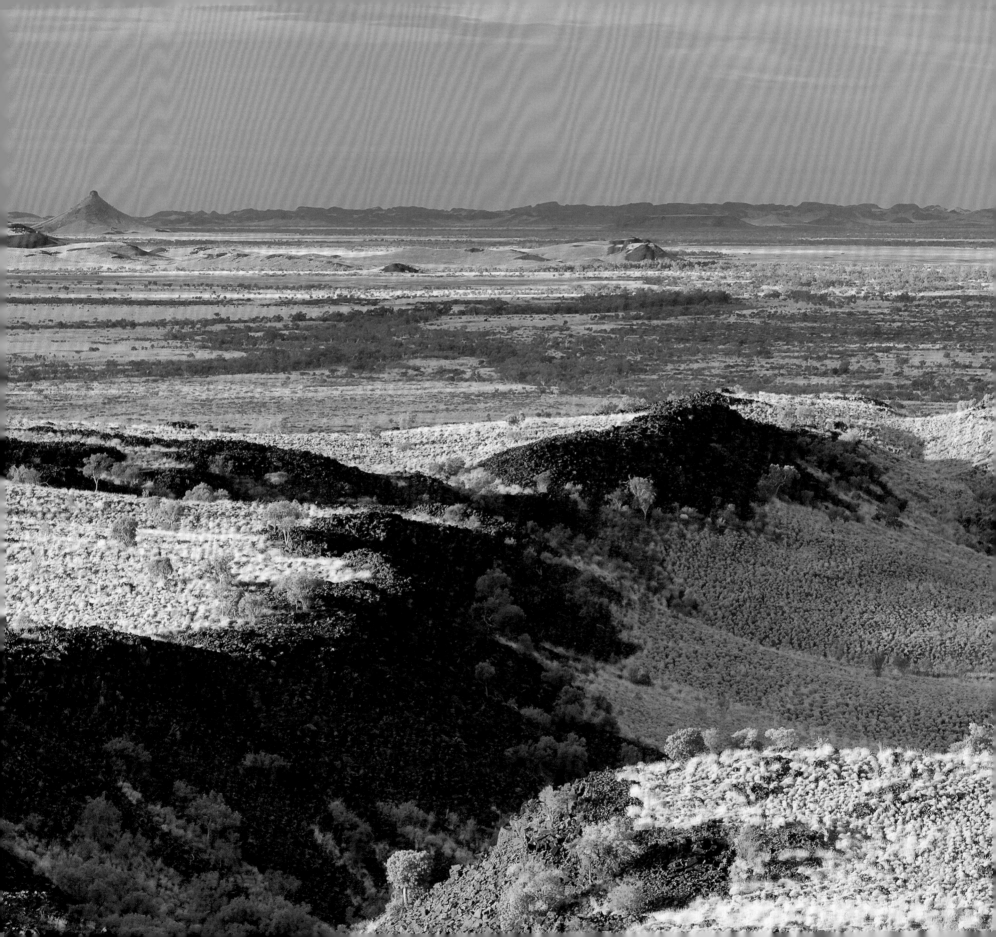

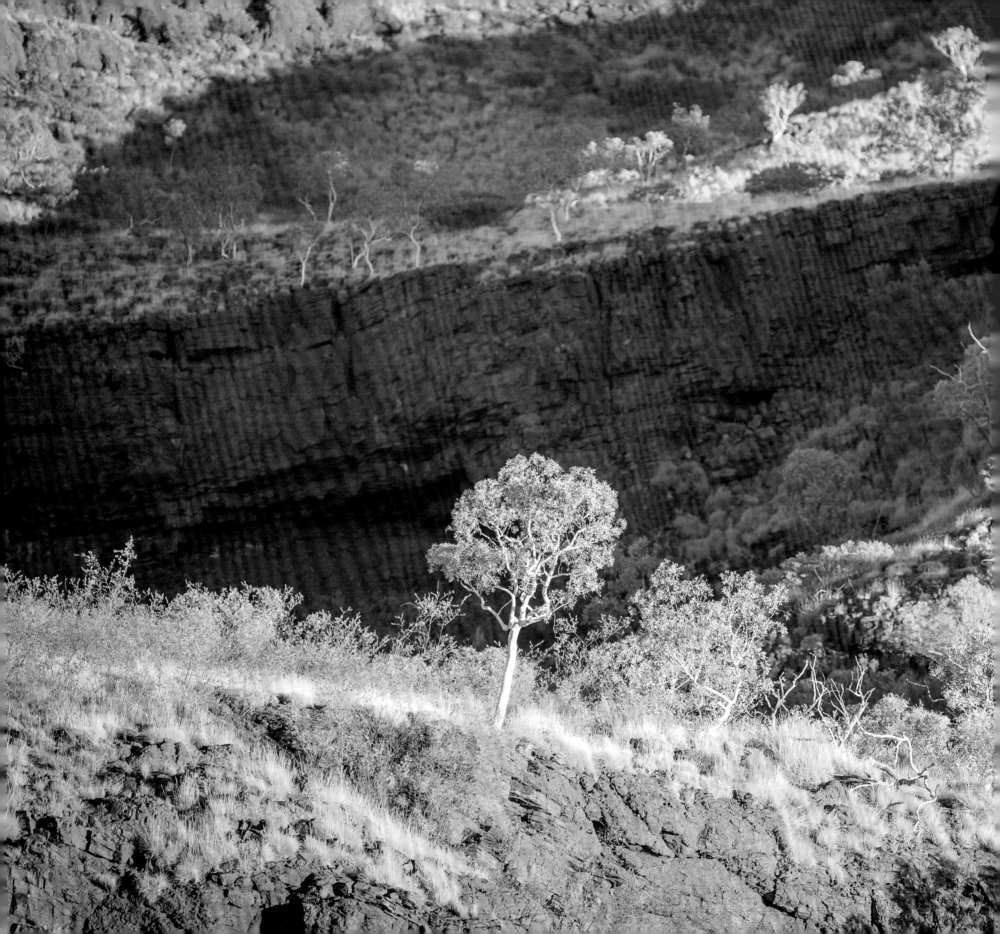

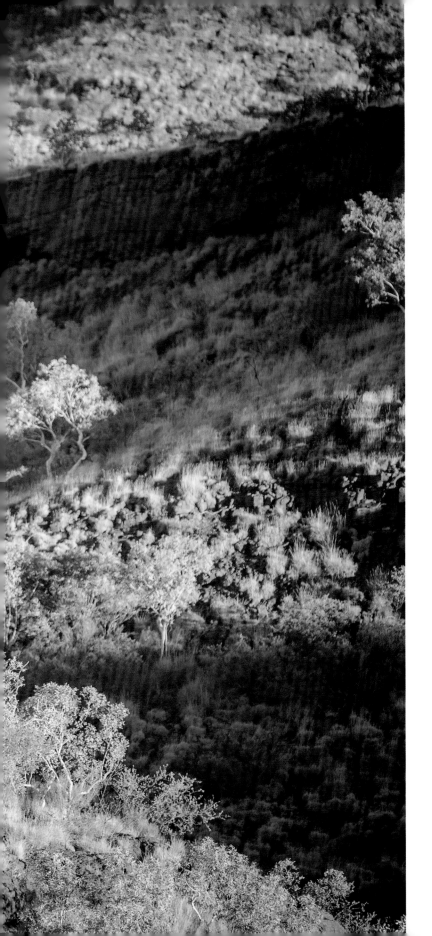

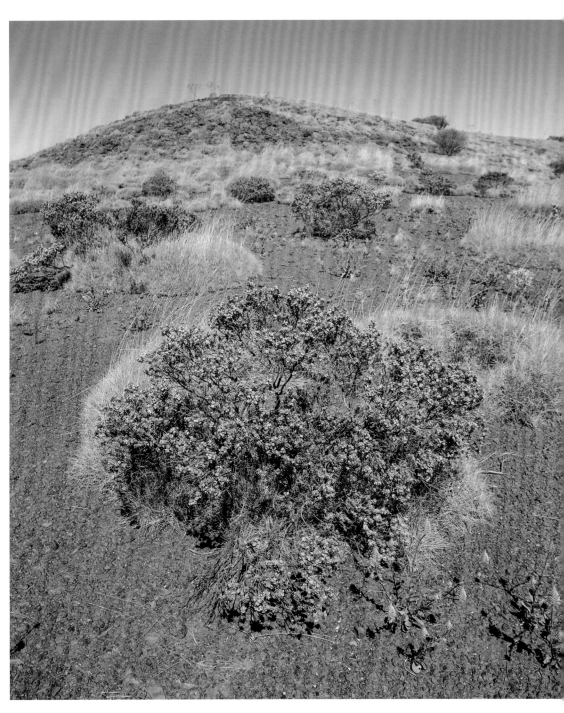

ABOVE The Pilbara shows much geological upheaval, unlike the more stable regions to the east.

LEFT Turkey bush sprouts on the western fringes of the Little Sandy Desert near Newman in the Pilbara.

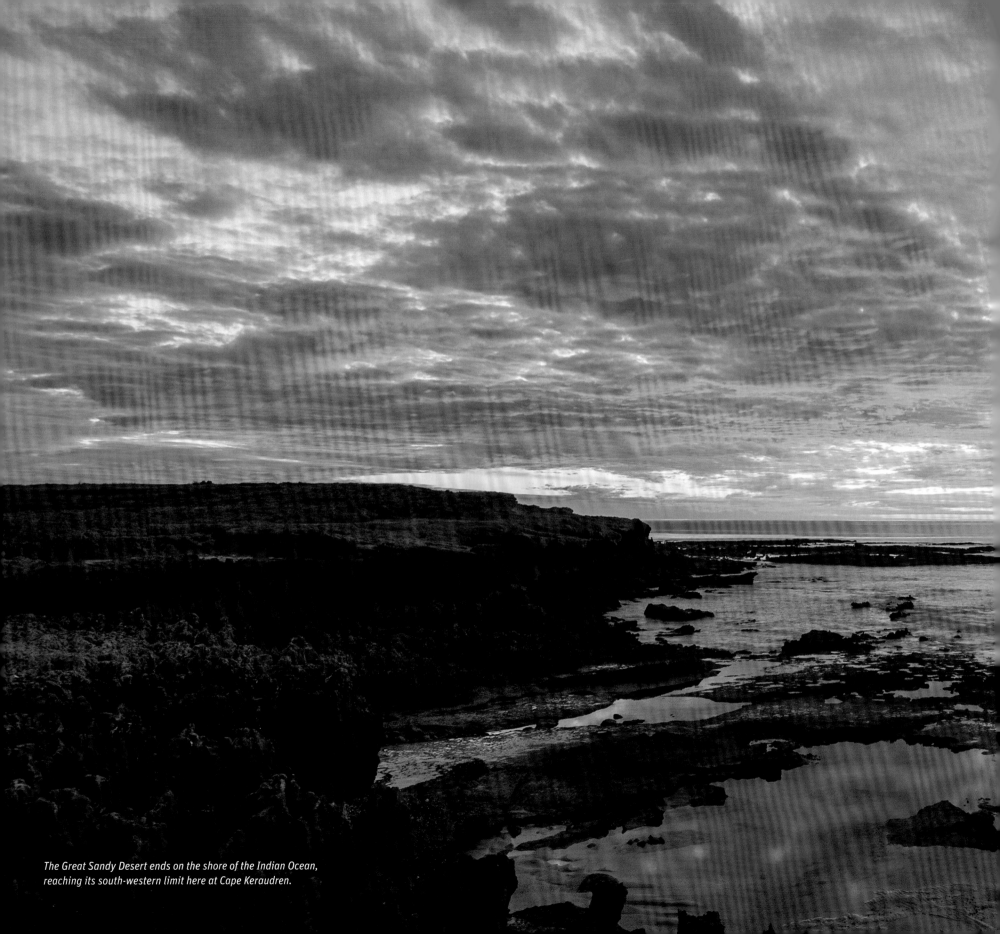

*The Great Sandy Desert ends on the shore of the Indian Ocean,
reaching its south-western limit here at Cape Keraudren.*

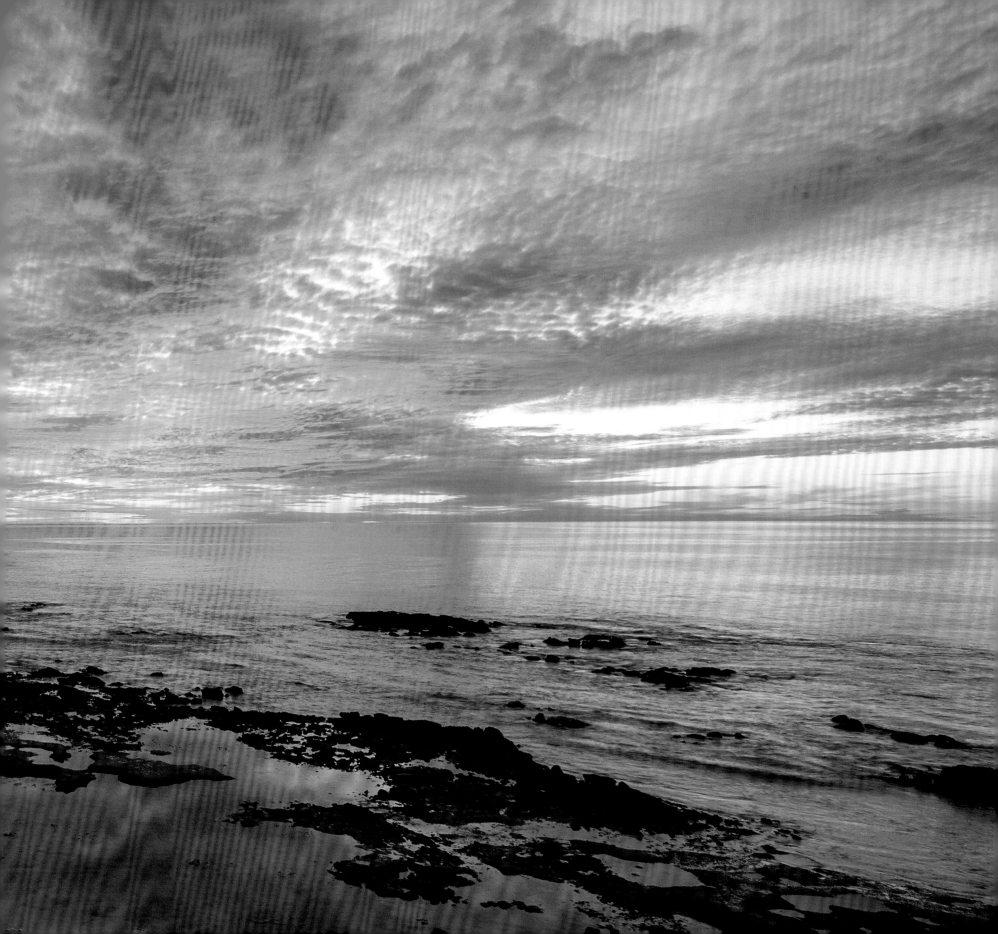

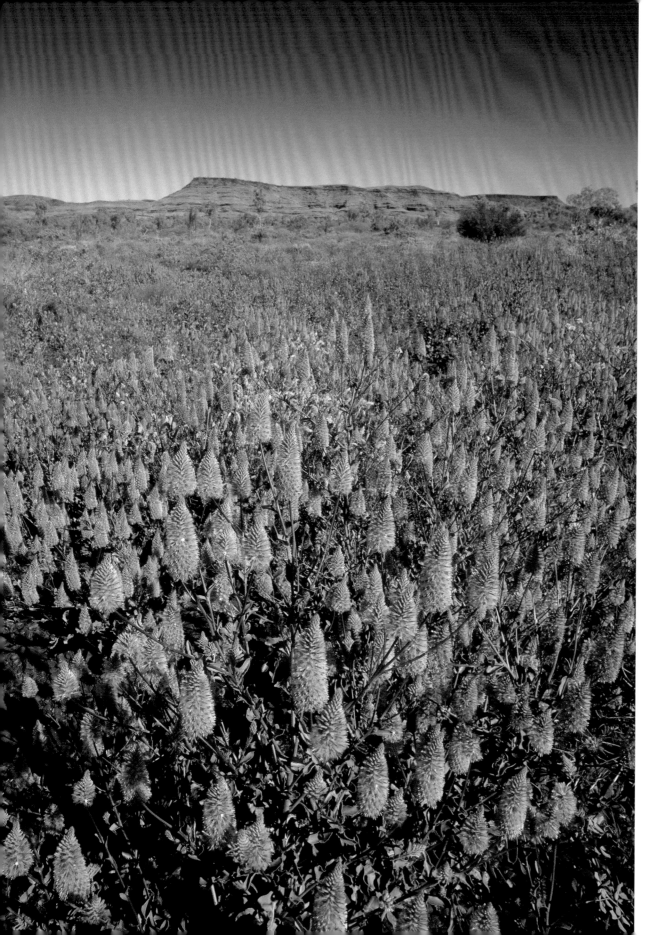

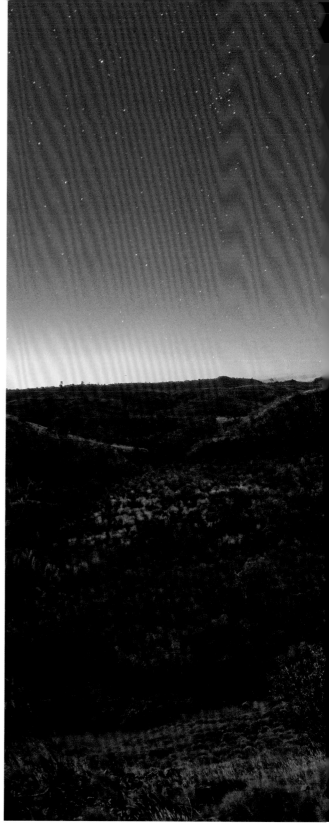

LEFT *Mulla mullas bloom in profusion in the Pilbara, within sight of Mt Bruce.*

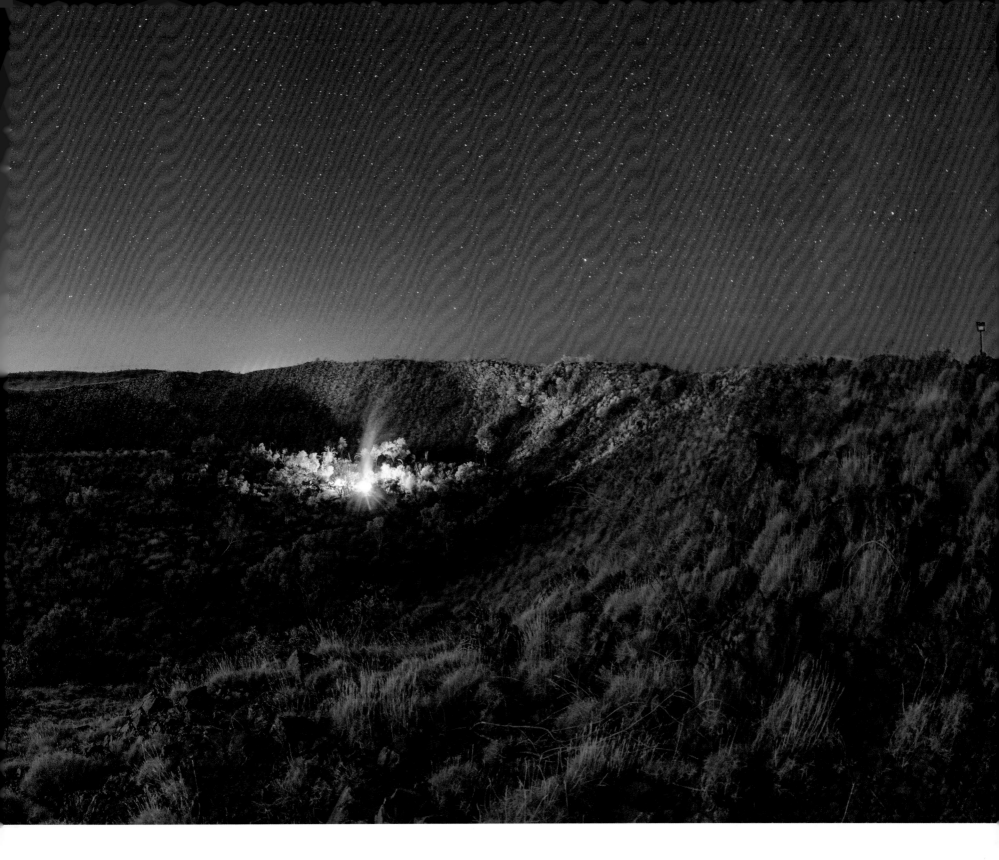

The Hickman Crater near Newman is named after Arthur Hickman, an Australian Government geologist who discovered the formation in 2007 while studying satellite images.

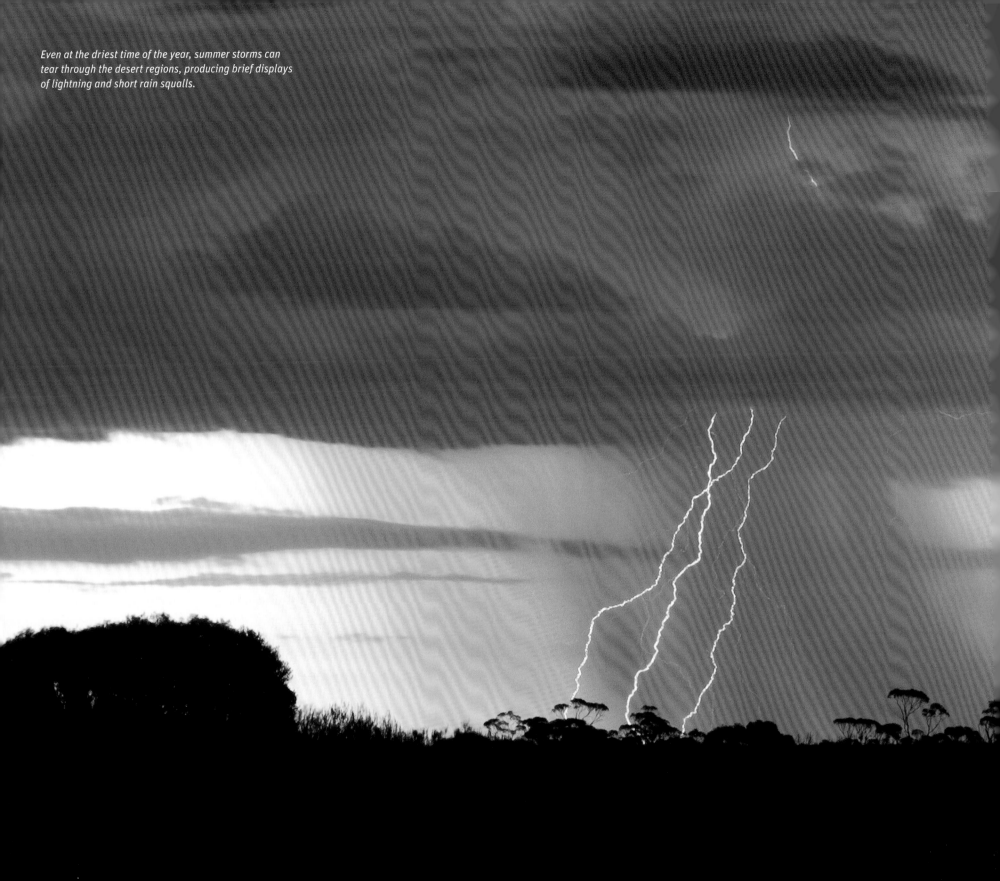

Even at the driest time of the year, summer storms can tear through the desert regions, producing brief displays of lightning and short rain squalls.

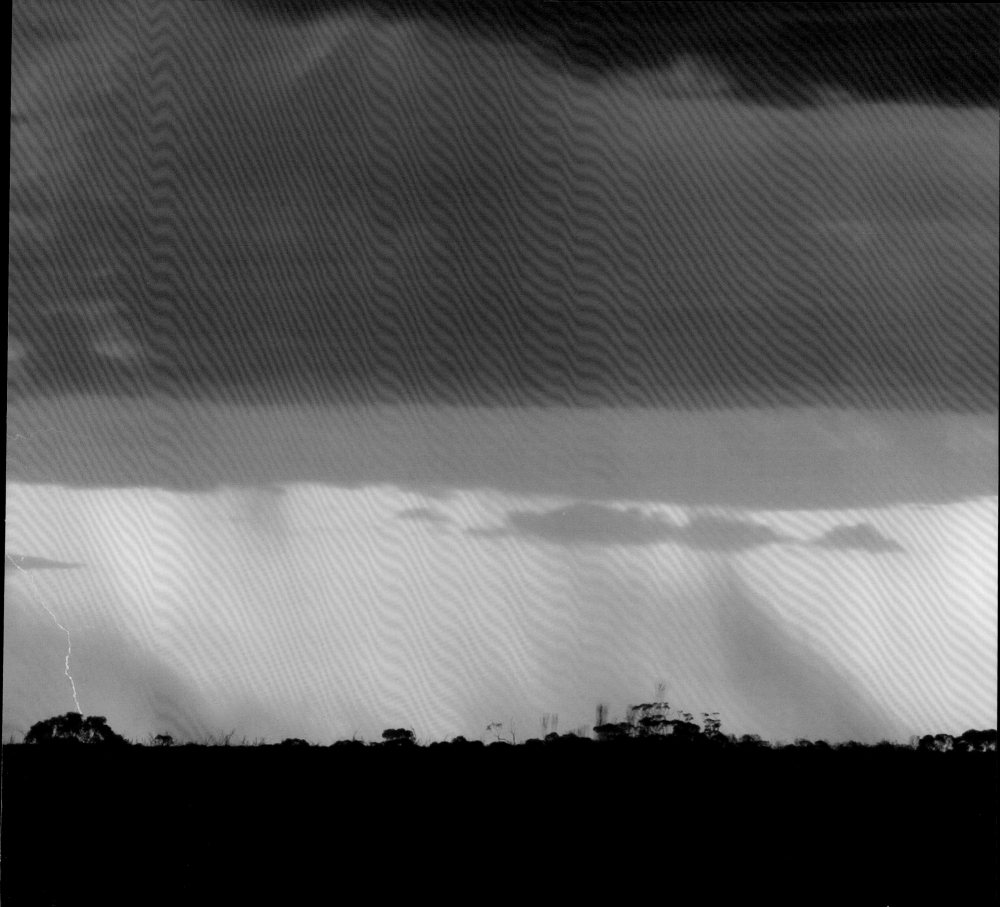

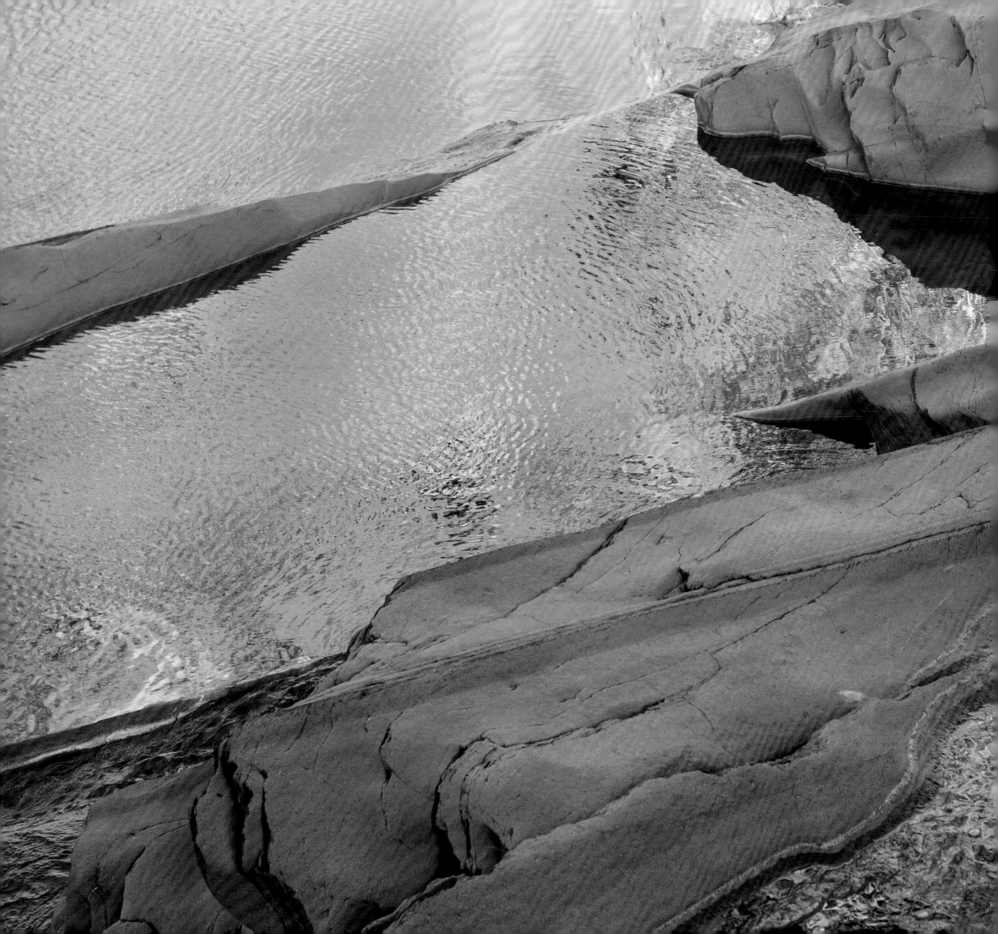

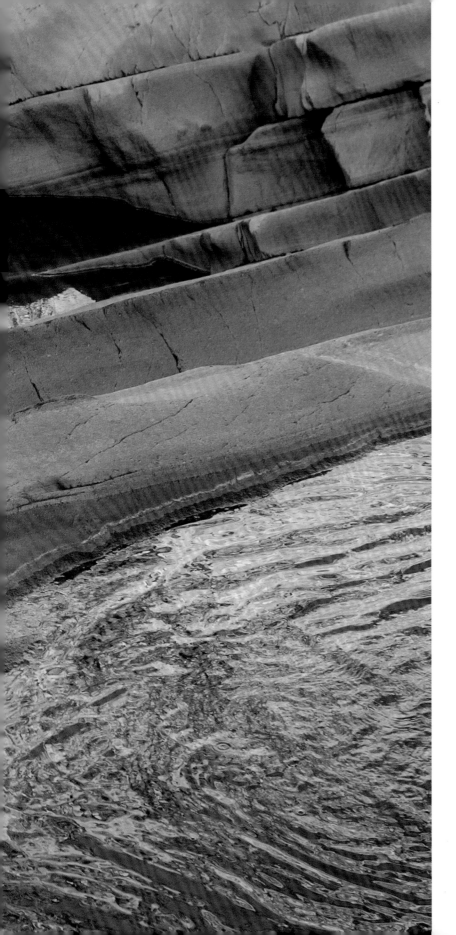

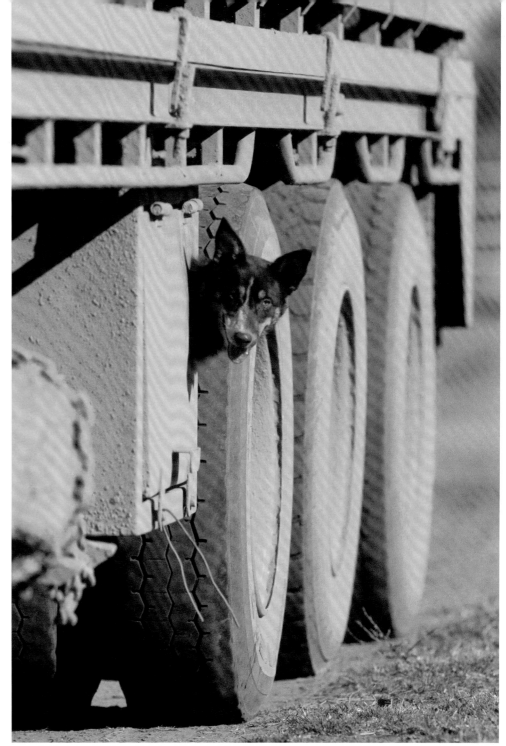

ABOVE A cattle dog peeks out of its 'kennel' in the chassis of a road train. Dogs are still used in station activities such as cattle mustering.

LEFT The reflections of sunlit red cliffs turn the water gold at Hamersley Gorge in the Pilbara.

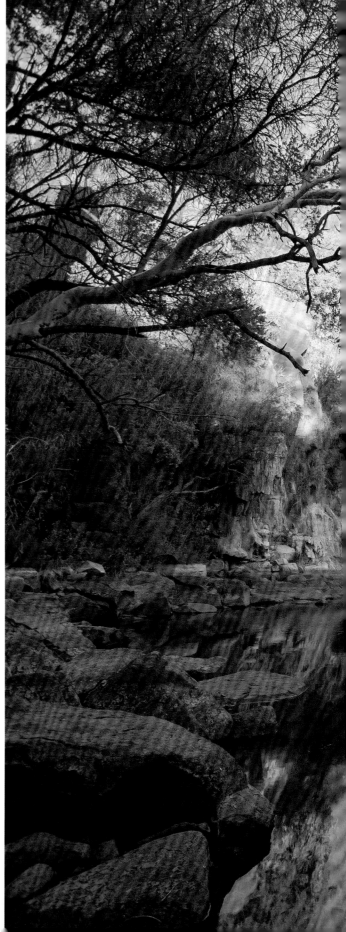

ABOVE To a geologist, the patterns in this rock at Hickman Crater, near Newman in the Pilbara, indicate clearly that this was the site of a meteorite strike.

RIGHT At Python Pool in Millstream–Chichester National Park, in the northern Pilbara, the waterfall only flows for a short time after heavy rain, but the pool is permanent.

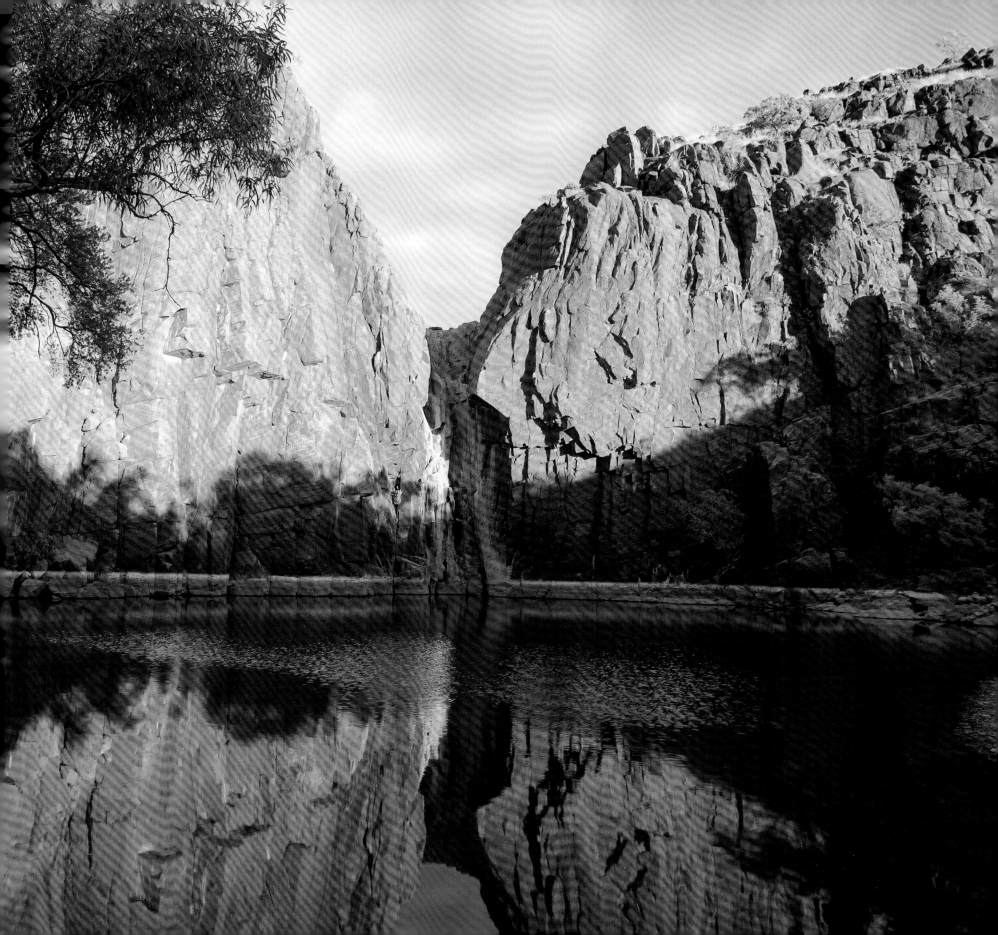

Lorna Glen

It constantly amazes me where stations were originally founded, often back in the late 19th century and early 20th century. There are few parts of the continent, no matter how inhospitable, where someone has not at least attempted to set up a viable pastoral concern.

Take Lorna Glen, for example. It's right on the edge of the Little Sandy Desert, north-east of Wiluna and about 900 kilometres as the crow flies from Perth. It was operated intermittently from the early 1900s as a pastoral property until 2000, when it was purchased by the Western Australian Government with National Reserve System (NRS) funding.

In 2007 I was commissioned by the NRS to visit a whole range of now-defunct pastoral leases around the nation – a dream assignment – to photograph what were described to me as their 'natural values'. Lorna Glen was one of those places, and I incorporated it in my itinerary by taking the Great Central Road via Warburton towards Uluru in the Northern Territory. Parts of this route used to be called the Gunbarrel Highway, and the old tracks still exist, running past Lorna Glen to Carnegie Station and on, deep into the Gibson Desert.

Lorna Glen is something of a surprise. Looking at a map, you'd expect it to be, well, a desert. But it's actually fairly high up (500 metres) on an inland plateau and features large, flat areas of spinifex and lots of mulga and eucalypt species. It's not at all as harsh as its location might indicate. The station homestead backs onto a stand of huge eucalypts and the birdlife, attracted by the permanent water, is prolific to say the least.

Combined with the neighbouring property, Earaheedy (now Kurrara Kurrara), Lorna Glen (Matuwa, to give it its modern name) is today operated as a 6000-square-kilometre nature and research reserve, managed in conjunction with the traditional Aboriginal owners, the Martu, from Wiluna, and can be visited by the general public. There are bunkhouses, camping areas and designated vehicle tracks to follow.

...an inland plateau with large, flat areas of spinifex, mulga and eucalypt species

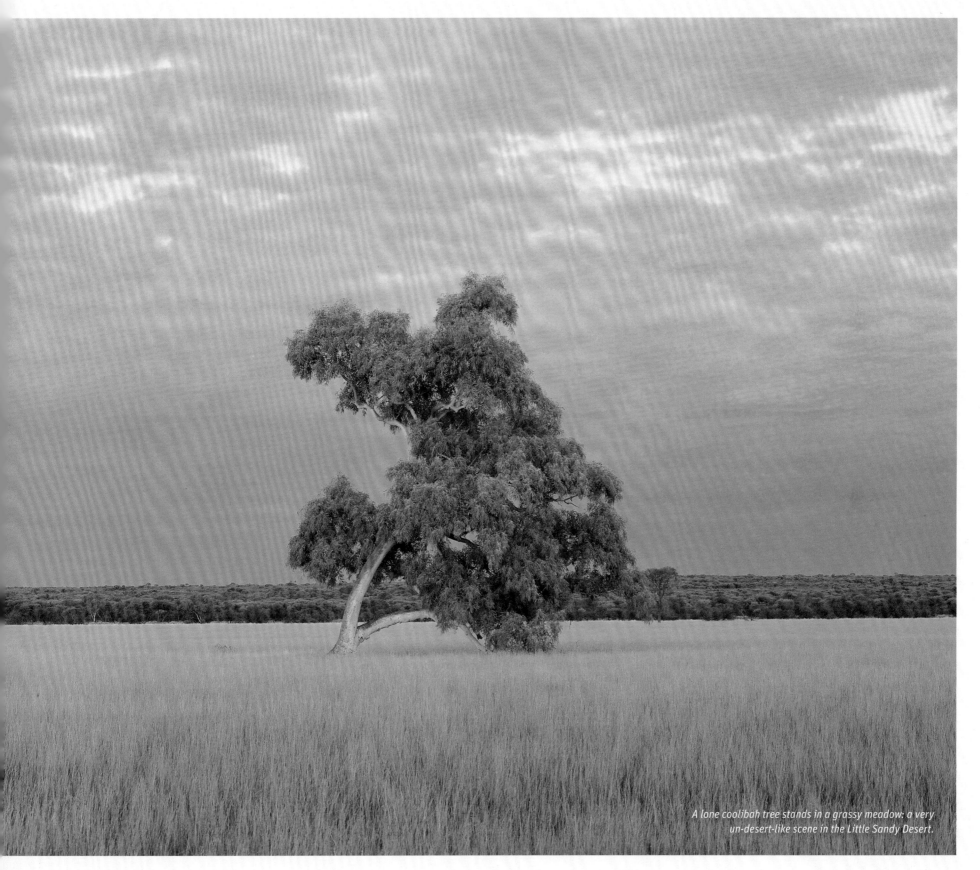

A lone coolibah tree stands in a grassy meadow: a very un-desert-like scene in the Little Sandy Desert.

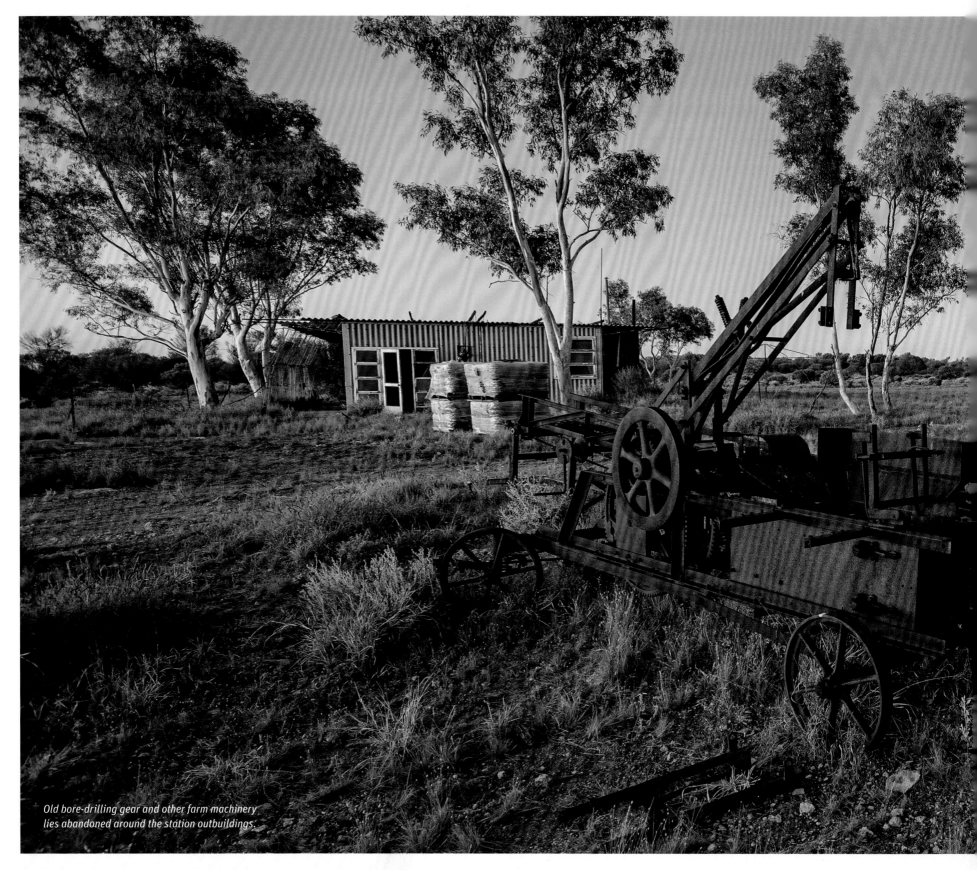

Old bore-drilling gear and other farm machinery
lies abandoned around the station outbuildings.

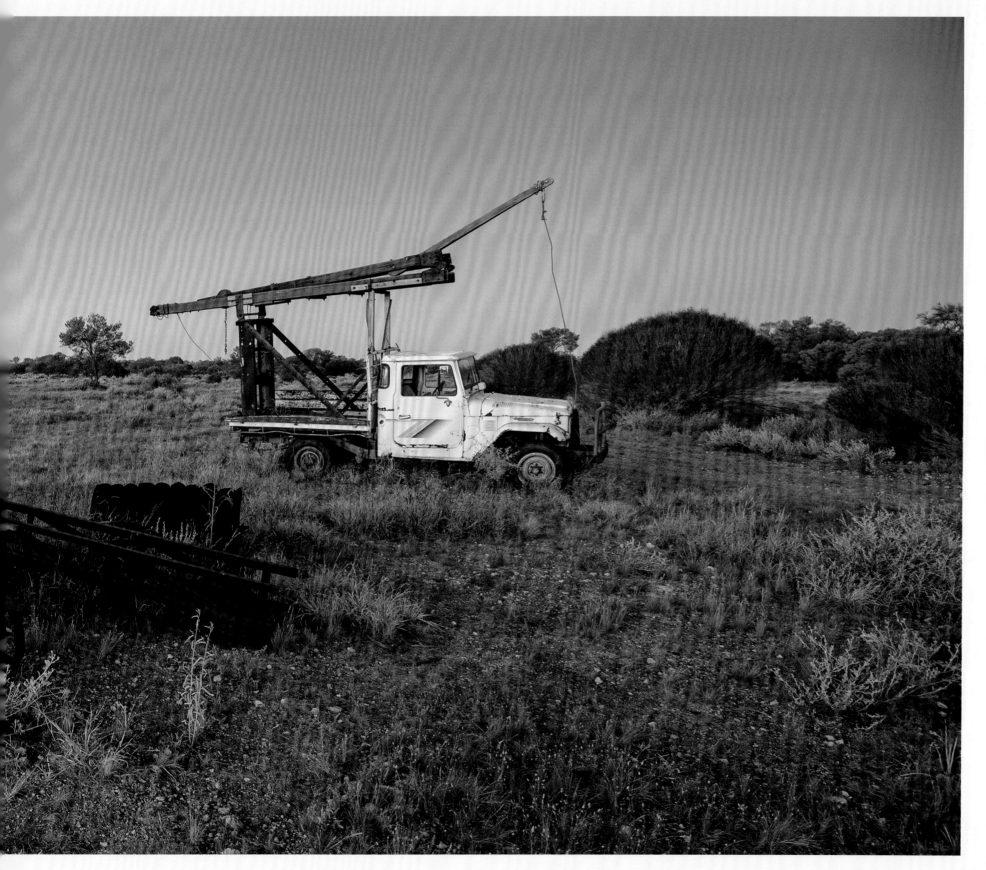

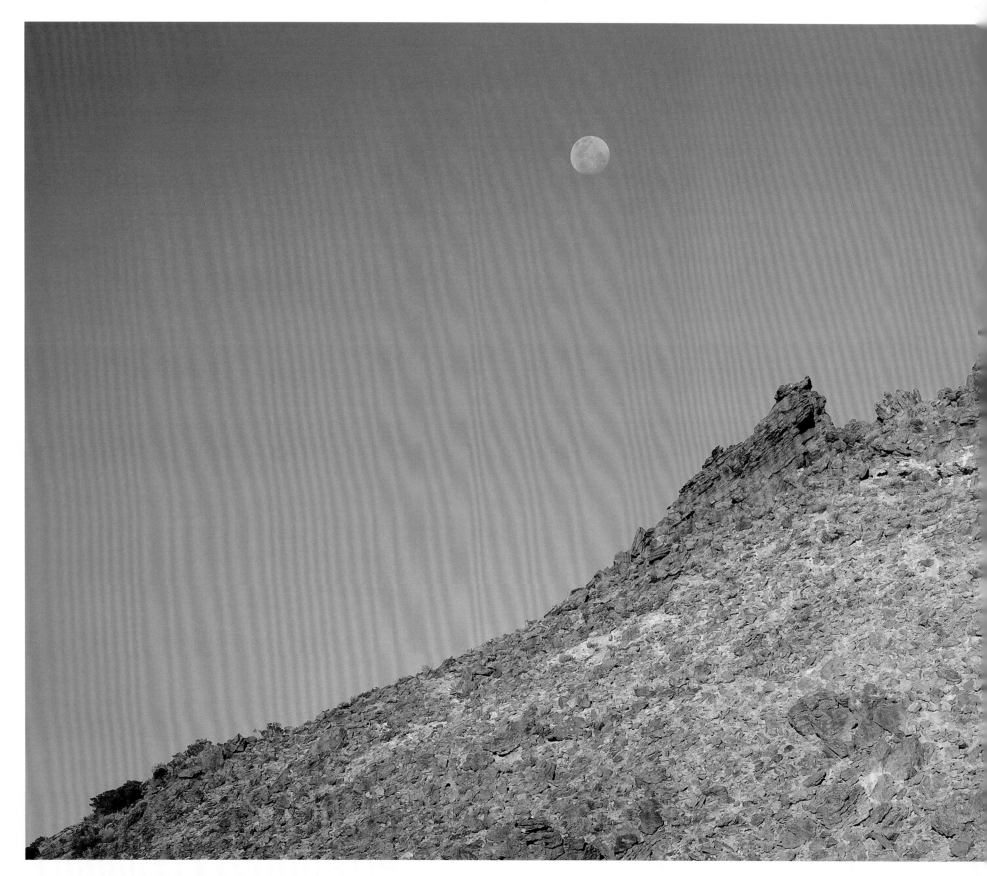

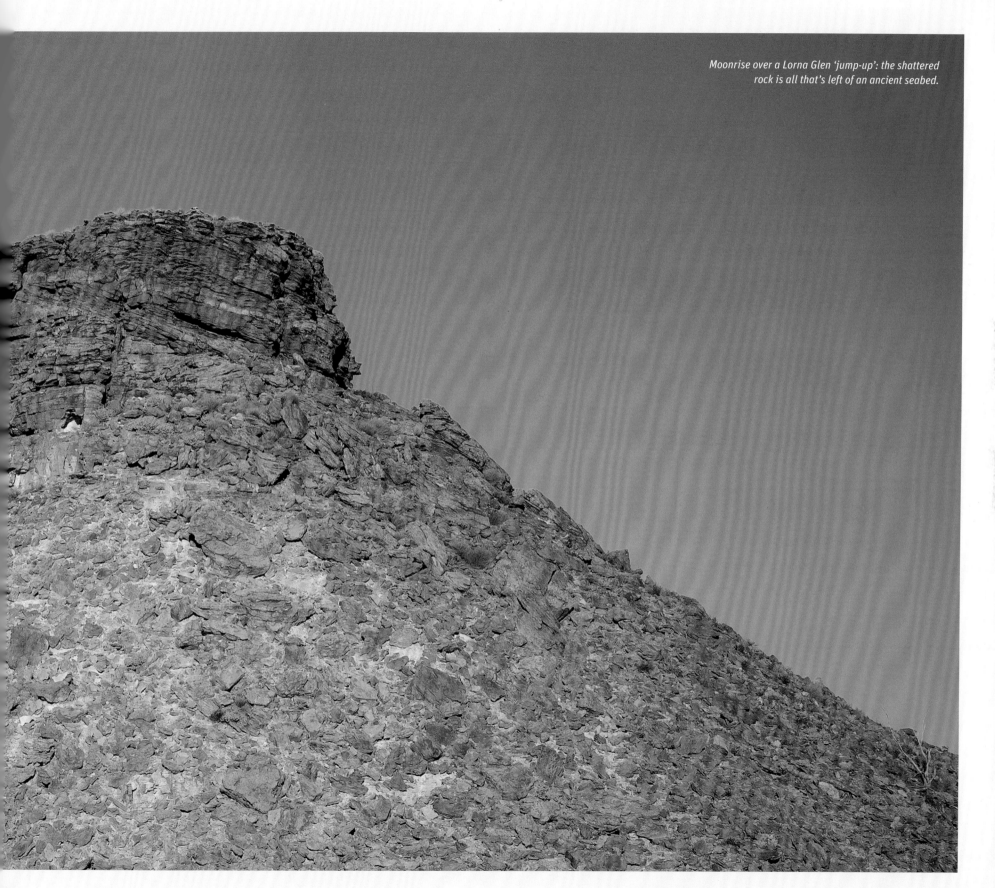

Moonrise over a Lorna Glen 'jump-up': the shattered rock is all that's left of an ancient seabed.

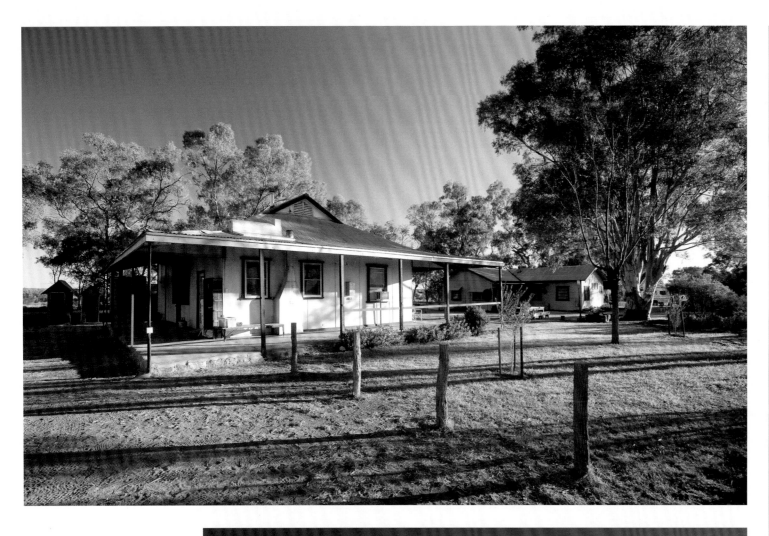

ABOVE *Lorna Glen Station has been refurbished and is currently used as a base for researchers.*

RIGHT *All that remains of the Lorna Glen woolshed are the shearing mechanisms and frames.*

OPPOSITE *Galahs are prolific where there is food and water, for example around station bores.*

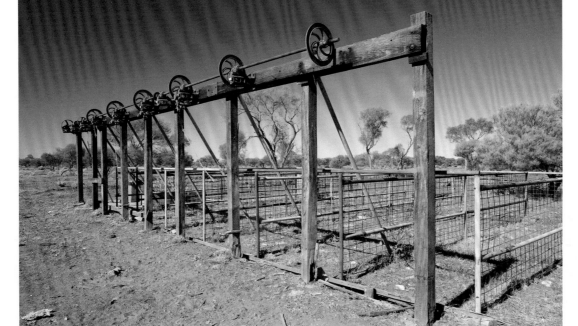

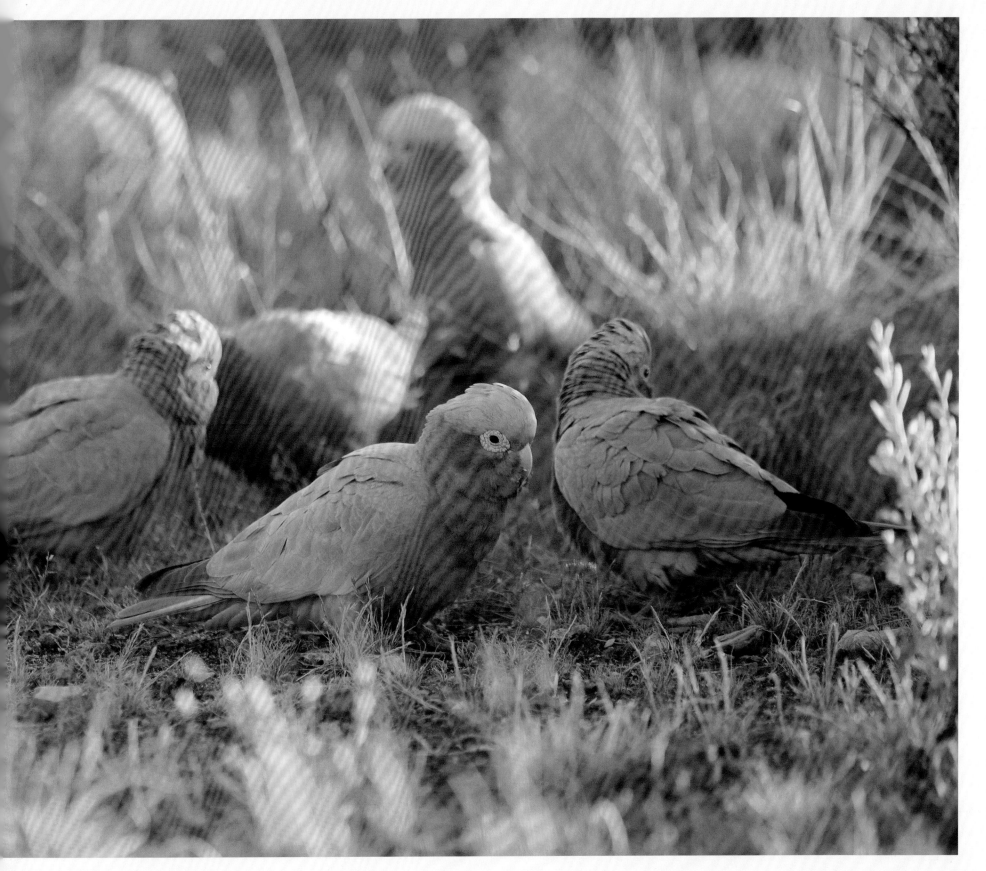

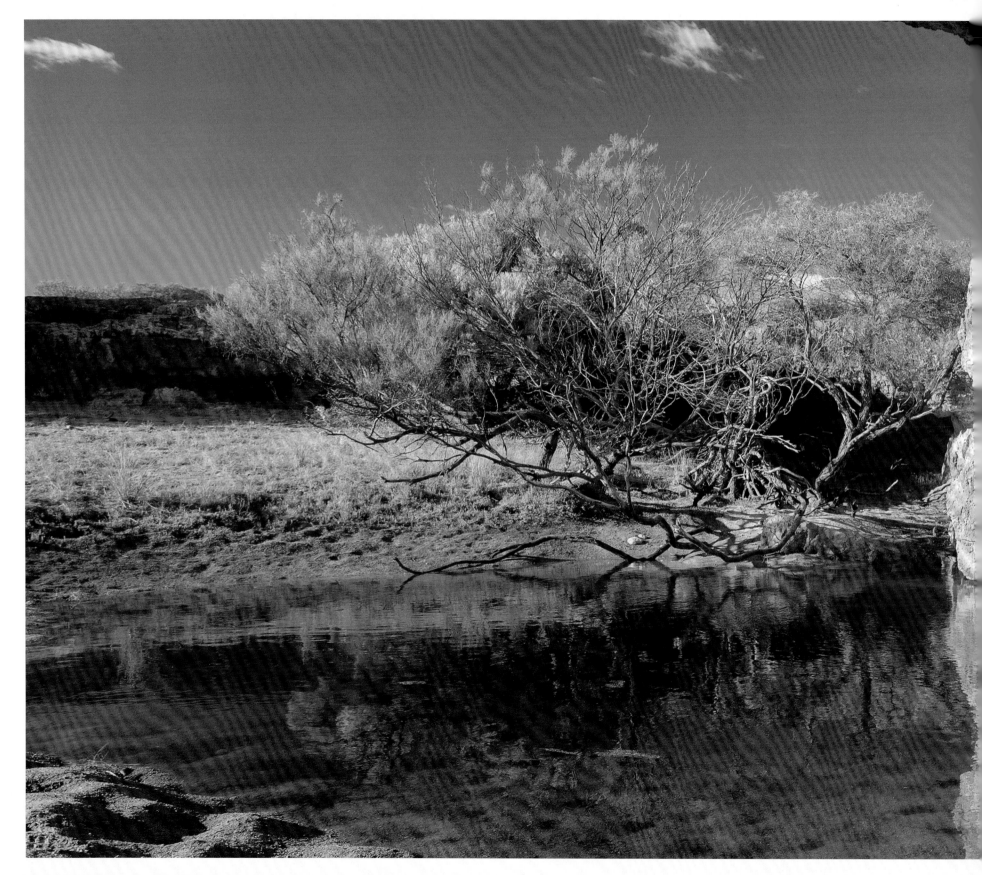

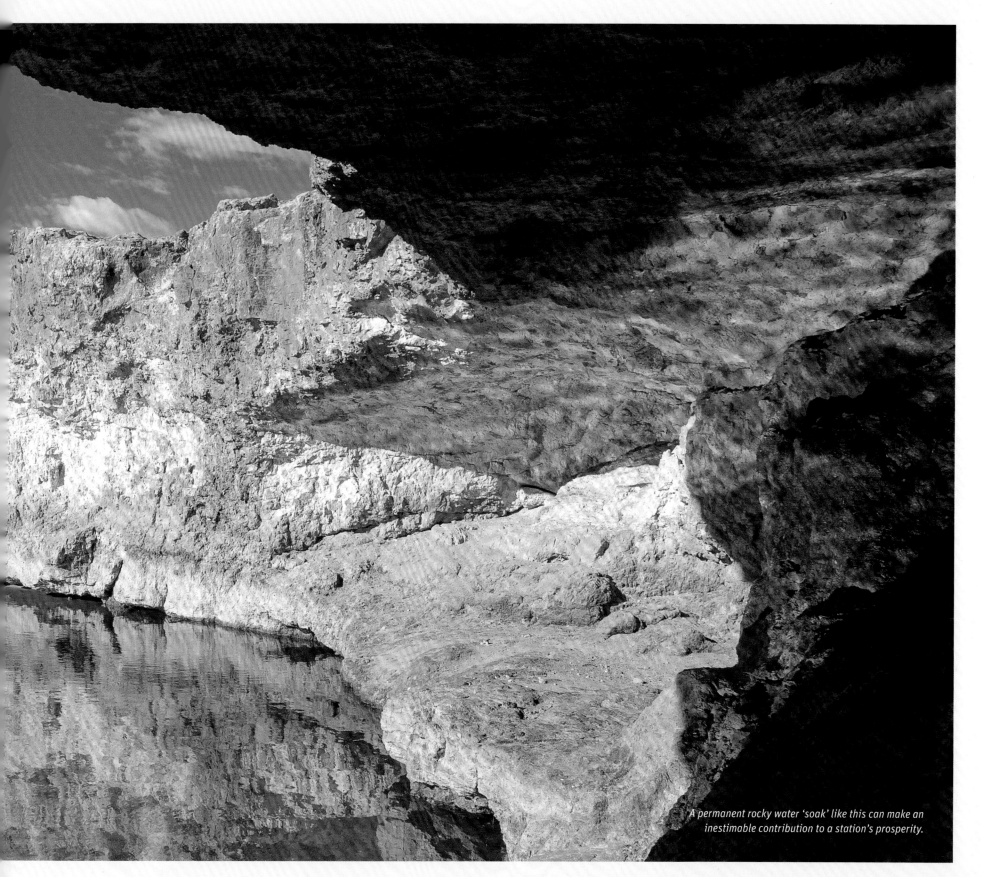

A permanent rocky water 'soak' like this can make an inestimable contribution to a station's prosperity.

ACKNOWLEDGEMENTS

The publisher would like to acknowledge the following individuals and organisations:

Commissioning editor
Marg Bowman
Melissa Kayser

Project manager
Lauren Whybrow, Kate J. Armstrong

Editor
Scott Forbes

Internal page design
Peter Dyson at desertpony

Cover design
Phillip Campbell

Pre-press
Splitting Image

Front cover: A thorny devil stands proud in the Simpson Desert
Back cover: Wind sculpts sand into ripples and dunes
Title page: Life blooms against all odds in the Simpson Desert
Page ii: The White Stacks in Kennedy Range National Park, Western Australia

Explore Australia Publishing Pty Ltd
Ground Floor, Building 1, 658 Church Street,
Richmond, VIC 3121

Explore Australia Publishing Pty Ltd is a division of Hardie Grant Publishing Pty Ltd

Published by Explore Australia Publishing Pty Ltd, 2016

Form and design © Explore Australia Publishing Pty Ltd, 2016
Text and Images © Nick Rains, 2016

A Cataloguing-in-Publication entry is available from the catalogue of the National Library of Australia at www.nla.gov.au

ISBN-13 9781741175097

10 9 8 7 6 5 4 3 2 1

Printed and bound in China by 1010 Printing International Ltd

Publisher's note: Every effort has been made to ensure that the information in this book is accurate at the time of going to press. The publisher welcomes information and suggestions for correction or improvement. Email: info@exploreaustralia.net.au

Publisher's disclaimer: The publisher cannot accept responsibility for any errors or omissions. The representation of any road or track is not necessarily evidence of public right of way. The publisher cannot be held responsible for any injury, loss or damage incurred during travel. It is vital to research any proposed trip thoroughly and seek the advice of relevant state and travel organisations before you leave.

www.exploreaustralia.net.au